Beauty and Art
1750–2000

Oxford History of Art

Elizabeth Prettejohn is Professor of Modern Art at the University of Plymouth, and was formerly Curator of Paintings and Sculpture at Birmingham Museums & Art Gallery. She is co-author of the exhibition catalogues *Dante Gabriel Rossetti*, *Sir Lawrence Alma-Tadema*, and *Imagining Rome: British Artists and Rome in the Nineteenth Century*; author of *The Art of the Pre-Raphaelites*, *Interpreting Sargent*, and *Rossetti and His Circle*; and editor of *After the Pre-Raphaelites: Art and Aestheticism in Victorian England* and (with Tim Barringer) *Frederic Leighton: Antiquity, Renaissance, Modernity*.

Oxford History of Art

Titles in the Oxford History of Art series are up-to-date, fully illustrated introductions to a wide variety of subjects written by leading experts in their field. They will appear regularly, building into an interlocking and comprehensive series. In the list below, published titles appear in bold.

Oxford History of Art

Beauty and Art 1750–2000

Elizabeth Prettejohn

OXFORD
UNIVERSITY PRESS

OXFORD
UNIVERSITY PRESS

Great Clarendon Street, Oxford OX2 6DP

Oxford New York

Auckland Bangkok Buenos Aires Cape Town
Chennai Dar es Salaam Delhi Hong Kong Istanbul Karachi
Kolkata Kuala Lumpur Madrid Melbourne Mexico City Mumbai
Nairobi São Paulo Shanghai Taipei Tokyo Toronto
and associated companies in Berlin Ibadan

Oxford is a registered trade mark of Oxford University Press
in the UK and in certain other countries

0–19–280160–0

10 9 8 7 6 5 4 3 2 1

British Library Cataloguing in Publication Data
Data available

Library of Congress Cataloging-in-Publication Data
Prettejohn, Elizabeth
 Beauty and art 1750–2000 / Elizabeth Prettejohn.
 p. cm. — (Oxford history of art)
 Includes bibliographical references and index.
 1. Art—Philosophy. 2. Aesthetics. I. Title. II. Series.
N66.P74 2005
701'.17'0903–dc22 2004061707
ISBN 0–19–280160–0

Picture research by Elisabeth Agate
Copy-editing, typesetting, and production management by
The Running Head Limited, Cambridge, www.therunninghead.com
Printed in China on acid-free paper by C&C Offset Printing Co. Ltd

Contents

Acknowledgements

I should like to thank the anonymous reviewers for Oxford University Press, Stephen Bann, Tim Barringer, Colin Cruise, Joan Esch, Chris Green, Shelley Hales, John House, Sally Huxtable, Katy Macleod, Anna Gruetzner Robins, Debbie Robinson, and most of all Charles Martindale, the best of critics and most devoted lover of beauty. Elisabeth Agate has been a creative and resourceful picture researcher, and I should like to thank my editors, Katharine Reeve, Penny Isaac, and Matthew Cotton, as well as David Williams at The Running Head, whose work has improved the book in countless respects. This book is dedicated to the members of the Art History Research Seminar group at the University of Plymouth, who prove that disinterested intellectual enquiry may still be possible even in the instrumentalist world we now inhabit.

Introduction

Since the eighteenth century philosophers have explored the human faculty of taking pleasure in the beautiful. During the same period the historical study of works of art has grown steadily in range and sophistication. Surprisingly, these two areas of enquiry have remained largely separate. Philosophical aesthetics has concentrated on the human subject's experience of the beautiful in general terms: what do we mean when we call something in nature or art 'beautiful'? Art history, on the other hand, has attended to the particular class of objects that societies, past and present, have designated 'art': what are the characteristics of the historical artefacts that have been valued aesthetically? This book brings together human subjects and crafted objects. It aims to juxtapose the abstract question of beauty, as it has been posed since the beginning of modern philosophical aesthetics in eighteenth-century Germany, with the concrete objects that have been made or enjoyed in the same period. How have artists responded to speculations on the beautiful? Which works of art have been called beautiful, and why? What are we saying about these works when we call them beautiful, rather than finding them useful or informative, morally edifying or politically progressive?

These questions mark a significant departure from the recent concerns of academic art history, which since the 1970s has focused predominantly on questions of historical, social, and political context. During the past thirty years the beauty of the work of art has seemed secondary to the work's ideological functions in negotiations of class and power, gender and politics. The love of beauty has seemed at best an evasion or escape from the problems of social reality, at worst a way of shoring up the status of the rich and powerful. Judgements of aesthetic value have been seen as tainted by association with the art market, or with the self-interest of the wealthy and patrician. In the same period, many practising artists have felt themselves under pressure to choose between aesthetic pleasure and political engagement. To choose the former was effectively to court a reputation as a reactionary; thus many artists have felt that, in practice, there was no choice at all.

As we shall see in the Afterword, the late-twentieth-century view of beauty as irrevocably opposed to any form of responsible politics has

Detail of 31

9

itself come under attack. Thus a number of artists, critics, and curators have begun to call for a new attention to beauty as a significant issue in both contemporary life and contemporary art, and one purpose of this book is to support such calls. As the scholar Wendy Steiner (b. 1949) puts it, in her influential book of 2001, *The Trouble with Beauty*, 'Invoking beauty has become a way of registering the end of modernism and the opening of a new period in culture.'[1] Yet there is a danger that a new fashion for beauty in contemporary art will merely reverse the late-twentieth-century prejudice against beauty, without reconfiguring the debate in more nuanced terms. The premise of this book is that we can learn more complex and sophisticated ways of thinking about questions of beauty from the many philosophers, art theorists, critics, and artists who have engaged seriously with these questions since 1750.

There might be an argument for taking a longer or wider view of the question of beauty, which has been under debate in western thought at least since the ancient Greek philosophers, Plato (*c.*427–*c.*347 BCE) and Aristotle (384–322 BCE), and in non-western contexts ranging from ancient China to modern India.[2] Indeed, it is not possible wholly to isolate current thinking on beauty from these longer and wider traditions, and future studies will no doubt expand the range of enquiry. However, this book aims at depth rather than breadth, and concentrates on four particular moments from the relatively recent past, each of which demonstrates with special clarity problems and issues in aesthetics that remain profoundly relevant to today's worlds of art practice and art history. Chapter 1 serves as an introduction to the concerns of the book as a whole, by examining in detail the writings of Johann Joachim Winckelmann (1717–68) and Immanuel Kant (1724–1804), who may be called the founders of the modern disciplines of, respectively, art history and philosophical aesthetics. Chapter 2 explores a range of debates on aesthetic questions in early nineteenth-century France, from Madame de Staël (1766–1817), who introduced German aesthetic thought to the rest of Europe, to Charles Baudelaire (1821–67), whose writings have had the greatest possible impact on subsequent art theory and practice. Chapter 3 looks at Aestheticism in Victorian England; still, perhaps, the most controversial of the modern period's explorations of beauty. Chapter 4 traces the vexed fortunes of beauty in twentieth-century modernism, concentrating on two leading critics, Roger Fry (1866–1934) and Clement Greenberg (1909–94). The Afterword brings the discussion up to the present day, and asks how debates about beauty may continue to inform both art practice and the historical study of art in the future. Throughout the book, theoretical questions about beauty are considered in relation to the practices of artmaking and art appreciation in the periods under consideration. Implicitly, then, the book argues that speculation about beauty cannot

and should not be separated from the concrete practices of making, studying, and enjoying particular works of art.

A premise of the book is that the questions about beauty raised in late-eighteenth-century Germany, and discussed in Chapter 1, remain vital and urgent throughout subsequent debates, up to and including the present. However, it should be stressed that the book does not amount to a comprehensive history of the dissemination of German aesthetics; that remains a project for the future, and for a much longer book. A number of important thinkers on aesthetics, such as the German idealist Georg Wilhelm Friedrich Hegel (1770–1831) or the American pragmatist John Dewey (1859–1952), are mentioned only in passing; similarly, many artistic practices that explored aesthetic questions in distinctive ways, such as Surrealism or Conceptual Art, are omitted. These and many other omissions, in one way regrettable, may in another reinforce a crucial argument of the book: what is distinctive about beauty, in the philosophical tradition explored here, is its capacity to stimulate fresh thinking and fresh debate. Thus a book about beauty can never claim to have exhausted its enquiry or to have reached a point of closure. Even if its primary focus is historical, as in the case of this book, it succeeds precisely to the extent that it opens possibilities for future exploration.

The following chapters will address, in more detail, the reasons why beauty has been configured, in the philosophical tradition, as a question that is open-ended rather than closural. However, the idea may seem surprising in the light of recent attempts to relegate beauty to the past, to declare it a dead issue. It is hoped that readers will find many such surprises in the following chapters. Indeed, it may be worth calling attention at the outset to a few of the limitations that have been most often, and most unwarrantably, imposed on the aesthetic in recent years. Baudelaire directed particular scorn at what he called 'the heresy of *The Didactic*', the tendency of his own contemporaries to limit art by imposing moral or educational strictures on it.[3] For many artists of today, who wish to rebel against the perceived need to preach a narrow political lesson, this heresy remains a live issue. However, we may also note some other 'heresies' of our own day, which may impede our enquiries unless they are dispelled from the start.

First, there is what might be called the heresy of hierarchy. It is often assumed that a commitment to the aesthetic, or to the beautiful, entails making relative judgements of quality or value, to privilege some objects above others. It is true that we may take delight in the superb technical quality of something like a fine Iznik pot [1], and that our perception of its superiority in this respect may be important to a decision to describe it as 'beautiful'. But as we shall see countless times in the following chapters, estimates of *relative* quality, or hierarchical rankings, are irrelevant to the judgement of beauty on the pot. That we

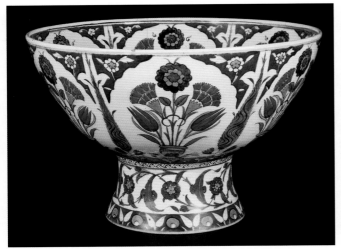

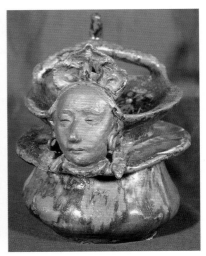

1 Anonymous (Anatolian—Iznik)

Bowl, c.1550–5

2 Paul Gauguin

Pot Decorated with a Woman's Head, c.1887–8

have called the Iznik pot beautiful has no bearing, one way or the other, on whether we call another pot beautiful. The second pot might be a clumsier production, for example by a modern artist relatively untrained in ceramic techniques [**2**], yet we may wish to call it beautiful on quite other grounds, for example its imaginative incorporation of a human face into the ceramic shape, or its lustrous, irregular glazing. To establish a hierarchy, based on technical quality or any other measure, is potentially to prevent us from valuing some new object with characteristics we have not anticipated. Modern art has, on the contrary, been much concerned (some would say obsessed) with inventing characteristics as different as possible from what has been admired in the past. An aesthetic theory that could not accommodate modernist innovation would be impotent, in our world.

Second, there is the heresy of formalism. Chapter 4 will examine in detail the problems of reconciling particular, twentieth-century theories of formalism with the aesthetic in its broader sense. At the beginning of the twenty-first century, though, we have become accustomed to thinking of formalism as identical to the aesthetic. But this, again, is to impose unnecessary limits. Baudelaire called drawings beautiful that anatomized the social classes of modern Paris [**60**]; Winckelmann called ancient sculptures beautiful that inspired him with ideas of heroism [**11**]; even Roger Fry, before he became a thoroughgoing formalist, was prepared to call a painting beautiful for representing a significant religious event [**99**]. There is no reason to consider a judgement of 'pure form' as in any way more valid, aesthetically, than these.

Finally, there is the heresy of 'art' itself. Many recent critics of the aesthetic have assumed that beauty is a quality ascribed, uniquely, to 'art', more especially to 'fine art' or 'high art', the privileged products of the art world. They have objected that inclusion in the category 'art'

reflects the ideological agendas of institutions such as museums, universities, the press, and the art market. For these critics this invalidates the aesthetic altogether, since the value ascribed to art objects can be seen to be motivated by non-aesthetic considerations such as commercial gain, political correctness, career advantage, or institutional self-promotion (the Museum of Modern Art in New York, it can be argued, has a stake in claiming that the art represented in its collections is the 'highest' art of the modern period). This argument is circular; it would make no sense to object to the *non*-aesthetic valuation of art objects unless we can suppose there *is* such a thing as 'aesthetic value' in the first place. But such an argument is in any case beside the point. If we cannot prescribe an aesthetic hierarchy, then for the same reasons we cannot make a distinction between 'art' and 'non-art' in purely aesthetic terms. We can of course distinguish a painting by Picasso [107] from the view of a starry sky at night on perfectly rational grounds: the Picasso is a crafted artefact, and one on which our society confers high value of various kinds (financial, institutional, historical), while the starry sky is a natural phenomenon. But that distinction is not relevant to whether we call either one beautiful or not. As we shall see, the question of the beautiful has been exceptionally important in artmaking of the modern period. But it has been equally important to preserve a clear distinction between the beautiful (as a human response to objects, whether they are art objects or not) and 'art' as a socially constituted product or commodity.

Chapter 4 will show that all of these heresies were powerfully, and often deliberately, reinforced in the modernist art criticism of the twentieth century. This helps to explain why they have become such conspicuous targets for attack from the late-twentieth-century generation that has rejected modernism. As we shall see, the modernist critics had cogent reasons, within their twentieth-century historical circumstances, for subscribing to all three heresies. Nonetheless, the heresies are reductive; the critics of the modernists are right to see them as outmoded by the later twentieth century. The contention of this book, however, is that the same critics are wrong to confuse the aesthetic with modernism, and gravely wrong to dispense with the former in their eagerness to reject the latter. It is important, then, to look seriously at the tradition of thinking about beauty within which modernism is only an episode, and no longer the most recent one.

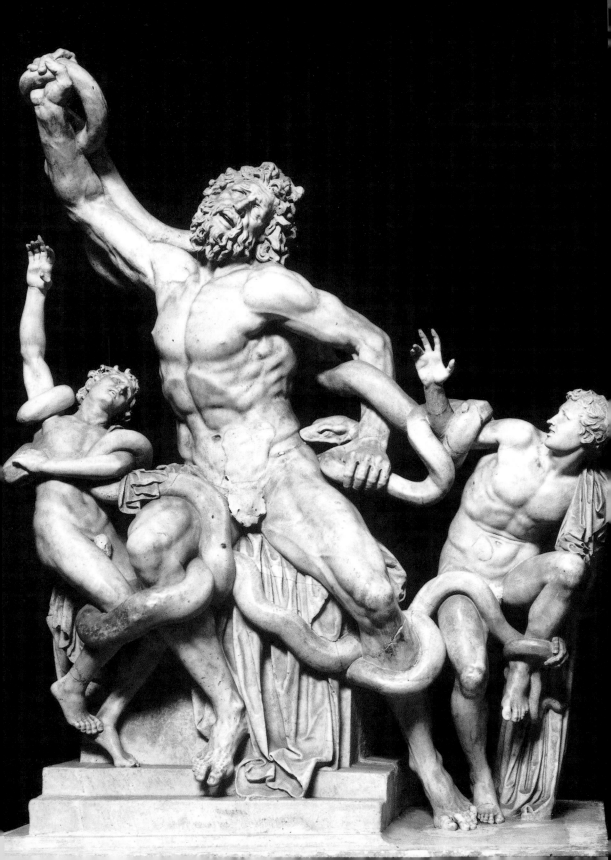

Eighteenth-century Germany: Winckelmann and Kant

1

> But how has it happened, that, whilst well-grounded elementary treatises on all other departments of knowledge exist, the principles of art and of beauty have been so little investigated?
>
> Johann Joachim Winckelmann, *History of Ancient Art*[1]

Imagine a time, two thousand years from now, when the world as we now know it will have vanished. After countless wars, revolutions, environmental disasters, the National Galleries of London and Washington, the Louvre, the Hermitage, and all other art collections will have been destroyed. Perhaps one or two of the artworks now famous will survive in a ruined state, but the archaeologists and historians of this future age will study principally the scanty records preserved by chance in electronic media. Digital archives, amazingly primitive by the technological standards of the years after 4000, will provide scattered but intriguing clues to a lost world of visual art, the beauty of which will have to be taken on trust.

This scenario may seem fanciful, or too distant in the future to be worth worrying about today. But it is an exact parallel to the situation in which Johann Joachim Winckelmann (1717–68, **4, 5**), the so-called 'father of art history', found himself when he travelled to Rome in 1755 to study the art of classical antiquity. The written records left by ancient travellers and historians proved that, two millennia earlier, the cities of the ancient world had been lavishly stocked with innumerable thousands of statues and paintings: 'we must be astonished', Winckelmann wrote, at the 'inexhaustible wealth in works of art' of the ancient world.[2] Yet by Winckelmann's time the overwhelming majority of these works had long since been destroyed. Moreover, the tiny proportion that survived, in fragmentary or ruined form, was negligible in quality compared with the great works that had once existed. Few enough of the ancient literary texts that described works of art were still extant; of these the only one with any pretension to comprehensiveness was that of Pliny the Elder (23–79 CE). Pliny listed hundreds of artists and works from the preceding six centuries—but with only a tiny handful of exceptions, the ancient works of art that survived in Winckelmann's day did not correspond to the ones mentioned in Pliny.

3
Laocoön, prior to twentieth-century restoration, perhaps first century CE

4 Anton Raphael Mengs

Johann Joachim Winckelmann, c.1758

5 Angelica Kauffman

Johann Joachim Winckelmann, 1764

The great artists of ancient Greece were well known by repute: ancient writers such as Cicero (106–43 BCE) and Quintilian (*c.*35–*c.*100 CE) cited the names of Phidias and Polyclitus (fifth century BCE), Apelles and Praxiteles (fourth century BCE) as bywords for excellence. But there was no firm evidence to connect any of these great artists with works of art that actually survived. At best, a few surviving artefacts could plausibly be considered later copies, made in Roman workshops, of the celebrated masterpieces of earlier Greek artists—the ancient equivalent of our photographic or digital reproductions. For Winckelmann to write a *History of Ancient Art* (1764) under these circumstances was exactly as if a historian of the fifth millennium were to write a history of Renaissance art without having seen a single original work by Michelangelo (1475–1564), Leonardo (1452–1519), Raphael (1483–1520), Titian (*c.*1485–1576), or any of the other artists whose names we revere.

The feat Winckelmann accomplished, by integrating the disparate scraps of evidence into a vast, compelling, and continuous story of the rise, culmination, and decline of ancient art, has been rightly recognized as inventing a new scholarly discipline: the history of art. He had no choice but to reproduce Pliny's chronology substantially without alteration. But Pliny's account is little more than a list of names and works. To shape this raw material into a story, Winckelmann wove it together with another history, a political and social history of the ancient world. For Winckelmann the development of the arts is intimately linked with the political freedom of the people that made them. This was not an uncommon view in eighteenth-century writing on art, but never before had a writer elaborated the notion into a comprehensive history that traced the connections between art and society systematically through centuries of development. If it now seems commonplace—or even obligatory—for an art historian to link the works of art under discussion to the political and social circumstances in which they were made, that again demonstrates Winckelmann's claim to the title 'father of art history'; his *History* might even be described as a pioneer of what we now call the social history of art.

But there is a third element to Winckelmann's project, one that has attracted less subsequent comment but which for Winckelmann himself was the key to his entire enterprise: the demonstration of the *beauty* of the art of antiquity, and particularly that of ancient Greece. Moreover—and this may be the most original aspect of Winckelmann's work—beauty for him was something that was not definable in general or abstract terms, but could only be discovered through profound and sustained observation of particular works. This posed formidable practical problems, for, as we have seen, the particular works available for direct observation were undocumented in the ancient sources Winckelmann used. But the mismatch between beauty and history went deeper, for in an important sense beauty, as Winckelmann conceived it,

did not belong to the ancient past at all: it was located in the present day and in the experience of the modern observer—Winckelmann himself and his readers, among whom he was particularly concerned to include practising artists.

Necessarily, then, much of Winckelmann's discussion of Greek art takes place outside any historical framework. First, he dwells on beauties he has observed in (undated) representations of each of the Greek gods—the 'delicate, round limbs' characteristic of statues of Bacchus,[3] the 'liquid' eyes seen in statues of Venus, with the lower lid elevated to give a 'love-exciting and languishing look' [6].[4] Then he analyses each part of the body: the fingers that taper 'like finely shaped columns',[5] or the knees of youthful figures, in which 'the space from the thigh to the leg forms a gentle and flowing elevation, unbroken by depressions or prominences'.[6] Even in the historical section of his account (which does not occur until the last four books of the twelve that make up the *History*), Winckelmann interrupts the smooth chronological flow at intervals to introduce a striking description of an existing work of ancient art, or more precisely a dramatic account of his own experience of such a work. Abruptly, at these points, the perspective shifts away

from scholarship, from history, from the past tense, from third-person narrative. Suddenly the emphasis is on the visual, on the present, on the singularity of the work rather than its position in a historical sequence, on the way 'I' (Winckelmann) experience it rather than on its objective properties.

These vivid moments are integrated into the narrative ingeniously, but also provisionally—for, as Winckelmann freely admits, there is no way to assign secure dates to the extant objects, and therefore no firm grounds for inserting them into the chronology at any particular moment. Thus he places one of his most compelling descriptions, that of the *Apollo Belvedere* [**11**], in a chapter on the reign of the Roman Emperor Nero (37–68 CE), on the plausible (but unsubstantiated) hypothesis that this might have been one of the statues Nero was said to have plundered from Greece. Another favourite work, the *Belvedere Torso* [**7**] is assigned to the period just after the reign of Alexander the Great (356–323 BCE), because Winckelmann thinks it too fine to be

7 Anonymous (Graeco-Roman)
Belvedere Torso, date unknown

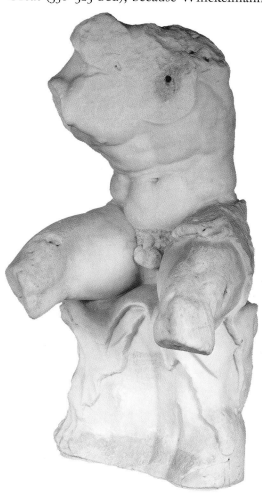

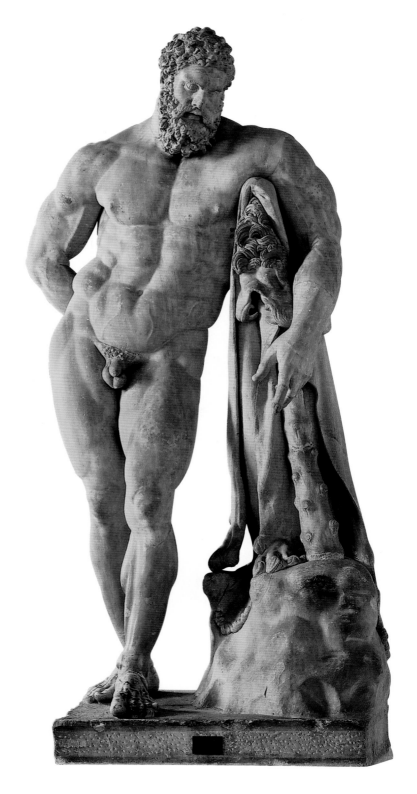

later (he accepted the opinion of ancient writers that Greek art had declined after Alexander's reign). After presenting reasons for considering the *Torso* a representation of Hercules, he proceeds by association of ideas to discuss another famous statue of the same hero, the *Farnese Hercules* [8]. Elsewhere he apologizes for such interpolations: 'I have been obliged to seek out such digressions in order to communicate instruction, because no monuments quite so remarkable . . . have come down to us from the times of which properly we treat'.[7] This acknowledges the double bind of the historian of ancient art. On the one hand, documented artefacts from the periods under consideration were lacking; on the other, the artefacts that *were* available, and whose beauty Winckelmann wished to emphasize, were undatable and therefore had no fixed location within the chronological story-line. Winckelmann therefore fills the gaps left by the disappearance of documented works with compelling accounts, instead, of works he has himself seen.

In effect Winckelmann was adding a third strand to his other two narratives: to the Plinian chronology of artists and the sociopolitical history of antiquity he added a third narrative about the direct experience of extant works. The historicity of this third strand was dubious, as Winckelmann freely acknowledged. But if it stretches a point to call this strand a *history* of art, the other two strands can scarcely claim to constitute a history *of art*. The third is the only one to involve the visual. Moreover, it is the only one that can make good Winckelmann's most cherished claim, that his writing will prove the beauty of Greek art.

It would be wrong to attribute Winckelmann's dilemma to the special circumstances of the eighteenth-century historian of ancient art. Since Winckelmann's time, many important works of ancient art have been unearthed; moreover, art historians have turned their attention to other periods, such as the Italian Renaissance or nineteenth-century France, for which much more historical data are available. It may seem, then, that the increase of scholarly knowledge has gone a long way towards solving the structural problem of Winckelmann's history. But we still face Winckelmann's dilemma: how can we reconcile the historical study of art with its visual impact on us in the present—in short, its beauty? Even if we were to leave aside evaluations of beauty, as some recent art historians have claimed to do, we should still face the dilemma as long as we continued to include the visual characteristics of actual works in our discussions: while we can *know* a great deal about the past history of a work of art, we can *see* it only in the present, and only insofar as it is *we* who see it. Winckelmann can perhaps be said to have concealed the gaps in his historical narrative behind vivid evocations of the beauty of particular works. We, on the other hand, may often conceal the beauty of the works behind the richness of the history we are able to write.

But what did Winckelmann mean when he called a work beautiful? In an extended theoretical chapter he reviews a number of aesthetic issues, including the perennial problem of why one person's taste may differ from another's, but he finally discounts the possibility of defining beauty with logical precision: 'We cannot proceed here . . . after the mode used in geometry, which advances and concludes from generals to particulars and individuals, and from the nature of things to their properties, but we must satisfy ourselves with drawing probable conclusions merely from single pieces.'[8] This emphasis on singular aesthetic observations, as we shall see later in this chapter, is not incompatible with new ways of thinking about beauty in the emerging discipline of philosophical aesthetics. More importantly, it is consistent with Winckelmann's method of studying a work of art. Beauty for Winckelmann is not something that the work of art simply displays of its own accord. Rather, it emerges in the course of prolonged contemplation and reflection on the part of the observer: 'The first view of beautiful statues is . . . like the first glance over the open sea; we gaze on it bewildered, and with undistinguishing eyes, but after we have contemplated it repeatedly the soul becomes more tranquil and the eye more quiet, and capable of separating the whole into its particulars.'[9] Winckelmann notes that he has 'imposed upon myself the rule of not turning back until I had discovered some beauty'.[10] He advises students to approach works of Greek art 'favorably prepossessed . . . for, being fully assured of finding much that is beautiful, they will seek for it, and a portion of it will be made visible to them'.[11] Beauty, then, is not the precondition but rather the result of aesthetic contemplation, of a kind of collaboration between the viewer and the work. It would therefore be nonsensical to define it in advance of, or apart from, an actual aesthetic experience. In order to learn more about Winckelmann's insights into beauty, then, we shall have to explore his responses to particular works of art.

Laocoön

Of all the works of ancient art above ground in Winckelmann's time, only a single one corresponded closely to a work documented in an ancient source: the *Laocoön* [3], unearthed in 1506 and instantly connected to a passage in Pliny that described a magnificent marble sculpture of the Trojan priest Laocoön, with his children, entwined in the coils of gigantic serpents (Laocoön's punishment for warning the Trojans against the wooden horse left by the Greeks). Even in this case, there were certain difficulties in identifying the actual artefact as the same one that Pliny had seen; for instance, Pliny had insisted that the work was made from a single block of marble, which the surviving sculpture was not (Winckelmann argued ingeniously that the joins

must have opened up more visibly since Pliny's time). Nonetheless, the *Laocoön* had the best claim of any extant sculpture to be considered one of the documented great works of antiquity, which, together with the exceptionally high quality of the carving, made it one of the world's most celebrated works of art from the Renaissance onwards.

Winckelmann was fascinated by the *Laocoön* even before he went to Rome. Although he could have known it only through reproductions, he made it the occasion for the first of his compelling descriptions, in the essay of 1755 that established his scholarly reputation, *Reflections on the Imitation of Greek Works in Painting and Sculpture*. The passage begins with a phrase that became famous: Greek art, wrote Winckelmann, was distinguished above all by 'a noble simplicity and quiet grandeur'. The phrase announces a striking reinterpretation of the *Laocoön*. Earlier observers, for example Michelangelo and Rubens (1577–1640, **9**), had valued the sculpture for its extreme drama and expressiveness. But now Winckelmann asks his readers to see beyond the struggling limbs and anguished facial expressions, to sense the underlying dignity of the figures, evident in the balanced disposition of the bodily forms. Winckelmann continues with the earliest example of what would become a trademark of his writing, a comparison between sculptural form and the flowing waters of the sea: 'Just as the depths of

9 Peter Paul Rubens

Laocoön, 1601–2

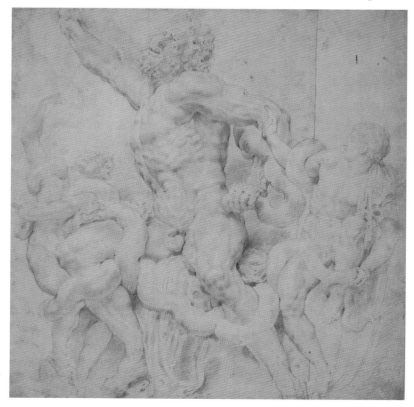

the sea always remain calm however much the surface may rage, so does the expression of the figures of the Greeks reveal a great and composed soul even in the midst of passion.' For a simple description of the *Laocoön* as demonstrating one emotion pushed to its limit, Winckelmann substitutes a more complex account based on a magical equilibrium between two seemingly opposite characters: 'The physical pain and the nobility of soul are distributed with equal strength over the entire body and are, as it were, held in balance with one another.' Already Winckelmann is beginning to emphasize the observer's involvement in the aesthetic response, so intense that it is felt corporeally: 'The pain is revealed in all the muscles and sinews of [Laocoön's] body, and we ourselves can almost feel it as we observe the painful contraction of the abdomen'. But as the observer responds to the sense of physical pain, the sculpture preserves its nobility; there is 'no sign of rage in his face or in his entire bearing'. Through empathetic response the viewer is inspired with respect or awe: 'his pain touches our very souls, but we wish that we could bear misery like this great man'.[12] Thus the double emotion, poised between pain and nobility, shifts in the process of contemplation from being a property of the sculpture to characterizing the viewer's response.

By the time Winckelmann published his *History of Ancient Art*, in 1764, he had been in Rome for nearly a decade, but the study of a wide range of surviving antiquities had done nothing to lessen his enthusiasm for the *Laocoön*. Indeed, his increasing knowledge made the *Laocoön* more important than ever, as the sole demonstrable link between the beauty that could be directly experienced and the glorious but lost world of art described in the ancient texts. Winckelmann emphasized this in the dramatic placement of the *Laocoön* within the *History*. Winckelmann presented the reign of Alexander the Great as the final culmination of Greek art, but he had to admit that no trace remained of the works Pliny had assigned to this period. 'Of the works of Lysippus not one probably has been preserved', he notes of one of the most famous names of the period; '[t]he loss of the works of this artist is an indescribable one'.[13] This is one of the most melancholy moments in the *History*, when the loss of ancient beauty is most poignant. Suddenly, though, the mood changes:

But the kind fate which still continued to watch over the arts, even during their destruction, has preserved for the admiration of the whole world, after the loss of countless works executed at this time when art was in its highest bloom, the most precious monument, the statue of the Laocoön, as a proof of the truth of the accounts which describe the splendor of so many masterpieces that have perished. . . .[14]

The *coup de théâtre* is brilliantly effective, even though as a responsible scholar Winckelmann is obliged to add a disclaimer: 'we say at this

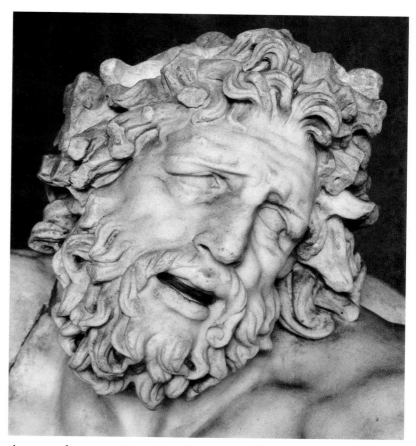

time, on the supposition that the artists of [the *Laocoön*] lived in the reign of Alexander the Great, which cannot be proved'.

By now Winckelmann can offer a much more nuanced description of the sculpture. He dwells, for instance, on the final finish given with the chisel, to refine and vary the smooth polish of the marble:

Though the outer skin of this statue when compared with a smooth and polished surface appears somewhat rough, rough as a soft velvet contrasted with a lustrous satin, yet it is, as it were, like the skin of the ancient Greeks, which had neither been relaxed by the constant use of warm baths . . . nor rubbed smooth by a scraper, but on which lay a healthy moisture, resembling the first appearance of down upon the chin.[15]

This evokes the experience of touching the marble surface, which in the viewer's imagination takes on the character of human skin. The sense of sensuous or even erotic pleasure is strong here. The face, too, is closely observed [see detail of **3** above]:

The struggle between the pain and the suppression of the feelings is rendered with great knowledge as concentrated in one point below the forehead; for whilst the pain elevates the eyebrows, resistance to it presses the fleshy parts

above the eyes downward and towards the upper eyelid, so that it is almost entirely covered by the overhanging skin.

Winckelmann's experience of the actual sculpture has not, then, altered his first insight about the balance between pain and nobility:

. . . in the parts where the greatest pain is placed he shows us the greatest beauty. The left side, into which the serpent with furious bite discharges its poison, appears to suffer the most violently from its greater sensibility in consequence of its vicinity to the heart; and this part of the body may be termed a miracle of art.[16]

Winckelmann's writing never makes the statue into an inert or distanced object; he dramatizes actions, such as the movement of the eyebrows or the injection of the poison, as if they were occurring before our eyes.

Among the multitude of writers who responded to Winckelmann's

10

Laocoön, after twentieth-century restoration, perhaps first century CE

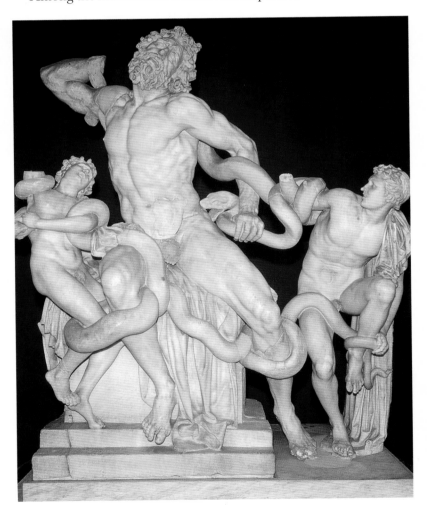

accounts of the *Laocoön* were the dramatist Gotthold Ephraim Lessing (1729–81), whose *Laocoön, or On the Limits of Painting and Poetry* (1766) explored the differences between the visual and verbal arts, and the great German author Johann Wolfgang von Goethe (1749–1832), whose essay 'Observations on the Laocoön' was published in 1798. In a passage on the left side of the figure Goethe emulates the way Winckelmann translates visual into corporeal experience: 'The serpent inflicts a wound on the unhappy Laocoön, precisely in the part in which man is very sensible to every irritation, and even where the slightest tickling causes that motion which we see produced here by the wound; the body flies towards the opposite side. . . .' Goethe even recommends a physical exercise, which seems to make the sculpture come alive: if we stand far enough from the sculpture to see it whole, then open and shut our eyes, 'we shall see all the marble in motion; we shall be afraid to find the group changed when we open our eyes again'. He goes on to use images much in Winckelmann's style: 'I would readily say, as the group is now exposed, it is a flash of lightning fixed, a wave petrified at the instant when it is approaching the shore'.[17]

 In a restoration of the late 1950s the extended right arm of Laocoön (missing from the sculpture unearthed in 1506 and conjecturally reconstructed) was exchanged for an antique arm, in a bent position, that had been subsequently unearthed [10]. The new version of the sculpture may have some claim to greater authenticity, despite the discrepancy in size between the two arms of the figure; it is debatable, though, whether the new-ancient bent arm is as beautiful as the previous restoration, fine enough to have led some observers to suppose it the work of the great sculptor Gianlorenzo Bernini (1598–1680). However this may be, the statue Winckelmann knew has become a lost work of art, although a plaster copy of it has been installed in the Vatican Museum, next to the marble.

Apollo Belvedere and *Venus de'Medici*

During Winckelmann's time in Rome another sculpture came to rival —or even to surpass—the *Laocoön* in his esteem; indeed, he frequently mentions the *Apollo Belvedere* [11] alongside the *Laocoön* as contrasting but equally compelling examples of beauty. While the *Laocoön* has retained its high reputation, the *Apollo* has fallen from favour. In *The Nude* (1956), one of the most widely read books on art of the twentieth century, the art historian Kenneth Clark (1903–83) confessed himself mystified that so learned a connoisseur as Winckelmann could admire the *Apollo*, which for Clark displayed 'weak structure and slack surfaces which, to the aesthetic of pure sensibility, annul its other qualities'; in no other famous work, Clark thought, 'are idea and execution more distressingly divorced'.[18] In fact Winckelmann himself freely conceded

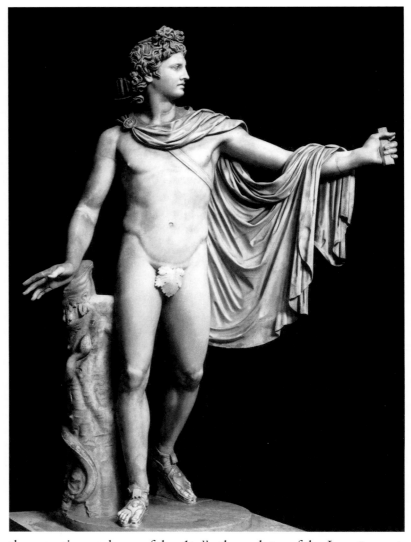

the executive weakness of the *Apollo*: the sculptor of the *Laocoön* must, Winckelmann insisted, 'have been a far more skilful and complete artist than it was requisite for the sculptor of the Apollo to be'.[19] As we have seen, he emphasized the virtuosic technique used for the surface finish of the *Laocoön*, but like Clark in the twentieth century he did not find the texture and detail of the *Apollo* equally fine.

But for Winckelmann beauty is not synonymous with the material characteristics of the object, as it often became in the modernist criticism of the twentieth century—which we shall explore in Chapter 4. Indeed, Winckelmann's descriptions of the *Apollo* tend to dematerialize it, to leave behind its physical existence and to contemplate what Clark calls the sculpture's 'idea' (as distinct from its 'execution'). Moreover he invites us to follow him:

Let thy spirit penetrate into the kingdom of incorporeal beauties, and strive to become a creator of a heavenly nature, in order that thy mind may be filled with beauties that are elevated above nature; for there is nothing mortal here. . . . Neither blood-vessels nor sinews heat and stir this body, but a heavenly essence, diffusing itself like a gentle stream, seems to fill the whole contour of the figure.

Winckelmann has been faithful to his own rule, not turning back until he has found beauty. Where Clark would stop at the slick, mechanical character of the copyist's execution, Winckelmann sees beyond the immediate surface texture. And as he looks, he responds corporeally: 'In the presence of this miracle of art I forget all else, and I myself take a lofty position for the purpose of looking upon it in a worthy manner.' The moral effect of the *Laocoön* had been to make Winckelmann conscious of his own weakness and thus desirous of self-improvement ('we wish that we could bear misery like this great man'). The *Apollo* produces a headier exaltation, so that the viewer's very body seems to expand in emulation of the statue. As he goes on looking, Winckelmann becomes in imagination one of the ancient oracles or priestesses, inspired by the god Apollo:

My breast seems to enlarge and swell with reverence, like the breasts of those who were filled with the spirit of prophecy, and I feel myself transported to Delos and into the Lycaean groves—places which Apollo honored by his presence,—for my image seems to receive life and motion, like the beautiful creation of Pygmalion.[20]

The final reference is to another ancient myth—that of the sculptor who made a statue so beautiful that he fell in love with it; by the grace of Venus (goddess of both beauty and love) Pygmalion's statue was brought to life (see **86**). The aesthetic encounter as Winckelmann imagines it is reciprocal, making the marble statue seem to come alive at the same time as it increases the viewer's sense of vitality. Such experiences as the latter are commonly described in clichés—powerful works of art are said to make the pulse race, the heart beat faster, the hairs of the neck tingle. What Winckelmann describes is like this, but far from being conventionalized it is adapted to the particular experience of contemplating the *Apollo*.

Winckelmann's corporeal response can also be read as an erotic experience; the *Apollo* conjures feelings of tumescence and of rising excitement or exhilaration. This is a homoerotic encounter, one in which similarity between the viewer-lover and the beloved statue is crucial; in the consummation of the aesthetic encounter viewer and statue become identified with one another (the description may also imply the possibility of shifting genders, when Winckelmann imagines himself as one of Apollo's prophetesses and invokes the female statue of Pygmalion). In an essay of 1805, Goethe speaks frankly of

Winckelmann's passionate friendships with men, which he sees as crucial to the older writer's aesthetic sensibility.[21] Subsequently Winckelmann's homosexuality has become inseparable from his fame, for instance in the frequent assumption that the strange event of his murder, in Trieste in 1768, must have had a homosexual or homophobic motive (although there is no evidence that the murder was anything more than a robbery that turned tragically to violence). Recent scholars have dwelt more positively on the homoerotic resonances of Winckelmann's writing, and rightly so: Winckelmann initiated a practice of homoerotic art criticism of superb quality in its own right, and which was inspirational for later critics such as Walter Pater, who will be discussed in Chapter 3.

Nonetheless, there is a danger in assuming that Winckelmann's response to the beautiful can be explained away as the effect of his homosexuality. The sensual element in Winckelmann's response to the beautiful cannot be reduced to an expression of desire for the sculptured male body. Rather, it permeates his descriptions, for instance of the texture of chiselled marble, of the fall of sculptured draperies, and even of female figures. He writes of the *Venus de'Medici* [12], then the most famous ancient female nude:

The Medicean Venus . . . resembles a rose which, after a lovely dawn, unfolds its leaves to the rising sun; resembles one who is passing from an age which is hard and somewhat harsh—like fruits before their perfect ripeness—into another, in which all the vessels of the animal system are beginning to dilate, and the breasts to enlarge, as her bosom indicates. . . . The attitude brings before my imagination that Laïs who instructed Apelles in love. Methinks I see her, as when, for the first time, she stood naked before the artist's eyes.[22]

Even without the final reference to Laïs, a famous courtesan of antiquity, the passage clearly involves fantasies of sexual awakening, expressed for instance in the image of the opening rose; the flower—the rose in particular—would soon and lastingly become the most common and efficient single symbol for pure beauty. Thus the rose, like the sea images Winckelmann used more frequently in descriptions of male figures, may be read either as a sexual image or as an aesthetic one—indeed, the two cannot easily be distinguished.

Passages such as that on the *Venus de'Medici*, as well as that on the *Apollo Belvedere*, raise urgent questions about the relationship between the beautiful and the erotic—questions which, as we shall see, have remained central to both aesthetic thought and art practice ever since. It would be easy enough to resolve them by collapsing the beautiful into the erotic. Thus in Winckelmann's case it is tempting to avoid difficulties by seeing his love of the beautiful simply as a disguised or sublimated form of erotic attraction to young men. Yet that would not only reinforce the stereotype, ingrained in modern western societies,

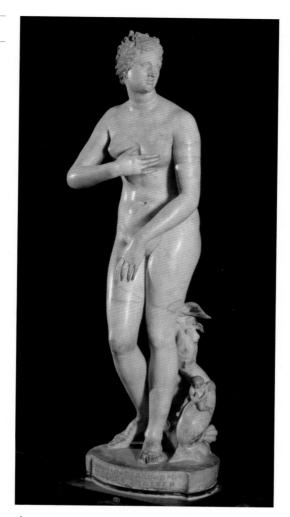

that presumes some innate affinity between homosexual desire and love of art; it would also reduce the theoretical question of the beautiful to mere personal preference, something about which people of different genders or sexualities would be unable to share ideas or opinions. Winckelmann's writings, however powerful their homoerotic resonances, cannot be dismissed as merely the fantasies of an eighteenth-century white European homosexual.

Winckelmann and contemporary art

The only way for us to become great or, if this be possible, inimitable, is to imitate the ancients.[23]

This paradoxical formulation, from the opening pages of Winckelmann's *Reflections*, seems to be asking modern artists to attempt the

impossible—not merely to imitate the art of the ancients, in Winckelmann's view the greatest art ever made, but to surpass the very terms of that project, to become 'inimitable'. A drawing by the Swiss-born artist Henry Fuseli (1741–1825), *The Artist in Despair over the Magnitude of Ancient Fragments* [13], can be taken to represent visually something of the modern artist's plight. Not only are the pieces of ancient sculpture vast in scale compared to the tiny artist; they are the merest fragments of a human body, the grandeur of which can only be imagined. The living artist might indeed flinch, as much before the radical unfathomability of ancient art as before the enormous task of trying to rival it. Yet that was exactly what Winckelmann demanded, in writings that frequently addressed artists directly. For Winckelmann the discovery of the beauty of Greek art was not of merely antiquarian interest: it was of vital importance to the creation of new beauty in the present and future.

The visual art of the second half of the eighteenth century appears to respond dramatically to Winckelmann's challenge. In the development that art historians have called 'neoclassicism', artists began to reject Baroque complexity and Rococo frivolity in favour of artistic practices more akin, although in diverse ways, to the 'noble simplicity and quiet grandeur' of the antique, in Winckelmann's famous words. However, this is no simple matter of cause and effect; rather, the links between Winckelmann's ideas and contemporary art practice were reciprocal. Winckelmann acknowledged his debt to the artists, first in Dresden, then in Rome, who taught him to look closely at ancient art. When, in the Preface to the *History*, he asks: 'What writer has looked at beauty with an artist's eyes?',[24] he implies that scholars and connois-

seurs need to learn from practitioners' visual skills. On the other hand, Winckelmann also expected his research and writing to make a much more direct impact on art practice than most art historians have even dreamed possible.

We have seen that for Winckelmann the beauty of ancient art was not immured in the past, but comes alive only in the present, in the observer's encounter with a particular work. Winckelmann's own writings can be seen as one way of making the beauty of ancient art vivid and communicable in the present day—in this sense they 'imitate' the ancient artists in words. But visual artists may be able to do something similar through the creation of new works. Throughout his writings Winckelmann keeps modern art (that is, European art since the Renaissance, as well as the art of his contemporaries) constantly in view. Already in the *Reflections*, the Renaissance artist Raphael is a key point of reference; he is the first to 'feel and to discover in modern times the true character of the ancients'.[25] Winckelmann writes of Raphael's *Sistine Madonna* [14] as a modern realization of the 'noble simplicity and quiet grandeur' of ancient art: 'Behold this Madonna, her face filled with innocence and extraordinary greatness, in a posture of blissful serenity! It is the same serenity with which the ancients imbued the depictions of their deities.'[26] Raphael's 'imitation' of ancient art is not, then, a matter of copying. Rather it involves the fresh creation of a beauty that corresponds to that of ancient art.

Winckelmann never wavered in his belief that such beauty was possible for modern art, even though much art since Raphael's day seemed to him to have veered towards extravagance and over-emotionalism. In the *History* Winckelmann welcomed experiments in neoclassicism among contemporary sculptors, but he reserved his greatest praise for a German painter and close friend, Anton Raphael Mengs (1728–79, named after the Renaissance master):

All the beauties here described, in the figures of the ancients, are embraced in the immortal works of Antonio Raphael Mengs, . . . the greatest artist of his own, and probably of the coming age also. He arose, as it were, like a phoenix new-born, out of the ashes of the first Raphael to teach the world what beauty is contained in art. . . .[27]

In retrospect Winckelmann's enthusiasm may seem excessive, for Mengs's scholarly neoclassical experiments were soon eclipsed by the more daring practices of artists such as Jacques-Louis David [26, 40]. Perhaps, though, Mengs's work can be seen as a form of preliminary research into what a new attentiveness to ancient sculpture might mean for modern art. Winckelmann and Mengs studied ancient sculpture together from 1755 to 1761 when both were in Rome; Mengs's sensitive portrait of Winckelmann [4] concentrates on the unusually large, wide-open eyes and level gaze, as if to acknowledge the scholar's

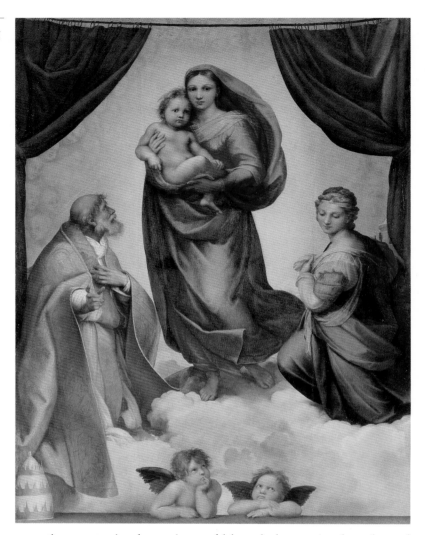

receptiveness to visual experience. Although the treatise they planned to write together never materialized, the results of their joint researches may be as evident in Mengs's paintings as in Winckelmann's *History*. In a painting of 1771, *Noli me tangere* [**15**], Mengs gives neoclassical serenity to a potentially dramatic moment from scripture, Mary Magdalene's encounter with the risen Christ. Where a Rubens or a Bernini might have introduced extravagant gestures and complex poses, Mengs presents the two figures as simply as possible. The outstretched hands of both figures, relieved in sculptural whiteness against the rich colours of draperies and background, economically convey the import of the story, Mary's astonishment at seeing the Saviour and his gentle rebuke ('Touch me not; for I am not yet ascended to my Father', John 20:17). The voluminous draperies and the clarity of the figures against the background, as well as the figure type of the Magdalene, are reminis-

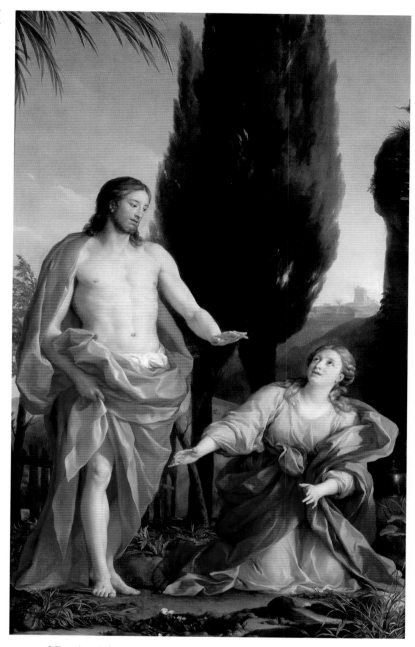

cent of Raphael (compare **14**). Perhaps Mengs also took a cue from Winckelmann when he gave Christ the beautiful body of a Greek statue. Winckelmann had written: 'Modern artists ought to have formed their figures of the Saviour conformably to the ideas which the ancients entertained of the beauty of their heroes, and thus made him correspond to the prophetic declaration, which announces him as the most beautiful of the children of men.'[28]

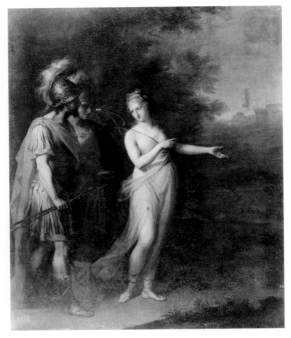

The Swiss painter Angelica Kauffman (1741–1807) also learned from Winckelmann to study ancient art intensively (see **5**). Perhaps Kauffman also made use of Winckelmann's chapters on the characteristic beauties of parts of the body, when designing the figures for a remarkable series of paintings that celebrated the deeds of female characters from ancient history and mythology. For *Venus Showing Aeneas and Achates the Way to Carthage* [**16**], Kauffman chose an unusual subject from Virgil's *Aeneid*, one in which the female figure takes the leading role. Venus is instantly recognizable by her 'liquid eyes' (compare **6**), and the draperies fall away to reveal the rounded thigh that Winckelmann considered the most seductive of female attributes. Her low forehead, with her flaxen hair curving over the temples, and her straight nose and rounded chin also correspond to the forms that Winckelmann identified in the most beautiful Greek heads (often, of course, male). Kauffman's procedure for constructing an ideally beautiful figure follows that attributed to the ancient artist Zeuxis and represented in another of her paintings [**17**]. According to legend, Zeuxis imitated the most beautiful features of numerous individual women to form a composite figure of perfect beauty. Kauffman, with the help of Winckelmann's researches, selected the most beautiful features of ancient statues, rather than living models, to form her own figures. In her work the visual beauty of the female figure signifies the nobility of the figure's character.

As if by magic, a type close to Kauffman's ideal female figure seemed to come alive in a young Englishwoman, Emma Hart (1765–1815).

17 Angelica Kauffman

Zeuxis Selecting Models for His Painting of Helen of Troy, c.1778

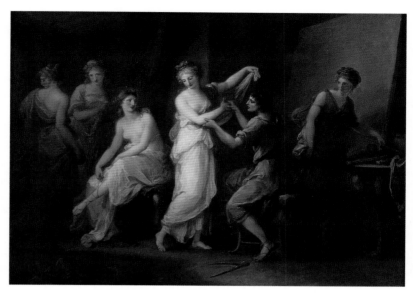

Drawings and paintings show Hart with the low forehead, deep-set eyes, straight-line profile, and rounded chin of the Kauffman female type [**18**]. Her beauty appeared compellingly reminiscent of ancient sculpture to Sir William Hamilton (1730–1803), British diplomatic envoy to Naples and an avid collector of classical antiquities. After joining Hamilton in Naples, Hart (Lady Hamilton after their marriage

18 Thomas Lawrence

Portrait of Emma Hart, 1791

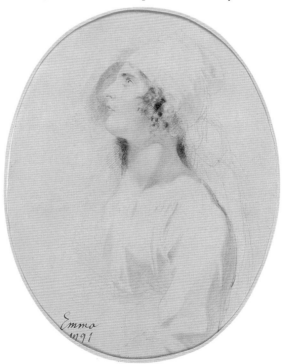

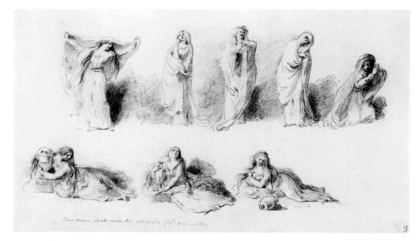

in 1791) developed a new art form based on her 'classical' appearance. Indeed, she might be called the first performance artist, for she used her own body to create a continuously changing series of images, many of which were imitated from ancient sculpture. These performed images became famous as the 'attitudes of Lady Hamilton' [**19**]. The attitudes are, of course, lost works of art, but Goethe's vivid aesthetic response gives an idea of what they were like:

Dressed in [Greek drapery], she lets down her hair and, with a few shawls, gives so much variety to her poses, gestures, expressions, etc., that the spectator can hardly believe his eyes. He sees what thousands of artists would have liked to express realized before him in movements and surprising transformations—standing, kneeling, sitting, reclining, serious, sad, playful, ecstatic, contrite, alluring, threatening, anxious, one pose follows another without a break. . . . In her, [Hamilton] has found all the antiquities . . . even the Apollo Belvedere.[29]

Hart's performances have been remembered mainly as embellishments to her sexual attractiveness; she became famous to posterity as the mistress of Lord Nelson (1758–1805). But the way she 'imitated' ancient art—making the poses of sculptures come alive in movement, and realizing them corporeally, in her own body—can be described as a startlingly original way of responding to Winckelmann's exhortation to modern artists.

Hart's attitudes, Kauffman's female figures, and Mengs's Raphael-esque neoclassicism demonstrate only a few of the approaches artists developed for imitating the antique. For these artists, as for Winckelmann, the beauty of ancient sculpture was not locked in the past, but was something to be perpetually reinvented in modern aesthetic experience. The *Laocoön* may survive as a physical artefact from the remote past, but there is no guarantee that a new generation will call it beautiful. Its beauty can, however, be freshly invented, for example in

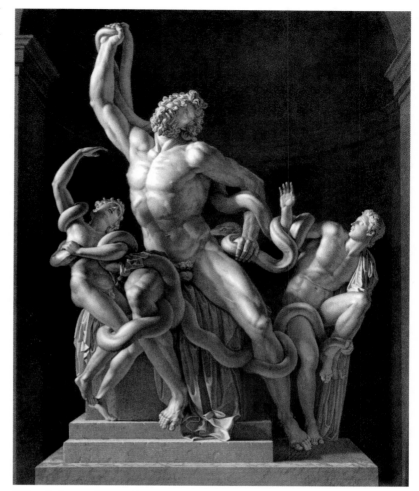

Winckelmann's novel interpretation of it, or in an engraving of 1809 by Charles-Clément Balvay, known as Bervic [**20**]. Bervic faithfully 'imitates' the antique. But his work is also original. This is overtly a representation, not of Laocoön and his sons, but of the celebrated *sculpture* of the *Laocoön*, presented in its museum setting. Through an almost unimaginable variation in the density of weave of the engraved lines, the tonal range, from velvety shadow to brilliant light, is pushed to its utmost, creating a new drama from the contrast between convex sculptural volumes and the shadowy concave niche. The composition of the sculpture group is reproduced with only the slightest of variations, but the suppleness and plasticity of the forms seems inexplicably enhanced, so that the eye ranges endlessly around the circling rhythms. All signs of wear or damage are smoothed away. Perhaps Bervic can be said to have reimagined the ancient statue as it appeared when newly made. But he has also made a modern work of art with a new range of connotations.

Kant's *Critique of Judgement*

While Winckelmann was conducting his empirical researches into the beauty of ancient art in Rome, the philosophical question of beauty was attracting increasing attention—and controversy—in his native Germany. Indeed, Winckelmann may have been exposed to the earliest stages of this debate in his student days at the University of Halle, where Alexander Gottlieb Baumgarten (1714–62) was a charismatic lecturer in philosophy. In his Master's dissertation of 1735, Baumgarten introduced the term 'aesthetic' (which he devised from a Greek word for 'things perceived by the senses', as opposed to 'things known by the mind'), and called for the establishment of a science of aesthetics—a science that would deal with human perception, something different from the well-established science that dealt with logical knowledge. Unlike previous philosophers who considered sensory perception to be nothing but undigested raw material, Baumgarten introduced the possibility that perception might have its own excellence—that a vivid sensory experience (say the sight of the starry sky at midnight) might offer something special that would not be improved by analysing it rationally (say by calculating the exact distances of each of the stars from earth). The something special—what perception offers that logical thought does not—can be called the beautiful. The structure of Winckelmann's *History* reflects some such distinction between logical knowledge (the systematic presentation of data about ancient art) and sensory experience, demonstrated each time Winckelmann interrupts the narrative to introduce a compelling description of his experience of a work of art.

However, Winckelmann doubted the possibility of a scientific account of the beautiful, one that would be able to specify general criteria for judging whether objects are beautiful or not; for Winckelmann, as we have seen, beauty emerges only from a direct encounter with a particular object. This conviction may reflect Winckelmann's temperament and habits of close observation rather than a rigorous theoretical position; nonetheless it anticipates, informally, a crucial element in the aesthetic theory of Immanuel Kant (1724–1804, **21**). By 1790, when Kant published his major discussion of aesthetics in *The Critique of Judgement*, the enquiry into the beautiful adumbrated in Baumgarten's dissertation had become a recognized branch of philosophy. This was despite fierce opposition, on the grounds that placing a high value on sensory experience was mere hedonism, and thus irresponsible, or indeed positively immoral. Such complaints, as we shall see throughout the following chapters, recur again and again in the history of aesthetics, and persist even in the present day. Among Baumgarten's students were several young poets who celebrated the life of the senses in their verses, much to the horror of their more moralistic elders. Aesthetics in its earliest stages as a philosophical discipline

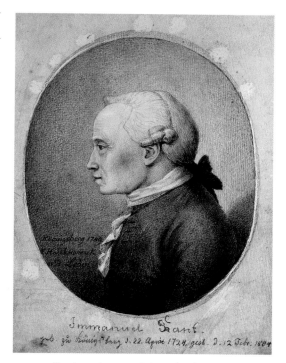

was radical and oppositional, closely associated with the Enlightenment political ideals of liberty and equality, and resolutely opposed to aristocratic cultural traditions that prescribed rules and precepts for the arts. But in an atmosphere of growing intellectual freedom the new discipline began to flourish in the German universities.

By the late eighteenth century, then, aesthetics was an area of study inasmuch as it was taught in universities. Nonetheless, Kant insisted that it could not be a science, in the way that logic (or in Winckelmann's example, geometry) was a science: according to Kant, the judgement that something is beautiful can never be proved. In the very first paragraph of the *Critique of Judgement* Kant demolishes any suggestion that such a judgement could be 'objective', that it could involve verifiably true or false statements about the object under observation.[30] Rather, it is entirely subjective; it refers to the feeling of delight experienced by the *subject*—the viewer or observer—when contemplating an object, and not to anything about the object itself. To call an object beautiful, Kant argues, provides no knowledge whatsoever of that object. Thus it is completely different from saying that the object is flat, or that it is made of canvas and pigment, or that it is three hundred years old—all of those statements can potentially be proved true or false, therefore they are logical and not aesthetic. Calling an object beautiful does not even involve knowing what kind of thing the object is (whether it is a work of art, for instance), nor does it depend on whether the object really exists or not (thus we may call a dream or a

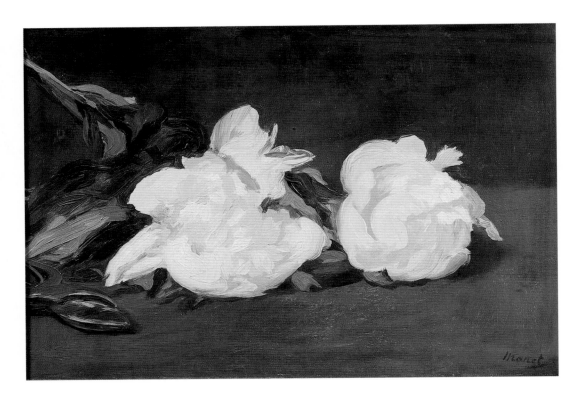

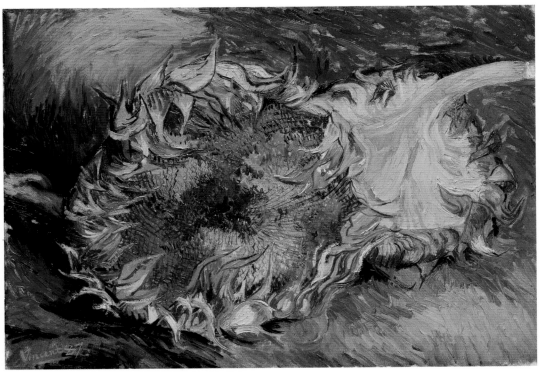

fiction or an imaginary landscape beautiful). Nor does it imply that the object is good, either in the sense of being good for something (that is, useful in any way) or in that of being good in itself, that is morally good.

Kant's theory utterly contradicts some commonly held assumptions, most obviously the notion that beauty is somehow 'in' the object. For Kant beauty is not essential or inherent to the object; it is not a property or a feature of the object. What, then, is going on when we declare that something is beautiful? Are we deceiving ourselves, in attributing to the object something that it cannot possibly possess? Many critics have thought so. It has been claimed, for example, that when we call something beautiful we really mean that it is a symbol of social belonging or class status—thus if I say that a piece of music by Bach is beautiful, I am proclaiming my membership of a cultured elite in western society.[31] Another common view is that when we call something beautiful we are betraying our submission to an authoritarian ideology, which provides us with sensuous pleasures in order to prevent us from rebelling against political or social injustices; thus when I call a Hollywood film beautiful I am simply accepting my powerlessness against the American culture industry, or when I call an English landscape beautiful I am allowing myself to be distracted from the hardships of the rural poor. Yet another view has it that when we call something beautiful we simply mean that it gives us some kind of personal gratification; thus I may call a diamond tiara beautiful because I like to imagine myself rich enough to own it, or Winckelmann calls the *Apollo Belvedere* beautiful because it gives him an erotic frisson.

Kant would not disagree with any of these lines of argument. However, he would ask us to distinguish rigorously among them; he would think that we were using the word 'beautiful' in a different way in each case, and that it would be clearer to use different words. For example, when we simply mean that something gratifies us or satisfies an appetite, Kant would prefer us to call it 'agreeable' rather than beautiful. But Kant would also insist that there is *another* kind of judgement, one that is different from all of the ones just considered in the crucial respect that it is *reflective* or *contemplative*. When we make such a judgement we do not expect to gain anything from it—neither trivial gratification, nor the furtherance of our self-interest, nor even the satisfaction of having benefited other people or worthy causes. Therefore it makes no difference to us whether the object we are judging really exists or not; we can contemplate it just as well in imagination, so long as we do not expect to derive any benefit, for ourselves or others, from it. Kant calls this state of indifference to the real existence of the object *disinterest*. This is not the same as being *un*interested in the object. We may be very absorbed—fascinated or delighted—in contemplating a landscape or in listening attentively to a piece of music. But our judgement that the landscape or the music is beautiful may nonetheless be

disinterested so long as we do not wish to benefit from its real existence (to own the land, for instance, or to play the music to factory-workers in order to increase their productivity). It is *only* this disinterested kind of judgement that Kant calls a 'judgement of taste', and for Kant *only* objects that are judged in this way can be called 'beautiful'.

But why should we want to make this strangely restricted kind of judgement, one that pays no regard either to our self-interest or to ethical considerations, and that can therefore do no good either to us or to anyone else? On most occasions, probably, we should not wish to do so, and on many we ought not to do so. For example we should be foolish if we ignored the sensuous gratification that a delicious wine or a lovely naked body can give us, and we should be despicable if we delighted in the gorgeousness of a raging fire without regard to the real

suffering of its victims, as the Emperor Nero supposedly did by playing the lyre while Rome burned. Yet Kant is determined to preserve the possibility that human beings can do this paradoxical thing, and evaluate an object without reference to the interests or purposes it may serve. In all other kinds of thought and judgement we are under some kind of compulsion—either the compulsion of our appetites (hunger, greed, sexual desire, and so forth) or the compulsion of our moral principles (philanthropy, duty, political conviction, and so forth). Even in purely logical judgements we are constrained by the requirements of proof, or by the limits of our objective knowledge. Only in the estimation of the beautiful are we utterly free.[32]

Kant explains the delight we feel, in the contemplation of the beautiful, as arising from the feeling that our mental faculties are in free play; they are not impeded or curtailed by the limits of our knowledge, the needs of our physical bodies, or the demands of our consciences. For Kant it is crucial that this free play involves both our intellectual faculties and our faculties of sense perception; only in the interaction of these faculties do we feel delight in what it is to be a human being, capable of both sensation and thought, and only in the freedom of their interaction is this delight unconstrained and undirected to a finite outcome.[33] This produces a feeling of liveliness or expansiveness that has no logical or practical limits—something we can get from no other kind of experience, for in every other case there is some definite goal, or some practical limitation, that stops the free play of the mind from ranging further. We might compare Winckelmann's descriptions of his own responses to works of art, in which he often dwells on feelings of intensified life.

For Kant the experience of freedom is unequivocally positive. But it is not difficult to see how his theory could be controversial, not only in the period of the French Revolution (which erupted in 1789, just the year before the *Critique of Judgement* was published), but also in later periods up to and including our own. If the judgement of taste is indifferent to personal prejudices and biases, it is equally indifferent to noble or altruistic motives. If it is not directed to an end or purpose, it cannot oppress or manipulate, but neither can it benefit anyone or accomplish any good deed. To the earliest critics of Kant's work this radical freedom of mind could seem terrifyingly amoral; more recently it has been accused of escapism or political irresponsibility.

Yet it is also possible to interpret Kant's aesthetics as politically emancipatory. Such ideas are developed in the *Aesthetic Letters* (1795) of Friedrich Schiller (1759–1805), the dramatist and close friend of Goethe. To think beyond the limits of existing knowledge, morality, or politics, Schiller believes we need the radical freedom of the Kantian aesthetic. He reconfigures Kantian disinterest into a new notion of 'aesthetic determinability', a state brought about by the experience of beauty, in

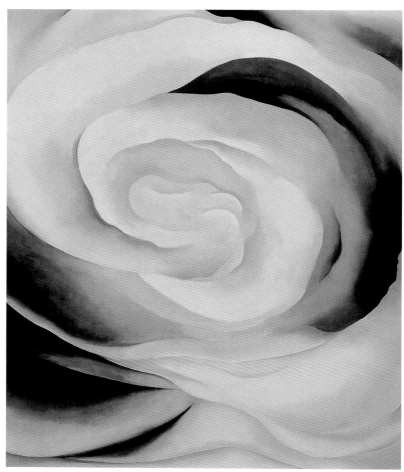

25 Georgia O'Keeffe
Abstraction, White Rose II,
1927

which the mind is open to all possibilities. It is a state of nothingness, in one sense; yet it is also a state of infinite potentiality, and therefore can allow the invention of the truly new.[34]

Another aspect of Kant's theory has proved even more controversial: that is, his insistence that the judgement of taste is *universal*.[35] For Kant, this follows rigorously from the notion of disinterest. If I sincerely believe that my judgement is unaffected by any interests personal to me, or special to a social group to which I belong, then I have no reason to suppose that anyone else with different interests will make a judgement different from mine—that is, I must believe that my judgement will be shared universally, by everyone. The notion of universality has seemed suspect in recent years, when there has been an overwhelming tendency to emphasize the differences among social groups. By claiming universality, it is argued, Kant simply imposes the taste of the white European male on everyone else. But this is a crude misreading of the *Critique of Judgement*. If a judgement differs according to whether the speaker is a man or a woman, white or black,

healthy or disabled, gay or straight, then in Kantian terms it cannot be a judgement of taste in the first place, for it is not disinterested. We may reasonably argue that in practice no one ever makes a judgement that is wholly independent of personal interests. But it may still be worth preserving the possibility that we might aspire to do something of the kind. If we can all agree that a rose is beautiful, that may perhaps be trivial; it may even be a disgraceful evasion of our responsibility to attend to more important political, social, or moral matters. But if the alternative is to accept that there is *nothing* about which universal agreement may ever be possible, then perhaps there is something to be said for the beauty of the rose.

Kant and art

The privileging of art as a specially important form of aesthetic experience is not a feature of Kant's philosophy, and it is easy to see why: in the Kantian judgement of taste, properties of the object, such as whether it belongs to the conceptual category 'art' or not, are altogether irrelevant. Nonetheless, it is obvious that Kant's ideas had the potential to cause a revolution in art criticism, previously concerned with establishing general rules or standards against which particular objects could be measured. Even Winckelmann never abandoned the habit of enumerating rules of thumb for the beautiful—thus the straight-line profile is to be preferred to one with a depressed nose, flaxen to dark hair, flowing lines to abrupt transitions, and so forth. But in the Kantian judgement of taste there can be no such rules or criteria—if there were, the critic would simply need to determine whether the particular object conformed to the general rule, which would be a logical and not an aesthetic judgement. No comparisons or generalizations are possible, for it would be necessary to point to properties that the objects shared in order to relate them to one another. In a favourite example of Kant's, the statement 'the rose I see before me is beautiful' is a judgement of taste, but the statement 'roses in general are beautiful' is no longer purely aesthetic; although the latter statement may draw on aesthetic judgements about particular roses, knowledge or logic would be required to group them together into a general statement. For Kant the judgement of taste is always *singular*: 'I must present the object immediately to my feeling of pleasure or displeasure, and that, too, without the aid of concepts'.[36]

Thus the beautiful can have nothing to do with rules or precepts, comparisons or classifications, canons or hierarchies of taste—in short, with all of the traditional tools of the art critic. This opens the possibility of a radical break with past criteria for critical judgement. In most art theories since the Renaissance, there are cogent reasons for preferring a major painting of an important historical subject, such as

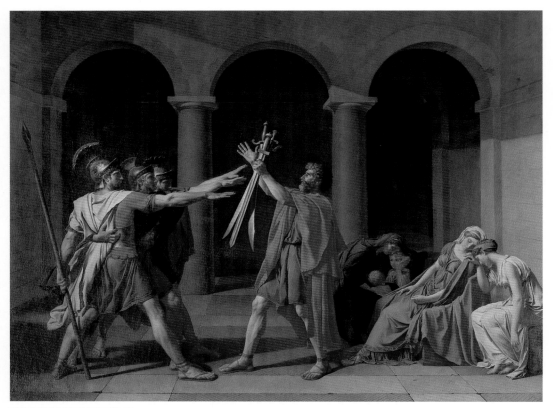

26 Jacques-Louis David
The Oath of the Horatii,
1785

The Oath of the Horatii by Jacques-Louis David (1748–1825, **26**), to a small picture of everyday objects, such as *Glass of Water and Coffee Pot* by Jean-Baptiste-Siméon Chardin (1699–1779, **27**). The David presents an inspiring deed of heroism in which the actors voluntarily sacrifice their private interests to the public good (the three brothers are swearing an oath to engage their enemies in single combat); nor does it neglect the human dimension, expressed in the group of grieving women. It is a vast composition, demonstrating both the painter's intellect and his exceptional technical skill. The Chardin is far less

27 Jean-Baptiste-Siméon Chardin
Glass of Water and Coffee Pot, 1760

ambitious in technical range and can be enjoyed without reference to moral or political considerations; it presents an assemblage of ordinary household objects, within limited dimensions. Both paintings are skilfully crafted. Nonetheless it is perfectly reasonable to prefer the David as an example of history painting, the highest category in the traditional hierarchy of pictorial types, to the Chardin as an example of the lowest type, still life.

But Kant's theory eliminates such distinctions. In the Kantian judgement of taste there is no reason for preferring a history painting to a still life, and the critic must consider each object in its uniqueness, without reference to any category to which it might belong. A conspicuous aspect of the history of modern art since Kant has been the rejection of traditional hierarchies of pictorial types. After Kant's *Critique of Judgement*, there are no limits or strictures on what kind of thing the beautiful object might be, or what properties it might display. It can be anything at all—for instance an assemblage of horizontal and vertical lines on a canvas [**109**], or a porcelain urinal on its back [**111**]. Indeed, there is no reason to prefer works of art to other kinds of objects; it can be argued that Duchamp's notorious presentation of the urinal as an aesthetic object, in 1917, was fully theorized more than a century before the fact in Kant's *Critique of Judgement* (see below, pp. 178–80). Perhaps, then, we can see Kant's theory as clearing the way, at least, for modern art.

Few will complain about the licence Kant's theory offers for placing a high aesthetic value on Chardin's painting. But where does that leave our estimate of the David? We may, of course, experience delight in the immediate encounter with David's painting. The sheer size of the painting makes it a powerful visual experience, and there is much scope for the free play of our minds as we scan the measured intervals of the architectural space in counterpoint with the diagonals and curves of the figure groups, or contemplate the brilliant lighting of flesh and metal against the deep background shadows. We need not exclude the resonances of the subject-matter from our reflections; the unanimity of the men's gestures may arouse thoughts of friendship and solidarity, or of fanaticism and militancy. Arguably, though, the didactic character of the work imposes certain limits to the free play of the observer's response; we must either accept or reject the picture's clear intention to strike us with awe for its masculine and military heroics. We could try to forget what we know about the picture's key role in the history of French neoclassical art, not to mention its iconic status for more recent generations as a major canonical work of the period leading up to the French Revolution. But why should we wish to forgo such edification, or to evade the moral issues that the picture raises? Is it possible to make a pure aesthetic judgement on this work, and if so, is it desirable? If it is not possible, or very difficult, to respond freely to the work, does

that mark a deficiency of the work, or does it perhaps point to the limitations of the judgement of taste itself?

There are two different ways of approaching such questions, both of which Kant entertains at various points in the *Critique of Judgement*. On the strictest interpretation, it is possible to make the judgement of taste about *any* object, so long as we divest ourselves ruthlessly of any interests of our own, and so long as we leave out of consideration any ends or purposes the object serves. To make a pure judgement of taste on David's *Oath of the Horatii*, we should need first of all to convince ourselves that we had set aside our personal commitments; we should need, for instance, to make sure that our left-wing sympathies did not bias us in favour of David as a courageous actor in the French Revolution, or in favour of the picture as a demonstration of political ideals of that period. We should also need to ensure that our judgement was uninfluenced by any of the purposes or ends proposed in the picture, such as its manifest ambition to make an impact at public exhibition, its promotion of an austere neoclassical idiom, or its celebration of male heroism. But if we felt confident that we had purged away all of our interests, and all thought of the work's purposes, then we should truly be entitled to call it beautiful in a pure judgement of taste. This would be exceptionally difficult, however; moreover, we would have to ignore many of the most salient or intriguing aspects of the work.

Such considerations suggest another possible approach, also entertained by Kant: we may need to distinguish between objects amenable to the judgement of taste in the strictest sense and others, such as the David, which are likely to involve non-aesthetic considerations. In the first case the judgement will be one of *free beauty*, altogether independent of interests or ends; in the second it will be one of *dependent beauty*, in which our response to the object is influenced by considerations other than the mere delight we experience in contemplating it.[37]

The distinction proves paradoxical. The judgement of free beauty is more rigorous and pure, and it is altogether unaffected by prejudice or bias; here there is no constraint whatsoever on the free play of mind. Yet the objects amenable to this kind of judgement turn out to be strangely haphazard, if not trivial. 'Flowers are free beauties of nature', Kant writes: 'Many birds (the parrot, the humming-bird, the bird of paradise), and a number of crustacea, are self-subsisting beauties which are not appurtenant to any object defined with respect to its end, but please freely and on their own account.'[38] It is possible to imagine great works of art that might elicit a judgement of free beauty, such as the delicate paper cutouts of Philipp Otto Runge (1777–1810, **28**). The intricacy of the silhouetted forms encourages the viewer to linger and to range freely over the complicated patterns, while the blankness of the white paper against its dark background removes any temptation to speculate on the 'real' existence of the plant forms. But this is a rare

28 Philipp Otto Runge
Spray of Leaves with Orange-Lily, c.1808

case. Indeed, Runge's cutouts are only comparatively free beauties in Kantian terms, for Runge must have had some kind of purpose in making them (we shall explore this point further in the next section); few objects—and fewer (if any) works of art—are likely to qualify as free beauties if the term is taken strictly. Thus free beauty, although it is the purer kind of beauty in theoretical terms, seems almost bizarrely restricted in practice.

Dependent beauty, on the other hand, is impure or hybrid; here the beautiful is no longer sufficient in itself, but is mixed with non-aesthetic considerations. Yet many, perhaps most, of the objects we value most highly fall inevitably into this category. Indeed, anything judged to be *ideal* or *perfect* is a dependent, not a free beauty, since a concept of what the thing is meant to be like is required in order to determine whether or not it is a perfect example of its kind. Once

again, Kant confounds commonly held assumptions—for him, perfection is incompatible with free beauty, and statements such as 'she has a perfect figure' or 'the Parthenon is a perfect example of a Greek temple' are not pure judgements of taste. More startlingly still, Kant declares that anything involving the human figure can only be a dependent beauty. At a stroke this overturns the most cherished assumption of all art theories since the Renaissance, one that remains basic for Winckelmann: that the human figure demonstrates the highest beauty of which we can have experience.

Kant's position is shocking, in relation to previous ideas about taste; yet it has considerable cogency. As Kant suggests, when we contemplate a human figure we are bound to respond to it as a man, woman, or child; we can scarcely set aside our own gendered identities in the

process.[39] Kant was also aware of the difficulties about race and ethnicity that have preoccupied recent cultural critics. As he points out, people who have lived among Africans, Asians, or Europeans have had different experiences of the visual appearance of human beings, which are bound to influence their judgements.[40] Moreover, in the circumstances of the modern world it would be not only impossible but often morally wrong to exclude political or social considerations from the contemplation of human figures of different races, ethnic or cultural backgrounds. The black sitter in *Portrait of Jean-Baptiste Belley* [**29**], by Anne-Louis Girodet-Trioson (1767–1824), is a tour de force of beautiful painting, but this is surely enhanced by the knowledge of Belley's political importance as the delegate to the French National Assembly who successfully argued for the abolition of slavery and for black citizenship.[41] The juxtaposition of Belley's black features with the white sculptured bust of another colonial reformer, Abbé Raynal, makes a political point in visual terms, vividly demonstrating equality between the political achievements of the two men; it would be not only practically impossible but morally questionable to separate this message from the picture's beauty. In *The Widow of an Indian Chief Watching the Arms of Her Deceased Husband* [**30**], Joseph Wright of Derby (1734–97) presents the figure of a Native American woman in dramatic silhouette against a stormy landscape, to emphasize the nobility of her conduct. It may be argued that both Girodet and Wright are idealizing or romanticizing the image of the non-western figure. Whether we consider this laudable or misguided, it clearly introduces a political or moral purpose into the works. However beautiful we may find either picture, we should miss an important dimension if we were to ignore the racial

30 Joseph Wright of Derby
The Widow of an Indian Chief Watching the Arms of Her Deceased Husband, 1785

specificity of the figure, and the political messages that entails, in order to make a pure judgement of taste. Thus works of this kind involve dependent, not free beauty.

Kant makes it clear that the same considerations necessarily apply to the representation of European figures, including the most celebrated Greek sculptures such as the *Apollo Belvedere*.[42] Startlingly, given traditional views of Greek sculpture as models of perfect human beauty, Kant declares that such figures cannot represent free beauty at all. The Greek ideal of human beauty is too inextricably intertwined with the European cultural heritage to be amenable to a wholly free judgement of taste. Moreover, for Kant the normative ideas involved in declaring the Greek sculptures to represent an 'ideal' or a perfect human form cannot be aesthetic, since they depend on a concept of what the human form *ought* to be like.

Kant seems, then, to vacillate between two different ways of thinking about beauty. On the one hand, he maintains that it is possible in theory to make a pure judgement of taste about any object whatsoever, provided we rid our minds of all personal interests and all thought of the ends the object might serve. On the other, he asserts that such a judgement will be extremely problematical in relation to many if not most of the objects we might wish to call beautiful. Moreover, he notes that there may be considerable advantages to combining a logical or moral element with the purely aesthetic in judgements of such objects.[43] We may, then, cite David's *Oath of the Horatii* or Girodet's *Portrait of Belley* as superb examples of *dependent* beauty, and even consider their moral and political resonances to add to their merit.

The notion of dependent beauty may seem attractive, since it allows us to take moral, political, and social considerations into account. But something has been lost. Impure or hybrid judgements of dependent beauty inevitably fall short of the complete freedom that characterizes the aesthetic in its most rigorous formulation. The most exciting possibilities of the aesthetic—the way it may allow us to leap beyond the limits of what we can currently know, prove, or justify—are curtailed in cases of dependent beauty. Perhaps Kant himself drew back in alarm at the most extreme implications of his own theory. But his *Critique* nonetheless opened up the possibility of an aesthetic experience that is genuinely free. For better or worse, that possibility has remained central both to artmaking and to debates about art throughout the succeeding two centuries, and up to the present day.

Genius and originality

In the work of Caspar David Friedrich (1774–1840) we repeatedly encounter a figure seen from behind—the *Rückenfigur*, engaged in contemplation of a view. This is the simplest of devices for representing

31 Caspar David Friedrich

Wanderer above the Sea of Fog, c.1818

aesthetic experience in the new, Kantian sense, centred quite literally on the observing subject. In *Wanderer above the Sea of Fog* [**31**], the *Rückenfigur*'s head is at the horizontal centre of the canvas, and his waist exactly bisects its vertical dimension. Moreover, the view is balanced with uncanny symmetry around the figure. Indeed, the space is

not measurable in the ordinary terms of post-Renaissance perspective, but only in relation to the figure itself. The rising fog makes unfathomable the spaces between the foreground crag, the rocks in the middleground, and the distant peaks. When we make out the trees on the rock to the right of the figure's elbow they seem unexpectedly tiny; then the distant peaks seem to spring away to a vast distance. As we scan the picture our efforts to comprehend the scale relationships are constantly tested or defied. Although this is not a particularly large picture, it gives a strong sense of the kind of aesthetic experience Kant called *sublime*, in which we strain to perceive something limitless or infinite. We are thwarted in the attempt to realize this perception fully, both by the magnitude of the view and by the scudding patches of fog, yet this failure to comprehend produces a feeling of awe or wonder that is the counterpart, in the experience of the sublime, to the free play of mind in response to the beautiful. It is not, then, the landscape itself, but rather the viewer's aesthetic experience, that can be called sublime in the Kantian sense.[44]

The *Rückenfigur* is unlike any previous figure in the history of art in one crucial respect: he (or she, as in **32**) is not just a represented object in the picture, but also the embodied subject of the aesthetic experience of the picture—we look *with*, rather than merely *at*, the *Rückenfigur*. Moreover, there is no way to distinguish our view of the landscape from that of the *Rückenfigur*. Unlike more traditional representations of landscape, this painting does not pretend to present us with a natural scene as it exists in its own right, but makes us conscious instead that we are seeing a human perception of nature. Friedrich has, then, found a way to present a scene that corresponds to the Kantian aesthetic experience. Moreover, the painting is not merely an anecdotal representation of a figure engaged in the experience of the sublime, it also provides us viewers with an aesthetic experience analogous to that of the *Rückenfigur* herself.

This is not to claim that Friedrich had the specific intention of demonstrating Kantian aesthetic philosophy. Had this been his aim, it would threaten the aesthetic credentials of the painting, which would then be tantamount to a logical treatise in visual form; it would be directed towards a specific end, that of demonstrating the Kantian theory of the sublime. This points to a serious difficulty that occurs when Kant moves from his theory of aesthetic experience, in the early sections of the *Critique of Judgement*, to a discussion of artmaking. While we can easily imagine that Friedrich may not have intended the painting to be a visual treatise on aesthetics, it is scarcely conceivable that he made it without any intentions at all. The very decision to make a work of art in the first place gives the work an end or purpose; the processes of designing and executing it require the planful application of specific skills and technical procedures. In other words, the

32 Caspar David Friedrich
Woman at the Window, 1822

activity of making an artwork is fundamentally incompatible with beauty in any free or pure form. Paradoxically, the 'beautiful' work of art is unmakeable.

This problem dominates Kant's discussion of art and artists:

[T]here is still no fine art in which something mechanical, capable of being at once comprehended and followed in obedience to rules . . . does not constitute the essential condition of the art. For the thought of something as end must be present, or else its product would not be ascribed to an art at all, but would be a mere product of chance.[45]

We are moving in circles: to make something, it is necessary to carry out a definite procedure for making that thing; but definite procedures are incompatible with free beauty; thus fine art, insofar as it is intentionally made by the artist, cannot be judged beautiful in a pure judgement of taste. It might be argued that Kant was simply mistaken in attempting to derive a theory of artmaking from one about aesthetic experience, and that we should make aesthetic judgements about works of art without reference to the artist's intentions, as if they were so many wild flowers. Nonetheless, the problem of intentionality has been among the most persistent concerns in art practice since Kant raised it in such uncompromising form. The overwhelming importance accorded to 'spontaneity' in the painting techniques of the Impressionists, the use of irrational and dream imagery in late-nineteenth-century

Symbolism, the *objets trouvés* ('found objects') of Cubism, Marcel Duchamp's 'readymades' (see p. 178), and the 'automatic' techniques of the Surrealists (designed to draw imagery from the unconscious mind) might all be described as experiments in reducing the artist's intentionality to a minimum. Kant himself, in the passage just quoted, dismissed as nonsensical the notion that a work of art could be a product of chance, but that is just what has been proposed in certain forms of twentieth-century art, poetry, and music that use random, or 'aleatory', procedures for generating images, words, or sounds.

Kant's own solution to the problem of intentionality is to invoke the notion of *genius*—a quality innate in creative artists that somehow swallows up or supersedes the premeditated character of artmaking. This recalls much older notions of artmaking as involving an element of magic, madness, or divine inspiration; such ideas were already associated with the term 'genius' and were much elaborated in nineteenth-century theories of Romanticism in the arts.[46] While Kant had little use for the more mystical aspects of such conceptions of genius, his theory clearly required some faculty by which the creative artist could operate outside the bounds of strictly logical thinking. Otherwise there would be a basic mismatch between the making of a work of art (intentional and purposive) and the experience of such a work (free and independent of any end). Thus the term 'genius' serves as the counterpart, in the process of artmaking, for 'taste' in the process of contemplating an object deemed beautiful. Both depend on an interaction of imagination and understanding in a free play that is neither determined by a definite concept nor directed towards a finite end. By attributing 'genius' to the creative artist, Kant attempted to explain how an artwork could be made intentionally, yet without sacrificing the element of free play.[47]

Arguably, though, traces remain of the mystical: how, unless by some kind of magic, can we accept that someone can make something without meaning to? Kant argued that genius involved making a work that was not limited to fulfilling its basic concept or intention, but that also expressed what he called *aesthetic ideas*.[48] This bridged the gap between the making and the experience of the work of art, for the aesthetic ideas would suggest or stimulate a multitude of thoughts and reflections, thus encouraging the free play of imagination and understanding in the mind of the observer of the work. An artist might paint a mountain landscape that could be judged acceptable according to determinate criteria for illusionistic representation; such a work would realize the artist's intention to paint a landscape of a certain kind. But Friedrich's *Wanderer above the Sea of Fog* goes above and beyond merely realizing its intention. It is a work of genius in Kant's sense, for it stimulates the observer's mind to range freely over the widest variety of further musings—about pictorial space, human perceptions of space,

or natural space, for example; about the relationship of human beings to nature, the spiritual dimensions of a sublime experience, or the presence of the divine in nature; about the unseen facial expression of the figure, his possible alienation from society, or his intellectual mastery of the scene before him (and us). Kant has often been accused of being a 'formalist', of concentrating on the formal features of objects to the neglect of their sociopolitical contexts. But there is no hint, in his discussion of aesthetic ideas, that we ought to limit our musings, in the contemplation of a work of art, to formal considerations. In response to the Friedrich, we may wish to think about a variety of non-aesthetic issues, such as the political or patriotic resonances of the figure's costume, the scientific implications of the portrayal of fog in the mountains, or the sociological entailments of the picture's inclusion in a major German museum collection. Any of these trains of thought would be compatible with the free play of mind so long as they did not stop short at a cut-and-dried conclusion. More importantly, when taken together they demonstrate the inexhaustibility of the thoughts and feelings to which the picture may give rise. Thus they exemplify the aesthetic ideas which, for Kant, distinguished the work of genius: 'I mean that representation of the imagination which induces much thought, yet without the possibility of any definite thought whatever, i.e. *concept*, being adequate to it'.[49]

The free play of mind is characteristic of all experiences of the beautiful. However, Kant speaks of aesthetic ideas only in relation to works of art. It is crucial that the aesthetic ideas are generated in the free play of imagination and understanding in the mind of a human artist, as well as stimulating an answering free play in the mind of the observer. We have seen that there is no reason why the aesthetic ideas should not involve any area within human experience. But they can also suggest or adumbrate what is *beyond* human experience, perhaps by imaginatively recombining sensory perceptions, or by inventing sensuous forms for immaterial ideas (Kant's examples include 'death, envy, and all vices, as also love, fame, and the like'[50]). This at last gives positive value to the work of art: unlike naturally occurring objects (such as wild flowers), art not only permits the human mind to leap beyond what empirical perception and objective knowledge can grasp, it also does so in a way that is communicable from one human being (the artist) to others.

But once again such notions drastically alter the emphases of previous art theories. No longer does the imitation of natural scenes or objects (*mimesis* in classical art theories) seem the most worthwhile activity. Instead the Kantian emphasis on aesthetic ideas seems to exhort the artist to invent as freely as possible, or even to defy everyday experience or logic; this passage in the *Critique of Judgement* might be held responsible for the more bizarre artistic fantasies of Romanticism, in the next generation. In the early nineteenth century Runge designed

a cycle of prints about *The Times of Day* [**33**]; each of the four prints supplements its basic concept (Morning, Midday, Evening, Night) with a wealth of aesthetic ideas that cannot be adequately encapsulated in words. Runge wanted to expand his black-and-white designs into colour, and to design an architectural setting where they would be accompanied by music, thus increasing the range of their aesthetic ideas in multiple directions. However, by the time of his early death in 1810 he had completed the colour only for the first of the series, *Morning* [**34**]. In the lower part of the central scene is a landscape of breathtakingly precise naturalism, with minutely observed plants in the foreground and a perspective recession through green fields that introduces a startling impression of deep space. The golden light of sunrise that illuminates this landscape is equally convincing as realistic representation. But the empirical or naturalistic observation seems to

34 Philipp Otto Runge
Morning (small version), 1808

stimulate intensified or more-than-natural visual experience. The light is also, of course, symbolic of the painting's basic concept, that of *Morning*. Moreover, the source of this seemingly realistic light is an imaginary vision. In the centre and at vast scale in relation to the earthly landscape is a Raphaelesque female figure, nude, wreathed in and shedding light, and called either Venus (goddess of love) or Aurora (goddess of the dawn)—or perhaps the aesthetic idea encompasses both personifications. Above her rises a colossal white lily, symbol of light for Runge and also the traditional symbol of innocence and of the Virgin Mary, connotations that cannot be excluded from the vast range of suggestiveness in this composition. The female figure is centrally positioned like an unclothed version of one of the most famous Virgins in the history of art, the *Sistine Madonna* [14], which is also echoed in the circles of immaterial angels' heads in the top border. The Christ child of the traditional Madonna and Child composition is given more generalized significance as the newborn baby, lying on his back in a pose that hints both at infantile helplessness and at the open-armed and wide-eyed welcoming of the vision above him. The complex imagery of the painting revolves around the basic idea of Morning, with its resonances of birth, innocence, and hope. Moreover, every-thing in the painting is clearly expressed: every form is represented with preternatural clarity, while the symbolism of each flower and each figure is specific. Nonetheless it is impossible to give the picture a definitive interpretation, to sum up its meaning. The painting's aes-thetic ideas leave its basic concept far behind.

Thus Runge's *Morning*, like Friedrich's *Wanderer above the Sea of Fog*, demonstrates the artist's 'genius' in the Kantian sense, by suggest-ing a wealth of aesthetic ideas. We might infer that these German artists learned from Kant himself, or from the dissemination of his thought in Romantic writing, to emphasize suggestiveness and open-endedness over logical meaning and imitative representation—to make work that enhanced their credentials as geniuses. But it was vital to Kant's theory that genius could not be learned or taught; if it were teachable, it could be described in precepts or rules, and thus would constitute a form of logical knowledge. Therefore Kant insists that genius is innate in the creative artist. Perhaps more than any other feature of Kantian aesthetics, this has been controversial in recent years. Genius, it has been argued, is elitist; it makes a pernicious and unwarrantable segregation between the few most privileged artists in the western tradition and the many artists whose contributions have not been recognized (including virtually all women and non-western artists). At times Kant seems to endorse this elitist notion; he writes, for instance, that 'the genius is one of nature's elect—a type that must be regarded as but a rare phenomenon'.[51] Yet this is inconsistent with his more basic characterization of genius as based on the same two

mental faculties (imagination and understanding) that constitute taste and which, in Kantian theory, must be attributed to every human being. Thus everyone might be presumed capable of genius, and creative artists may differ from other people only in choosing to develop this capability; this possibility has been explored in certain twentieth-century theories, such as that of the American philosopher John Dewey.

If Kant seems to contradict himself in order to emphasize the rarity of genius, that may be because of the overwhelming importance attached, in his theory of artmaking, to the notion of *originality*. Genius, he writes, 'is a *talent* for producing that for which no definite rule can be given: and not an aptitude in the way of cleverness for what can be learned according to some rule'; it follows that '*originality* must be its primary property'.[52] Kant therefore dismisses all followers of a style or artistic trend as second-rate, in comparison with the exceptional artists who are capable of genuine originality. Once again this demolishes previous doctrines, particularly the influential theories associated with academies of art. If beauty cannot be determined by rules, then it cannot be taught in art schools or in professorial lectures. The genius might learn technical skills from a teacher or in a school, but this carries the risk of stifling her or his originality; hence the many stories about modern artists and groups of artists, from the Pre-Raphaelites and Impressionists to Dada and Fluxus, who rebelled against academic or institutional authority. This set of ideas paved the way for the characteristic value systems of modern art: the overwhelming privileging of artists and works that demonstrate some striking innovation, and the utter denigration of 'academic' or institutionally based art forms. Although, as in the case of genius, there has been some criticism of the notion of originality as unfairly privileging certain kinds of art over others, originality nonetheless remains entrenched as the most important criterion for excellence in modern art.

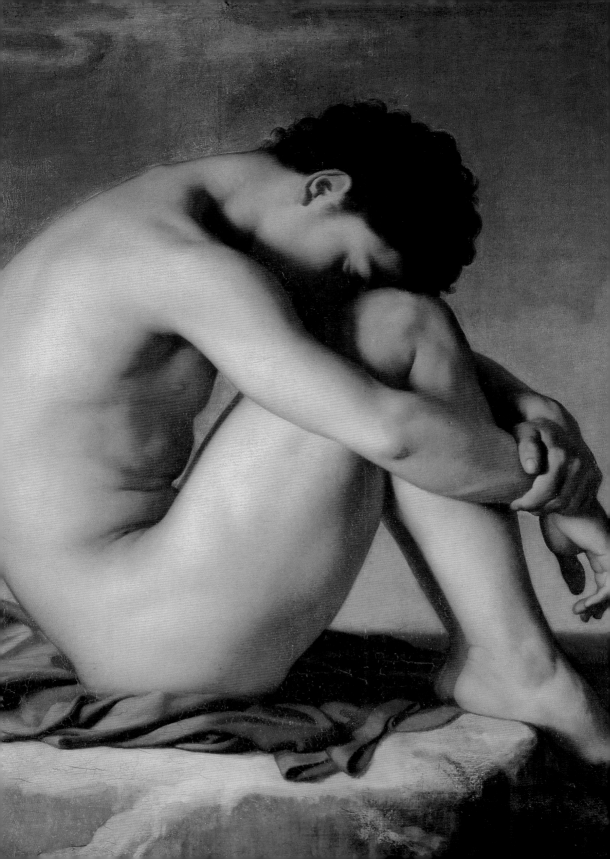

Nineteenth-century France: From Staël to Baudelaire

2

Beauty! Where shall one begin on a subject so vast, one that has stirred so many celebrated writers? What a theme! An endless one; and let it be said in passing, just such questions as these are the most interesting, because with them, the last word is never said and because everyone can have a different opinion.

Eugène Delacroix[1]

Hippolyte Flandrin's *Study* [**35**] began simply as an educational exercise. Flandrin (1809–64) was the pupil of Jean-Auguste-Dominique Ingres (1780–1867), himself the pupil of David, and seen as the leading proponent of the classical tradition in French painting. Like Ingres in 1801 and David in 1774, Flandrin attained the ultimate success within the French system for art education: in 1832 he won the Prix de Rome, the coveted prize that sent its winners to Rome, to study the great art of the classical and Renaissance past. Prizeholders were required to send examples of certain kinds of work back to Paris, to demonstrate the progress of their studies; Flandrin made this painting to fulfil one of these requirements, for a *figure d'étude* (study of the nude human figure), and duly sent it to Paris in 1837.

Thus far, Flandrin's painting would seem to have nothing to do with Kantian notions of 'free' beauty. It was executed in obedience to the strictest of rules, laid down by academic authority and passed on from master to pupil down the generations. It had an unambiguous purpose, to assist the education of the painter, and its making was clearly in the interest of furthering his career. Moreover, it is difficult to forget either the academic rules or the work's practical functions in contemplating it, for the figure approaches 'perfection'. The bodily forms are such as Winckelmann would have approved, of the youthful type of an Apollo, from the regular curls of the hair to the flowing forms of the knees and feet. The modelling of the flesh is flawless, flowing evenly around the contours, for example of the rounded thigh; the modulation from light to shade is so gradual that the roundness of the form appears as if by magic. Moreover, the pose describes almost a perfect circle, placed in the centre of a rectilinear canvas, in a reminiscence of Leonardo's famous *Vitruvian Man* [**36**], itself a demonstration of perfect human proportions. It also recalls the nude figures of Michelangelo's Sistine

Chapel ceiling; in this way, again, it meets the requirements of the academic exercise, for scholars were expected to learn as much as they could from the great art of the past while in Rome. The perfect figure is bound or locked into a perfect order of things, which it fits like clockwork. Its watchwords are control, perfection, tradition—not freedom, spontaneity, originality.

But some observers could find Flandrin's painting beautiful in a different way. The inturned pose suggests profound self-absorption or interiority, while the face is unseen. The figure is delineated with a clarity so intense that later observers likened it to Surrealism, and yet its mood or expression is left to the viewer's imagination; the surrounding expanse of sea is almost featureless but again seems to lead the thoughts to unfathomable distances. As the critic Théophile Gautier (1811–72) remarked, we could explain the figure as a shepherd who has lost his flock, or a shipwrecked man on a deserted island; but these rational explanations seem somehow inadequate to the haunting mood of the picture. Indeed, Gautier went on to describe it in Kantian terms: it offers no precise meaning, he wrote, nor does it proceed from any intention, but exists as a free manifestation of beauty, and communicates 'the dreams of the painter beyond the trammels of subject-matter'. Flandrin's study may, then, please us more than a fully resolved painting of a definite subject: 'Art here expresses itself, without other preoccupation'.[2] The artists and writers of subsequent generations who found this work fascinating forgot its origins as an academic exercise; for them it stimulated a wealth of aesthetic ideas [**84, 123**].

Flandrin's painting can be seen to meet the criteria of two altogether different ways of thinking about beauty, both of which were powerful in early nineteenth-century France. On the one hand, it is faithful to notions of an ideal or perfect beauty that exists in the object (in this case, the beautiful male body); such notions were upheld by the French system of art-teaching, with its competitions and prizes, its clear standards for excellence, and its respect for the artistic achievements of the past. On the other hand, Flandrin's painting is also amenable to re-interpretation in the subjective terms of the new German aesthetics, according to which the work gives rise to thoughts of beauty in the mind of the observer, or communicates such thoughts, in the form of aesthetic ideas, from the mind of the artist to that of the observer. In this painting, then, Flandrin succeeded in harmonizing two different approaches to beauty. More often, in the contentious art world of nineteenth-century France, the two came into collision. Yet the collision was productive. If debates about beauty in nineteenth-century France were fierce, that was because beauty was seen to matter. This was a world of political revolutions, of social reformism, of belief in progress and human perfectibility. Why was it that beauty mattered so much in such a world?

Aesthetics and art theory in France: Staël, Cousin, Quatremère

In nineteenth-century France there was no philosopher of the stature of Kant, or of the German philosophers who developed aesthetics in the next generation, such as Friedrich Wilhelm von Schelling (1775–1854, the first to write a philosophy, specifically, of art), Georg Wilhelm Friedrich Hegel (1770–1831), or Arthur Schopenhauer (1788–1860). All of these philosophers were influential in France, as was Winckelmann. There is a temptation, then, to see French thinking on beauty merely as a derivative or diluted version of a more rigorous German tradition. Most art-historical accounts of early nineteenth-century France do not emphasize aesthetics; instead they speak vaguely of the dissemination of 'Romantic' ideas about the rejection of academic rules, genius and originality, or art's expressive (rather than mimetic) potential. Yet nine-teenth-century France is by common consent one of the greatest periods for artistic production; it is not an exaggeration to say that for many scholars and art-lovers it marks a pinnacle of achievement, for modern art, equivalent to fifth-century BCE Athens for ancient art or the High Renaissance in Italy. Is it plausible that so flourishing an art practice was accompanied by merely derivative or mediocre thinking on aesthetic questions?

Kant's philosophy was introduced to France amid controversy, in *De l'Allemagne* ('Of Germany'), a comprehensive survey of German society, culture, and ideas by Anne-Louise-Germaine Necker, baronne de Staël-Holstein (known as Madame de Staël, 1766–1817). Staël was already famous throughout Europe as an author and political activist; her novel of 1807, *Corinne*, presents a woman poet as a creative genius, a radical move for this date. A painting by François Gérard (1770–1837), *Corinne at Cape Miseno* [**37**], represents a scene from the novel in which Corinne gives a moving performance; the representation of the poet has often been interpreted as an idealized portrait of Staël herself. Staël visited Germany while in exile for her opposition to the increas-ing despotism and imperialist ambitions of Napoleon's régime. In *De l'Allemagne* she presents German thought and culture as a powerful counter-image to Napoleonic France, which she depicts as superficial, materialistic, and devoted to self-interest; the philosophy of Kant plays a crucial role in this project. The point was not lost on the French authorities: the first edition of 1810 was seized, and all copies pulped. Despite or as a result of this censorship, it was an immediate best-seller when it was finally published in London in 1813, in both French and English editions; it went through 25 French editions in the next seventy years.[3]

The research required to write *De l'Allemagne* was prodigious, and Staël has often been accused of oversimplifying her countless German sources. In fact she offers an accessible and almost miraculously suc-cinct summary of the main arguments of the *Critique of Judgement*;

these virtues made her version of Kant's aesthetics exceptionally power-
ful in its influence on later artists and writers. But by the same token her
account is necessarily partial. Moreover, her version of Kant is filtered
not only through subsequent German interpretations of his thought,
familiar to her through extensive personal contacts in German literary
and philosophical circles, but also through the agenda she sets herself.

For Staël, Kant's account of the beautiful as an activity of the human
mind, rather than a characteristic of objects, is valuable for combatting
what she sees as French materialism, or overvaluation of externals;
moreover, his insistence that the beautiful should not serve a specific
end or purpose aligns with Staël's opposition to utilitarianism and doc-
trines of self-interest. Thus she gives a cogent account of Kant's double
separation of the beautiful, from what is merely agreeable on the one
hand, and from what is directed towards an extraneous end on the
other. But even though she demonstrates a secure grasp of Kant's ter-
minology, she substitutes her own keywords in ways that emphasize
her special concerns.

Staël's use of the word *utile*, or 'useful', as a shorthand for anything
directed towards an end is brilliantly effective, for it makes lucid, if
oversimplified, sense of the very difficult passages in Kant that deal
with the non-instrumentality of the judgement of taste. Thus Staël
asserts: 'Kant, in separating the beautiful from the useful, clearly proves
that it is not at all in the nature of the fine arts to give lessons.' While

this is blunter than anything in the *Critique of Judgement*, it is a plausible reading, but Staël goes on to expand the point dramatically: 'as soon as one has the intention of putting in evidence a moral precept, the free impression that artistic masterpieces produce is necessarily destroyed; because the end . . ., when it is evident, limits and hampers the imagination.'[4] This is not exactly inconsistent with Kant, who, as we saw in Chapter 1, observed that a judgement that included a moral or intellectual element was not a judgement of free beauty, but merely one of dependent beauty. However, Staël changes the emphasis. For Kant, there was nothing wrong with judgements of dependent beauty (see pp. 50–4 above). In Staël's formulation, though, the addition of the moral element actually vitiates the aesthetic impression of the work of art. This idea proved highly influential not only in nineteenth-century France, but later in modernist art theories as well. The fine arts, she concludes, 'ought to elevate the soul and not indoctrinate it'; this is one of the motto-like formulations for which Staël had a special flair, and which made her interpretations so memorable. Note, too, another of Staël's keywords: 'soul', which in Staël's text repeatedly replaces Kant's sober emphasis on the mind with a more religious conception of the human subject.

But the most important substitution of terms is Staël's use of the word 'ideal' as a virtual synonym for Kant's 'beautiful'. As we saw in Chapter 1, Kant distinguished 'free' beauty quite explicitly from the ideal. Staël, however, discards this altogether in what must be called a significant misrepresentation of Kant's theory. Like the substitution of 'soul' for 'mind', the word 'ideal' perhaps imparts a flavour of the noble or elevated. But it also imports a link to the art theories of the European academies (in particular the French Academy), which identified the ideal with some higher standard, to which any individual work was expected to aspire—just the link that Kant was anxious to deny, when he carefully distinguished free beauty from the ideal. It might be argued that Staël used the term in order to make her account more comprehensible to French audiences, to whom idealist art theories were more familiar than Kantian aesthetics.[5] Moreover, she carefully separates her own usage of the term from at least one common way of understanding the ideal in academic art theory. It is not, she writes, a matter of selecting the most beautiful individual forms in nature, and recombining them into a more perfect whole in the work of art (the version of the ideal seen for example in Kauffman's *Zeuxis Selecting Models*, **17**).

Instead, Staël locates the ideal in the soul of the observer: it is 'the realised image of that which our soul represents to itself'. Thus Staël proposes a subjective account of the ideal, as something within the human mind or soul, rather than an external or objective rule, as in some versions of academic art theory. Nonetheless this refers the

judgement of taste to a higher principle, rather than locating it as Kant does in the free response of the observer to a particular aesthetic experience. Like academic theories of the ideal, Staël's version derives its ultimate sanction not from the philosophy of Kant but from that of the ancient Greek philosopher Plato and his later 'Neoplatonic' followers, according to which everything we see in the material world is merely a reflection of a higher ideal in the spiritual or transcendent realm. Thus Staël concludes this passage with an evocation of the divine: 'all men must admire what is beautiful, either in the arts, or in nature, because they have in their souls the sentiments of celestial origin which beauty awakens, and in which it causes them to rejoice.'[6]

It is true that Kant himself suggested that the contemplation of beauty could lead the mind beyond its everyday limits. But Staël pushes this well beyond anything in the *Critique of Judgement* when she makes the tendentious claim that Kant had described two distinct kinds of beauty: 'one which relates to time and to this life, the other to the eternal and the infinite'.[7] This notion of two types or aspects of beauty, one transient and the other eternal, was, again, to make the strongest impact on subsequent French thought. Perhaps it owes something to Kant's distinction between dependent and free beauty, but by invoking the theological idea of eternity Staël drastically misrepresents Kant's aesthetics. Indeed, it is scarcely possible to theorize the beautiful as something that is *both* within human experience (a basic premise of the *Critique of Judgement*) *and* beyond it (as it would be if it gave access to what Kant called the 'supersensible' realm). The idea that the contemplation of the beautiful can lead to a transcendent realm derives from Plato's dialogue, the *Symposium*, frequently referenced in French art theory; but it is not compatible with Kant's philosophy.

Did Staël simply fail to understand the niceties of the Kantian text she was so eager to present to her innumerable readers? Or did she deliberately conflate Kantian philosophy with Platonic ideas that remained deeply embedded in French thought?[8] We cannot answer those questions definitively, but it is certain that the enormous influence of *De l'Allemagne* encouraged such a conflation. Indeed, that was the explicit aim of the leading French philosopher, Victor Cousin (1792–1867), whose lecture series of 1818 at the Sorbonne (in the University of Paris), *Du vrai, du beau et du bien* ('On the true, the beautiful, and the good') was received with wild enthusiasm among the student generation, and published in numerous editions from 1836 onwards. At least by the time of publication, Cousin had much more extensive learning in contemporary German philosophy than Staël; he was also personally acquainted with Hegel. Nonetheless, Cousin's interpretation remains close to the outlines sketched by Staël. He follows Staël, too, in combining this with idealist art theory. Indeed, his distinctive

contributions derive from his sophisticated knowledge of the dialogues of Plato, a complete translation of which he undertook in the 1820s. Cousin's synthesis of different philosophical traditions was deliberate; he christened his own philosophical method 'eclectic', and declared his aim to take the best from each theory.

Perhaps the most attractive feature of Cousin's theory is his emphasis on love. In a sense this is an attempt to correct Kant. For Cousin imagination and understanding are not enough, by themselves, to produce either a generous appreciation of the beautiful or powerful artistic creation; something more is needed, a love of the beautiful that enlivens both aesthetic experience and artmaking. Nonetheless Cousin's conclusion is consistent with Kant's emphasis on positive judgements of the beautiful, and he sets an inspiring agenda for the critic: 'To understand and demonstrate that a thing is not beautiful—mediocre pleasure, ungrateful task; but to discern a beautiful thing, to be penetrated with it, to put it in evidence, to make others share in the sentiment—exquisite delight [*jouissance*], generous task.'[9] Cousin uses the language of romantic, or even sexual, love to convey the power of aesthetic delight. However, he is careful to distinguish this from erotic desire. He therefore exaggerates the emphasis, in Kant and Staël, on distinguishing the beautiful from what is merely agreeable to the senses; in this respect, again, he is drawing on an antipathy to sensuous experience characteristic of idealist art theories. For Cousin, Rubens's women are too earthy to be found beautiful [**38**], and the 'love' of the beautiful must be rigorously separated from 'desire': 'If the Venus [compare **12**] or the St Cecilia [**39**] excite sensual desires in you', he cautions, 'you are not made to experience the beautiful'.[10]

Cousin, following Plato's *Symposium*, constructs an ascending scale

38 Peter Paul Rubens
The Judgement of Paris,
1638–9

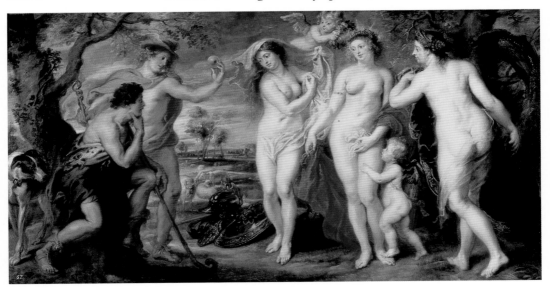

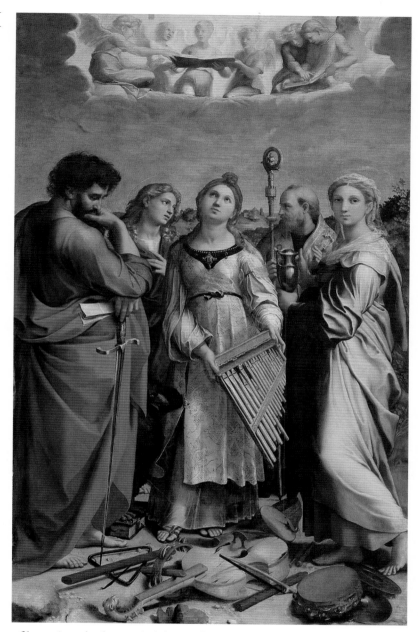

of beauties: the lowest is 'physical' beauty. Next come intellectual and moral beauty, which for Cousin are still kinds of 'real' beauty, available in this world. Among his examples are Winckelmann's description of the *Apollo Belvedere* (**11**; see pp. 27–31 above) and, tellingly, Plato's account of the death of Socrates, as painted by David [**40**]. Socrates is not physically beautiful—but behold him as he faces death, morally resolute, 'and his figure will appear sublime to you'. Nonetheless, even this sublime kind of 'real beauty' is still lower than 'ideal beauty', which

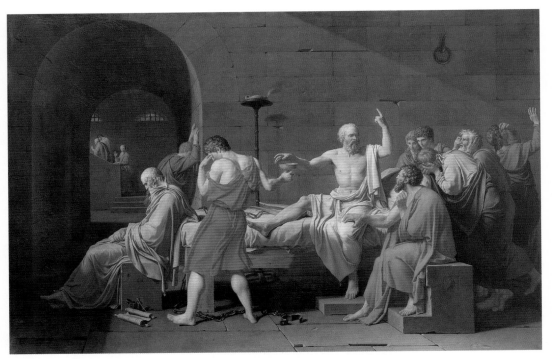

40 Jacques-Louis David
The Death of Socrates, 1787

aspires to the infinite. The wording is similar to Staël's distinction between transient and eternal types of beauty, but in Cousin the religious dimension becomes explicit: 'the true and absolute ideal is nothing other than God Himself'.[11]

Cousin, like Staël before him, is adept at fusing aspects of German aesthetics with idealist art theory. Thus he dwells at length on a standard aspect of idealist theory, the rejection of close imitation of nature (the artist should seek to improve upon nature, in an aspiration towards the ideal). Yet he weaves this into a larger pattern, reminiscent of Kant's careful distinctions between the beautiful and other human experiences. If the aim of art is not the imitation of nature, Cousin continues, neither is it to imitate human actions so as to inspire pity and terror beyond a certain measure: too realistic a depiction of a storm or a shipwreck will be simply unbearable to contemplate (perhaps Cousin is thinking of Théodore Géricault's hard-hitting depiction of a shipwreck, *The Raft of the Medusa*, **41**). This, again, is a fairly conventional point, but Cousin then proceeds to something much more daring: the aim of art should not be to serve religion or morality—art should not try 'to make us better and to elevate us to God'.[12]

This comes as something of a surprise, given Cousin's insistence, elsewhere, on an ascending scale of beauties that culminates finally in God. As often happens in Cousin's text, the 'eclectic' procedure draws incompatible material from two different philosophical systems. Thus Cousin's broadly Platonic theory of ideal beauty is somewhat at odds

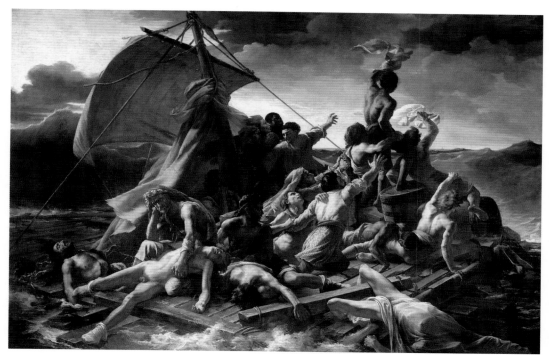

41 Théodore Géricault
The Raft of the Medusa,
1819

with this passage, which is drawn loosely from Kant's separation of the beautiful from the good, via Staël's insistence that art should not give lessons. Yet, despite the contradiction, Cousin lays considerable stress on the separation between art and either religion or morality, in a passage that made a striking impact on subsequent artists and writers: 'art is no more in the service of religion and morality than in the service of the agreeable and of the useful; art is not an instrument, it is its own end in itself. . . . There must be religion for religion's sake, morality for morality's sake, just as there must be art for art's sake [*l'art pour l'art*].'[13]

Why does Cousin insist so strongly on art's independence, not only from vulgar utilitarian interests, but from religion and morality (and, in the next paragraph, from politics as well)? Perhaps this was in part a protest against censorship and government control of the arts. Certainly Cousin's stance proved too liberal for the authorities, and he was dismissed from his post in 1820.[14] It is impossible to know how much this had to do with his aesthetic theory. Nonetheless Cousin's forthright assertion of art's independence, or autonomy, was the most exciting aspect of his theory for the new generation of artists and writers dubbed 'Romantics' in the 1820s and 30s; it was also the most persistently controversial.

Cousin also restates Staël's point that art will have social benefits only if it does not aim specifically at them. However, he sees this as characteristic of religion and morality too—that is, his philosophy is

concerned not just to argue for the autonomy of art but to promote more widely the notion of an intrinsic value for human activities, as against utilitarian or self-interested doctrines. Thus his agenda is like Staël's, and even more than Staël he wishes to place religion at the centre of his philosophical system. Art, Cousin writes, is itself a sort of religion.[15] Cousin sets up his system along Kantian lines, to distinguish the true, the beautiful, and the good as three separate areas of human endeavour. Yet he ends by collapsing them together again, to make all three ultimately culminate in God. To us, in a highly secularized twenty-first century, this may seem too easy a solution to a difficult philosophical problem. But in the nineteenth century Cousin's way of harmonizing philosophy with religion was highly attractive to many readers.

Cousin's position is distinctive. He asserts the independence of art and beauty uncompromisingly, and yet he remains a thoroughgoing idealist, altogether opposed to an art of sensuous pleasure and committed to an aspiration towards the 'infinite', explicitly identified both with a Christian God and with Plato's transcendent realm. Indeed, Cousin lent strong support to Antoine-Chrysostome Quatremère de Quincy (1755–1849), a major art theorist who has often been identified as the archetypal 'academic', due to his official position as Permanent Secretary of the Academy of Fine Arts (the section of the Institut de France that administered the visual arts). Quatremère's strong support for the *beau idéal* ('ideal beauty') in his theoretical writings has seemed, to many art historians, the inevitable counterpart of his powerful position in the French academic system, and with some justification. Both required submission to an authority: an aesthetic one, in the case of the *beau idéal*; an institutional one, in the case of the Academy. For precisely these reasons, Kant considered neither the ideal nor 'academic' methods of art education and artmaking to be compatible with genuinely free beauty.

But the French Academy did not have a unitary doctrine of the *beau idéal*, as Cousin showed when he reported a debate of 1807 between Quatremère and another eminent scholar, Toussaint-Bernard Émeric-David (1755–1839), on the question of how the Greeks had produced their art (and, by extension, how the modern world could produce an art equally great). Émeric-David argued for the close imitation of nature. Quatremère, however, insisted upon the *beau idéal*, which he defined much in the manner of Staël. Artistic greatness could not come through the imitation either of a single model from nature (which would inevitably display imperfections), nor even through the imitation of the best aspects of a number of models, for that would not result in a coherent or unified beauty. Rather, the ideal should transcend nature, and should derive above all from the genius of the artist.[16] This kind of theory, valuing the expression of the artist's genius over the imi-

tation of nature, is often associated with Romanticism, but Quatremère (to Cousin's approval) is able to support it using exclusively classical sources, Plato and Cicero.[17] Appropriately, Cousin adds a reference to a famous letter by Raphael, in which he too gives preference to the mental ideal over observation of the model: 'In order to paint a beauty I would have to see several beauties, but since there is a scarcity of beautiful women, I use a certain idea that comes to my mind'.[18]

Clearly, 'academic' art theory was not a monolith, but itself involved a range of debates about both art and beauty. Moreover, there is no 'pure' academic or idealist position in French art theory of the earlier nineteenth century: if, in the debate of 1807, Quatremère relied on classical texts, he was cognizant of Kant and German aesthetics by the time he came to write his major theoretical treatise of 1823, *Essay on the Nature, the End and the Means of Imitation in the Fine Arts*. On the other hand, there is no 'pure' Kantian or Romantic position in French writing of any kind; so powerful were the idealist and Platonic traditions in French thinking about art that they could not be simply forgotten or discarded by a new generation.

By the same token it is not possible to isolate 'conservative' from 'radical' positions on beauty. Many writers of the left felt powerfully the fascination of ideal beauty, which could symbolize a utopian future of social harmony as well as the authority of the established order.[19] On the other hand, Kantian ideas of artistic freedom and the originality of the artist-genius might be aligned with revolutionary calls for political liberty, with an artistic elite apart from society, or with capitalist competition in the art market.

The one constant is that beauty remained a key term for writers across the entire spectrum of political, moral, religious, and artistic opinion. Perhaps that is why beauty mattered so much, in a world where other concerns might seem more urgent. It could be argued that the aesthetic was important because it could not be mapped on to another set of concerns (political, moral, religious, or social) in any straightforward fashion. That is, debates on beauty may have offered a different set of terms in which the customary alignments no longer applied, and which could therefore produce genuinely new thinking.

Ingres and Delacroix

When we pass from art theory to art practice, however, the simplified polarities seem to reassert themselves, for nothing in this period of the history of art is so conspicuous as the archetypal opposition between two towering figures: Ingres, inheritor of the Classical legacy of his master David, and Eugène Delacroix (1798–1863), invariably described as the arch-Romantic. We can see the opposition, already, in the two artists' contributions of 1824 to the Salon, the major, state-sponsored

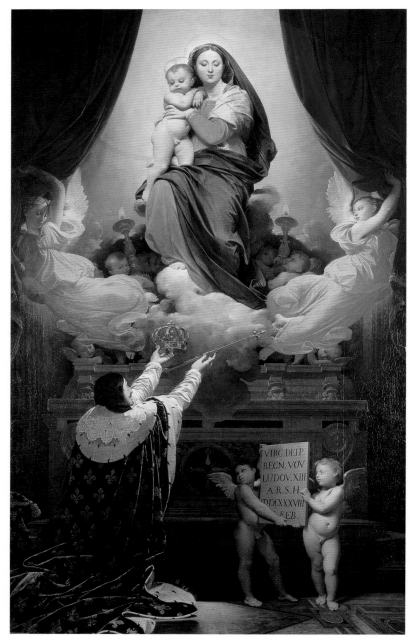

exhibition of nineteenth-century Paris. Ingres's *The Vow of Louis XIII* [**42**] is pious and patriotic: the seventeenth-century king reverently offers his crown and sceptre, symbols of his earthly power, to the Madonna and Child revealed in a heavenly vision. Delacroix's *Scenes from the Massacres of Chios* [**43**], on the other hand, is modern and activist: it shows an event of just two years earlier, the Turks' brutal suppression of a Greek uprising, and encourages sympathy for the Greeks,

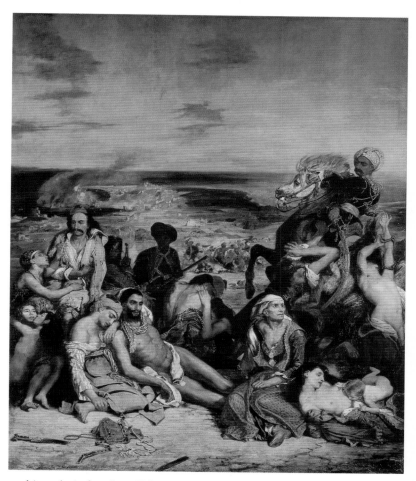

seeking their freedom.[20] In every aspect of pictorial style, too, the two pictures are starkly contrasted. Symmetry, simplicity, balance of complementary colours, and precision in drawing all contribute to the sense of hushed contemplation in the Ingres; complicated figure groupings, contorted poses, scattered accents of colour, and energetic brushwork convey the disarray and sheer horror of Delacroix's massacre.

Thus in both subject-matter and style the two pictures represent the battle between Classicism and Romanticism, at the heady moment of its emergence—'War has already been declared', wrote the critic Stendhal (pseudonym of Marie-Henri Beyle, 1783–1842, later most famous as a novelist). For Stendhal, David had been a genius, but his Classical followers were a mere school, without original inspiration. The way of the future was Romanticism—still a new term—since it 'represents the men of today and not the men of those remote, heroic times, which probably never existed anyway'.[21] This is an early example of a kind of criticism that would burgeon in the next decades, one that urged painters to take up the challenge of painting the life of the

present day. It is Delacroix's picture, of course, that fits Stendhal's definition of Romanticism. Ingres, on the other hand, is the pupil of David; if his subject is not literally classical, he makes his allegiance clear, nonetheless, by paying overt visual homage to Raphael's *Sistine Madonna* [14], and through it to the tradition inherited from classical antiquity.

We seem to be at a stalemate, locked into the perennial confrontation between art-historical binaries, Classical and Romantic, past and present, old and new. But we should not accept this conventional polarization: as we saw in Chapter 1, such habits of categorization are alien to the aesthetic as a distinctive mode of judgement. At the Salon of 1824, both paintings were freshly created aesthetic statements of exceptional ambition. If we can see each of them as a singular attempt to grapple with the question of beauty in modern art, perhaps we can break the deadlock.

Ingres's painting might be regarded simply as an exercise in nostalgia, an escapist flight into a past in which ideal beauty, religion, and patriotism were in harmony, a past which, in Stendhal's words, 'probably never existed anyway'. But the picture does not attempt to hide, or gloss over, the difference between transient 'reality' and transcendent eternity (the two aspects of beauty in Staël or Cousin). On the contrary, the picture forces us to recognize the difference between the two (here the artistic model is another Raphael, the *Transfiguration* of the Vatican [44], with its division between earthly and heavenly zones). The king inhabits the real-world register at the bottom, in a space we viewers encounter more or less at our own level. The light here is cool and matter-of-fact, and material objects are specific and detailed: the king's silk sleeves with their many creases, his intricate lace collar and the weighty folds of his gown, or even the chubby bodies of the little angels. Perhaps, indeed, those figures give us Ingres's interpretation of the two similarly chubby angels who lean on the bottom parapet of the *Sistine Madonna*; with their slightly bored expressions, like real babies, they mediate between our world and the heavenly one that might otherwise be no more than a fantasy.

In Ingres's picture, the king is the mediator; he is on his knees, facing in the same direction as us spectators, towards the celestial vision above. The eternal or transcendent region is bathed in a golden light and elevated far above us, so that the perspective of the stone altar seems abruptly to lift or jump at the level of the king's head. The heavenly vision is absolutely symmetrical and composed of perfectly balanced masses of complementary colour (blue and orange-gold). It is revealed by two flying angels who sweep back the curtains to offer us a spiritual experience. But what is it that we experience? Is it the Madonna of the Christian faith, and thus a religious icon? Is it a vision of beauty which would lead to transcendence, and which (according to

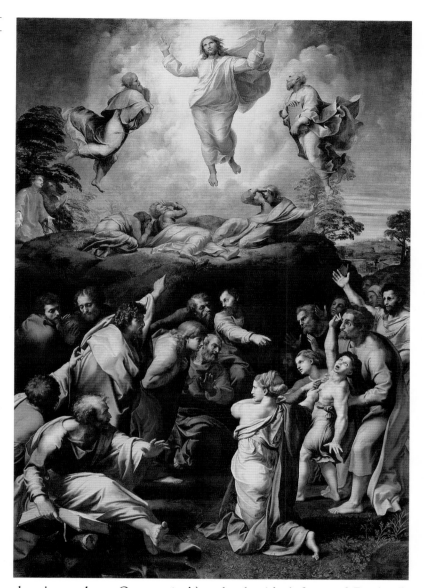

theories such as Quatremère's) only the ideal form of Raphael's Madonna is adequate to represent? Or is what we experience, literally, a painting by Raphael—something in the real world, after all? Or, finally, is it a modern copy of a painting by Raphael, by an artist highly skilled in the representation of the living model? The composition and perspective of the picture put the viewer into the position of worshipper; they force us to our knees, so to speak, behind the king. But in which cult are we asked to participate: that of the Madonna, that of Cousin's 'religion of art', or that of modern painting, in which we are struck with awe at the genius of a Raphael or of his modern avatar, Ingres?

Ingres's writings indicate that, for him, these were not necessarily

distinct alternatives: 'Study the beautiful only on your knees', he admonishes; 'Have religion for your art.'[22] Yet the *Vow of Louis XIII* does not even pretend to offer direct access to a transcendent realm; instead, it articulates the passage through successive degrees of idealization, from the present day of the spectator, through the historical register of the king, to the eternal realm of ideal beauty or of the Madonna herself. And yet this last conceptual leap, into the timeless, is referred back to the historical and material world not only through the overt reference to Raphael's picture, but also through the need to visualize the visible appearance of the Madonna. For Stendhal, the process of idealization remained incomplete: 'The Madonna is beautiful enough, but it is a *physical* kind of beauty, incompatible with the idea of divinity.'[23] It is the Romantic Stendhal, here, who is the idealist. Ingres, the heir to the classical tradition, has no expectation of somehow transcending the 'physical' beauty of well-drawn bodies and human facial expressions; thus his baby Jesus appears capable of wriggling and his heavy-lidded Madonna, perhaps, of eliciting the kind of sensual response to which Cousin objected so strenuously. On the one hand, the painting declares an unconditional commitment to ideal beauty that is at least equivalent to, and possibly indistinguishable from, religious faith. On the other hand, this is not an unconscious or unselfconscious act of faith; it is one that remains acutely aware both of its own history, through the very obviousness of the reference to Raphael, and of its own contingency, by accepting the need to put ideal beauty into the physical form of contemporary art.

Delacroix's *Scenes from the Massacres of Chios*, by contrast, might seem to have little to do with beauty. Indeed, Stendhal criticized Delacroix for making his figures too unattractive to move the spectator.[24] However, the panoply of figures can also be seen to experiment with a newly expanded, 'Romantic' conception of beauty that rejects the single ideal of the Raphaelesque model. Three years later, the leading Romantic writer Victor Hugo (1802–85) would develop such ideas in the preface to his play *Cromwell* (1827). In modernity, according to Hugo, the uniform beauty of antiquity—magnificent but monotonous—gives way to the variety of character and expression that Hugo terms 'grotesque'. Thus the gaunt and wrinkled older woman to the right of centre in Delacroix's picture, the woman next to her who has collapsed in death, her neck awry and her flesh already pallid, the merciless Turk on the rearing horse, the suffering and emaciated man stretched passively across the centre—all of these figures can be seen, not as 'beautiful' in the conventional sense of lovely or pleasing, but as aesthetically significant in the new sense of Hugo's grotesque.

Delacroix himself, writing of his work on the picture in his journal, emphasized the expressive power of the figures as a 'truer' beauty than the merely attractive:

O! the smile of the dying man! The look in the mother's eyes! Embraces of despair! Precious realm of painting! That silent power that speaks at first only to the eyes and then seizes and captivates every faculty of the soul! Here is your real spirit; here is your own true beauty, beautiful painting, so much insulted, so grievously misunderstood and delivered up to fools who exploit you. But there are still hearts ready to welcome you devoutly. . . .[25]

The passage hints at something akin to Kant's aesthetic ideas, which might be opened up in the viewer's mind through the contemplation of the work's beauty. Some years later, in 1850, Delacroix gives more precision to the notion: 'I have said to myself over and over again that painting, i.e. the material process which we call painting, is no more than the pretext, the bridge between the mind of the artist and that of the beholder.'[26] The echo of Kant's aesthetic ideas is probably not a coincidence, for the pages of his journal show that Delacroix was well versed in the contemporary literature on aesthetics. Yet in both passages there is perhaps a lingering vestige, too, of academic art theory, in the implied subordination of the merely sensuous or material aspect of painting to an immaterial idea. Later still, in 1853, Delacroix refines the notion, by proposing that painting is distinctive in the way it offers *both* sensuous and spiritual delight at once:

In painting you enjoy the actual representation of objects as though you were really seeing them and at the same time you are warmed and carried away by the meaning which these images contain for the mind. The figures and objects in the picture, which to one part of your intelligence seem to be the actual things themselves, are like a solid bridge to support your imagination as it probes the deep, mysterious emotions, of which these forms are, so to speak, the hieroglyph, but a hieroglyph far more eloquent than any cold representation, the mere equivalent of a printed symbol.[27]

For Delacroix this gives painting a distinctive advantage over verbal modes of artistic expression, which fail to offer enjoyment of the 'actual representation of objects'; the 'printed symbols' on the page are only means to an end, whereas painted forms are both means and themselves 'eloquent'. It is important to note that Delacroix does not take the further step of proposing that the painted forms are pleasurable *as painting*, as colour and brushwork, or as abstract patterns; this development would need to wait for the modernist art theories that we shall explore in Chapter 4. Instead, Delacroix is describing something like a pure pleasure in representation for its own sake, which coexists with the meanings that representation might arouse in the mind of the observer.

Thus when Delacroix contemplates *Study of Truncated Limbs* [45], by his friend Théodore Géricault, he finds it supremely beautiful despite the horror of the subject-matter. But he does not make the move a twentieth-century observer might make, to attribute its beauty to abstract form, to the compositional rhythm of the intertwining

45 Théodore Géricault

Study of Truncated Limbs,
*c.*1818–19

shapes or the play of light against deep shade. He sees a human foot, more accurately painted than the hand; crucially the foot is 'coloured by the artist's personal ideal', while the 'power of the style' lifts the hand to the level of the rest, even though it is not perfectly drawn.[28] Elsewhere he comments, apropos of the same work, that painting does not necessarily need specific subject-matter; it is the 'originality of the painter' and not the subject *per se* that matters.[29] It is, of course, possible to ascribe subject-matter to Géricault's painting, which is related to his work on *The Raft of the Medusa* [**41**]; in nineteenth-century France the depiction of severed limbs might call to mind thoughts of the guillotine or of violence in the streets. Yet Delacroix's comment suggests rightly that such associations are more in the nature of aesthetic ideas, generated in the free play of the viewer's mind, than of specific subject-matter. The dark background gives no indication of any context that might limit the viewer's speculations on these body parts, rendered anonymous and yet locked together in a configuration for which there is no obvious explanation; it is not even clear whether the assemblage has come about by chance, by neglect, or by some macabre design. But Delacroix's brief observations suggest something more: it is not just the compelling representation of what are immediately recognizable as a human foot and hand—'as though you were really seeing them'—nor even the wealth of aesthetic ideas they may stimulate that makes them beautiful. For Delacroix, their beauty is due above all to what might be called the artist's aesthetic personality, unique to Géricault—his 'personal ideal' or 'originality'. Evidently this 'personal ideal', not abstract beauty of form, makes this potentially revolting representation

'the best possible argument in favour of the Beautiful, as it should be understood.'[30]

Delacroix here uses the word 'ideal' in a very different sense from that of Kant, who associates it with a rule or standard and distinguishes it from free beauty. In Delacroix's two articles on beauty, published in the 1850s in the influential *Revue des Deux Mondes*, he repudiates the notion that there is one inviolable standard of beauty. He follows Victor Hugo in emphasizing the diversity of beauties found in different times and places, and German aesthetics in his insistence that the beautiful cannot be determined in advance, by standards or rules, but must be judged on its own merits in a direct encounter. But he shifts the emphasis from the perceiver of the beautiful, as in Kant, decisively towards the artist: 'We must see the beautiful where the artist has wished to place it'.[31] Perhaps that is only what we should expect from a practising artist, but the change is nonetheless crucial. It both reflects and promotes one of the developments that made nineteenth-century France such a powerful centre for artistic innovation: the increasing conviction that the beauty of art comes from the aesthetic personality of the individual artist, and not the things represented.

When Delacroix speaks of an 'ideal', then, he has in mind not the single or absolute ideal of some versions of academic art theory, but one instead that is infinitely variable—it has as many forms as there are artists, or at least artists with original vision. Indeed, Delacroix's increased emphasis on the role of the artist intensifies the importance of originality. Thus it is not surprising that he consistently denigrates the exact imitation of nature, or of the human model, as giving insufficient scope to the artist's individual vision: 'The model seems to draw all the interest to itself so that nothing of the painter remains'.[32] Yet this produces a paradoxical result, for it leads Delacroix to champion a new version of the 'ideal'. This ideal is individual to the artist. Nonetheless it retains the sense of higher spiritual value that is characteristic of idealist or academic theories:

It is therefore far more important for an artist to come near to the ideal which he carries in his mind, and which is characteristic of him, than to be content with recording, however strongly, any transitory ideal that nature may offer— and she does offer such aspects; but . . . the beautiful is created by the artist's imagination precisely because he follows the bent of his own genius.[33]

Delacroix's disdain for mere imitation is no less pronounced than that of Quatremère, and depends ultimately on the same Platonic notion of the inferiority of the material world to some higher ideal. Even the location of the ideal in the mind of the artist is not inconsistent with traditional art theory, for it recalls the famous letter by none other than Raphael himself, quoted on page 77, in which he too gives preference to the mental idea over the observation of the model.

Thus Delacroix, in his writings, is able to produce a synthesis of idealist art theory and German aesthetics, similar to that of Victor Cousin (a friend, in fact, of Delacroix's) but more explicitly adapted to the practice of the artist. Delacroix ends the second of his articles on the beautiful with a forthright declaration that it is the individuality of the artist that produces the beautiful, and makes the bridge between the artist's soul and that of the observer: 'can't one, without paradox, affirm that it is this singularity, this personality that enchants us in a great poet and in a great artist; that the new face of things revealed by him astonishes us as much as it charms us, and that it produces in our souls the sensation of the beautiful . . .?'[34] But is that all there is to it? Is Delacroix proposing to replace all the dignity and grandeur of the antique, of Raphael, and of the whole western tradition of artistic excellence, with nothing more than the uniqueness of the artist's personality? We are back to one of the basic problems addressed in the *Critique of Judgement*: if we are to reject an objective standard for the beautiful, how can we regard it as anything more than individual whim?

Delacroix takes this problem seriously. Noting that he finds an opera by Cimarosa more appealing than Mozart (whom he believes intellectually to be a greater composer), he wonders if this is just a personal preference, but immediately rejects the implications: 'to reason in such a way would be to destroy all standards of good taste and true beauty, it would mean that personal inclinations were the measure of beauty and taste'.[35] Thus Delacroix holds a position that is consistent, at least in broad outline, with Kant: he believes that each singular example of the beautiful must be judged on its own merits, and yet he remains convinced that there is nonetheless something universal about beauty. To support this position, he draws on the notion we have already seen in Staël and Cousin, of a double aspect of the beautiful:

I have not said, and no one would dare to say that [the beautiful] could vary in its essence, since it would no longer be the beautiful, it would only be caprice or fantasy; but its character can change: such-and-such an aspect of the beautiful, which has seduced a distant civilisation, doesn't astonish or please us as much as one which responds to our sentiments or, if you like, to our prejudices.[36]

Delacroix seems to have made creative use of some such conceptual schema, which permitted him to find the beautiful in novel or unlikely situations. In the drawings, letters, and journal entries made during his journey to North Africa [46], he emphasizes not only the exotic character of what he was seeing, but also its fundamental beauty, which he explicitly describes as akin to that of classical antiquity. One of the most notable features of his journal is the constant and dedicated observation both of nature and of art. Delacroix never takes beauty for granted. He returns again and again to examine critically even his favourite paintings by Rubens, admired countless times before. By the

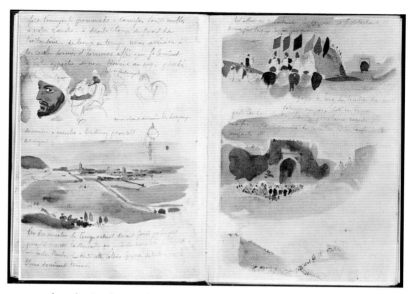

46 Eugène Delacroix
Arrival at Meknès, 1832

same token he is alert to beauty in the most unexpected encounters, as when he becomes fascinated by the sight of an anthill: 'Here are gentle slopes and projections overhanging miniature gorges, through which the inhabitants hurry to and fro, as intent upon their business as the minute population of some tiny country which one's imagination can enlarge in an instant.'[37]

But how is the artist to proceed? How can she be sure that the individuality of her work goes beyond mere caprice to attain the 'personal ideal'? Delacroix does not offer an explicit answer to this question, but he strove to develop working methods that could assist the process. Thus he emphasizes the role of the artist's memory in transforming an initial impression into a genuine expression of the 'personal ideal'. While he was in Algiers he made quick watercolour sketches of women [**47**]. It was not, however, until after his return that he worked up these sketches into what would become one of his most famous paintings,

47 Eugène Delacroix
*Two Seated Women, c.*1832

48 Eugène Delacroix
Women of Algiers, 1834

Women of Algiers [**48**]. Delacroix reproduces the poses of the two seated women, which must have struck him as having a special beauty, suppler than the poses usual among European women; he even retains the hookah and basket. But he is not content merely to reproduce his observations. Transforming the impression in his memory, he gives it a moody atmosphere, juxtaposing figures from different sketches in a sumptuously decorated interior, in which colours and patterns weave in the complex harmonies that are crucial to Delacroix's own 'personal ideal'. There is no anecdotal subject-matter. Moreover, the nuances of lighting add to the sense of mystery, leaving the face of the farther woman in shade and half-shadowing the face of the reclining woman; we cannot tell what the women are thinking. The critic Gautier singled out the work, however, for conveying the kind of meaning proper to painting, as opposed to anecdotal subject-matter:

An idea in painting has not the slightest relation to an idea in literature. A hand placed in a certain way, the fingers held apart or together in a certain style, a cast of folds, an inclination of the head, an attenuated or inflated contour, a marriage of colours, a coiffure of elegant strangeness, a piquant reflection, an unexpected light, a contrast of characters between different groups, form what we call an idea in painting. That is why the painting of the women of Algiers is full of idea. . . .[38]

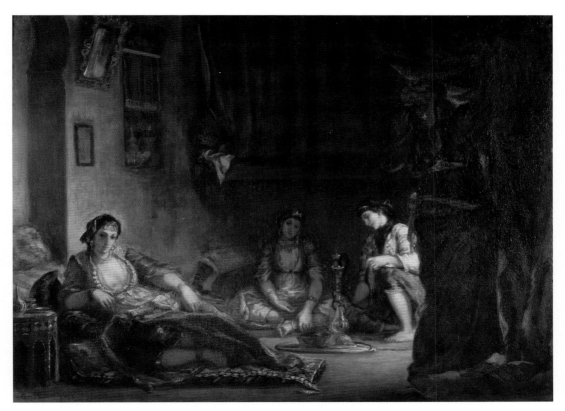

49 Eugène Delacroix
Women of Algiers, 1847–9

As in Delacroix's account of Géricault, the specially pictorial 'idea' here is not concerned with abstract form, nor anecdotal or literary subject-matter, but the powerful visual impact of represented objects.

In memory, the observed scene may also become fused with other memories, and perhaps that has happened here in the reminiscence of Rubens's compositions of voluptuous female figures (for example **38**); Delacroix was no less immersed in artistic tradition than Ingres. More-over, as he often did, Delacroix repeated the scene again on a later canvas [**49**]; filtered through another stage of remembrance, it becomes still moodier. Scenes of North Africa were a staple product of French nineteenth-century artists, and some art historians have taken them to task for presenting an Oriental fantasy-world, more imaginary than accurate. But this complaint would have made little sense to Delacroix. For him the scene reached its full potential for beauty only when it was thoroughly infused by the personal ideal of the artist.

Ingres, Gautier, and *l'art pour l'art*

If Delacroix proves to have had an abiding interest in the notion of the ideal, Ingres—surprisingly, given his reputation for academic ortho-doxy—was actually critical of it. Ingres's fragmentary writings on art,

compiled after his death by his biographer Henri Delaborde (1811–99), cannot be described as a theory, nor do they amount to the sustained exploration of aesthetic issues found in Delacroix's journal. Nonetheless, we should take seriously his critique of the traditional notion of the *beau idéal*.

Among the undated fragments that form the bulk of the compilation, Delaborde chose to begin with this statement of Ingres's artistic creed: 'There are not two arts, there is only one: that is the one that has as its foundation the beautiful, which is eternal and natural.'[39] Ingres was perhaps opposing the contemporary notion, which we have seen in Staël and Delacroix, that beauty had both transient and eternal aspects. But he seems principally to mean that there is no difference between imitating nature and emulating the great artists of the past. This rests on some such theory as Émeric-David's, which as we have seen held that the Greeks owed their excellence to the imitation of nature. Ingres's theory of imitation, then, is startlingly simple: since the Greeks imitated nature, it makes no difference whether we imitate the Greeks or nature itself. In either case we shall find the beautiful that is inherent in nature. There is no room here for a 'personal ideal'. Indeed, Ingres seems voluntarily to relinquish any claim to be an original genius in the modern sense.

It will be immediately obvious that this is at odds not only with Delacroix, but with theorists such as Quatremère, who resolutely opposed any form of close imitation. Ingres's portraits are wonders of attentiveness to material detail, for example in the way he captures the glistening tear-duct in the corner of an eye or the wisps of hair on a temple, in a male portrait such as that of *M. Marcotte* [50], or catches in a mirror the coiled and plaited bun fixed with a tortoiseshell comb, and enlivened by a red ribbon intricately folded, in *Vicomtesse Othenin d'Haussonville* [51]. Yet such characteristics are exactly what led Quatremère to be critical of portraiture as a genre. Portraits, Quatremère argued, are successful precisely insofar as they compellingly copy the model. Apart from the interest we may take in the person represented, and admiration for the artist's skill, portraits offer nothing further for the viewer's imagination to linger and expand upon—in short, portraits for Quatremère are liable to be deficient in aesthetic ideas.[40]

Yet Ingres was unswerving in his faith that there is no difference between the beauty of art and that of nature, so that the reverent imitation of nature is sufficient *by itself* to achieve the beautiful. Indeed, Ingres's writings show him to be a realist of the most uncompromising convictions:

It is in nature that one can find this beauty which constitutes the great object of painting; it is there that one must seek it, and nowhere else. It is just as impossible to form the idea of a beauty independent of, or a beauty superior to

that which nature offers, as it is to conceive a sixth sense. We are obliged to found all of our ideas, including that of Olympus and its divine inhabitants, on objects purely terrestrial.[41]

Ingres's wording is precise. He regards it as nonsensical to posit a sixth sense; that is, we have only the five ordinary senses, which perceive the material or 'terrestrial' world. Surprising as it may seem, this position is similar to that of Gustave Courbet (1819–77), the arch-Realist and enemy of Classicism. Both Ingres and Courbet were resolute materialists, insisting that they could paint only what was available, in nature, for sensory perception. As Courbet put it, in a letter of 1861 to a group of young artists who wished to work under him: 'I also hold that painting is a quite concrete art, and can consist of nothing but the representation of real, tangible things. It is a physical language, whose words

are visible objects. No abstract, invisible, intangible object can ever be material for a painting.'[42] Only the final point is inconsistent with Ingres's position. Unlike Courbet, who famously declared that he could not paint an angel because he had never seen one, Ingres was willing to permit terrestrial objects to stand in, as it were, for invisible ones. Thus for Ingres there is no essential difference between painting a portrait [**50**, **51**] and painting a Madonna [**42**] or the Greek gods [**52**]. In all of these cases the artist has no choice but to depend on observation of terrestrial objects available to the human sense of sight. In a way this leads Ingres to a stranger, more surreal art than Courbet's common-sense approach, since Ingres gives terrestrial bodies to his supernatural beings.

Ingres, as we have seen, considered the imitation of works of art no different from that of nature. In *Jupiter and Thetis* [**52**], Ingres represents the 'divine inhabitants' of Olympus. This is an imitation of the antique in a special way, for it is modelled on one of the most celebrated

works of ancient art, although one that is no longer extant: the chryselephantine (ivory and gold) sculpture of Jupiter made by Phidias (the greatest sculptor of ancient Greece) for the sanctuary at Olympia. Phidias had represented a seated Jupiter, at exactly the moment represented in Ingres's picture: he nods with his dark eyebrows, granting the request of the nymph Thetis to favour her son Achilles in the Trojan War.[43] Thus Ingres may have imagined his work as a kind of modern reincarnation of Phidias's lost Olympian Jupiter. But to re-create the ancient work, Ingres is obliged to give the god the physical body of a terrestrial human. The flesh is perhaps smoother and more flawless than any human model, but the figure nonetheless depicts a human male, down to precisely observed details such as nipples, knuckles, and toenails.

In his blunt insistence on imitating only what can be perceived by the five ordinary senses, Ingres pits himself as squarely as Courbet ever did against idealism. Indeed, he uses the example of Phidias to criticize the very term *beau idéal*—an inept expression, he says, because it implies there is an 'ideal' beauty that is other than, or above, nature. This Ingres categorically rejects; Phidias united all natural beauties in his statue of Olympian Jupiter, but all of them originate in nature alone.[44] Art historians have often associated Ingres with idealist art theories and with the bias of the French Academy towards such theories, but this is a drastic oversimplification. Proponents of the *beau idéal* such as Quatremère chose the same exemplars of ideal beauty in art as Ingres—the ancient sculptors and Raphael, on whom Quatremère published a study in 1824. But, as we have seen, it was no part of Quatremère's idealist theory to limit beauty to what could be experienced by the senses.

Fanatical in his devotion to the beauty of the classical tradition, Ingres nonetheless refused to locate that beauty in a transcendent realm, intellectual, moral, or spiritual. This position was potentially objectionable to moralists on both the right and the left—to proponents either of ideal beauty or of an art of social reform. In relation to both positions, Ingres's doctrine, as well as his art, could seem irresponsibly devoted to the world of the senses. Moreover, Ingres's painting did not preserve the demarcation, central to idealist art theory, between the beautiful and the erotic. Whereas idealist theories denigrated the erotic as merely physical, while elevating the beautiful as intellectual or spiritual, Ingres's non-idealist conception of the beautiful could make no such distinction [53]. The intense sensual engagement in Ingres's work is surely one reason for the extravagant admiration he inspired in the critic Gautier, notorious for his love of the pleasures of the senses. Gautier's response to the voluptuousness of Ingres's painting animates his writing on the artist, down to details such as his description of the toes of the *Grande Odalisque* [54], which, 'seen, from underneath, softly

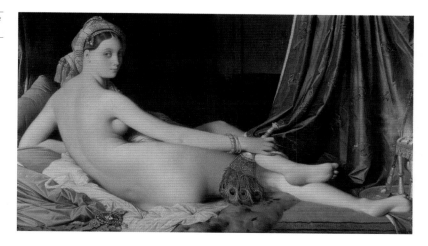

bend back, fresh and white like camellia buds, and seem modelled on some ivory by Phidias rediscovered by a miracle . . .'.[45]

Throughout his criticism, Gautier was flagrantly guilty of the error Cousin had warned against, of responding to art with erotic desire. Yet it would be wrong to dismiss this as a personal foible, for it is integral to what made Ingres an exemplary artist for Gautier. Gautier was the Romantic critic *par excellence* [55]; the catholicity of his taste, in his forty-year career as an art critic, is the practical expression of the calls of both Hugo and Delacroix for a multiplicity of beauties. Gautier's

most extended discussion of Ingres occurs in a review of the artist's retrospective display at the Exposition Universelle (Universal Exhibition, or World's Fair), held in Paris in 1855, and its portentous tones might be attributed to the importance of the event (Delacroix was also given a large retrospective). But Gautier is in earnest: for this passionate Romantic, the art of Ingres, the Classicist, represents a summit of artistic achievement. Moreover, Gautier does not shrink from invoking the full authority of the classical tradition, in high-flown language that stops just short of pomposity:

Alone, he now represents the high traditions of history, of the ideal and of style; for that reason, he has been reproached for not inspiring himself with the modern spirit, for not seeing what goes on around him, for not being of his time, in short. Never was an accusation more just. No, he is not of his time, but he is eternal.[46]

In this passage Gautier sounds like the most entrenched defender of the values of the Academy and the western tradition. And yet there is a crucial difference: throughout Gautier's laudatory account of Ingres there is not the slightest tinge of moralism, no suggestion that Ingres's works will edify or elevate the soul of the observer beyond the terrestrial beauty accessible to the senses. Thus Ingres's imperviousness to

the world around him is not, for Gautier, escapist but a refusal to be distracted by non-artistic matters, and thus a guarantee of his aesthetic integrity. This is startlingly different from earlier criticism of works in the elevated classical tradition. Critical responses to the work of Ingres's own teacher, David, rarely failed to stress its politically, socially, or morally elevating aspects (as we have seen in Cousin's praise of David's *Socrates*, **40**).

Thus in Gautier's writing Ingres's art becomes the ultimate example of art's autonomy, as it had been theorized with progressive clarity from hints in Kant, through Staël's repudiation of the 'useful', to Cousin's insistence that art should have an intrinsic value equivalent to that of religion or morality. Indeed it may have been the passage from Cousin's lecture series of 1818, quoted on page 75, that coined the motto under which this art theory became notorious: *l'art pour l'art*.[47] In his writing on Ingres Gautier perhaps adapts Cousin's notion of art as a kind of religion in itself: 'Closed voluntarily in the depths of the sanctuary . . . the author of . . . the *Vow of Louis XIII* has lived in the ecstatic contemplation of the beautiful, on his knees before Phidias and Raphael, his gods; pure, austere, fervent, meditative, and producing in freedom works testifying to his faith.'[48] Such language has often been seen to promote some kind of transcendent value for art, elevating it above real-world political and social issues. Yet the passage can also be read as recommending a very modern replacement of the spiritual claims of traditional religion with the material and sensuous immediacy of art in the here-and-now. This can also help to explain the important role implicitly accorded to the erotic in Gautier's writing: the vocabularies of both religion and eroticism are used to indicate the exceptional power of the sensuous experience of beauty.

In 1847, Gautier contributed an article to the *Revue des Deux Mondes*, which presents the fullest explication of his theory: '*L'art pour l'art* signifies, for its adherents, a work disengaged from all other preoccupation than that of the beautiful in itself'. Gautier takes Kant to task for failing to give sufficient emphasis to sensuous experience. Acknowledging that it is a 'noble and grand idea' to make beauty a matter of the human mind, as Kant did, he wonders whether this does not 'suppress too decidedly the material world'. Moreover, he supports this with an argument similar to Ingres's: the artist, he writes, has no 'alphabet' of forms except that of the visible world, so the beautiful cannot be purely subjective.[49] In fact Kant had strongly emphasized that the aesthetic response, although it occurs in the mind, could only come about through sensory experience. For Kant, as for Gautier and Ingres, human beings have only the five terrestrial senses and cannot have access to a supersensible realm; it was, as we have seen, in the interpretations of Staël and Cousin that the experience of the beautiful acquired intimations of transcendence. It seems likely that Gautier

had read Cousin's account of Kant, and not the *Critique of Judgement* itself.[50]

It was of course Cousin, not Kant, who specifically objected to the erotic in art, something that is often found in academic art theory. It is true that Kant himself might have seen the erotic as a form of the agreeable, since it may crave satisfaction in the real world, rather than of the beautiful. On the other hand, it can be argued that the erotic in art is different from sexual pleasure in real life precisely because it does not offer real-world satisfaction; instead it can be seen to extend the range of aesthetic ideas. In either case Gautier is right to raise the issue: the erotic is a test case for both idealist art theory and Kantian aesthetics.

It is in Gautier's criticism, rather than his theoretical writing, that he develops his ideas of how the erotic may be involved in aesthetic experience. Gautier finds the sensuality of the *Bather of Valpinçon* [56] suffused throughout the picture, and not limited to the nude body: the white and red turban 'twists itself with coquetterie around the head', the linens 'give value by their beautiful mat tones to the firm and superb flesh of the bather'. It is as if his erotic engagement stimulates the intensity and closeness of his observation. Moreover, Gautier never describes the figure as if it were a 'real' woman. He sees in it countless other works of art—the palette of Titian, the draperies on which there might lie a sculptured Venus or a courtesan from Venetian painting, 'a fragment of a Greek statue burnished with the tawny tones of Giorgione [the Venetian painter, 1476/8–1510].'[51] Gautier does not, then, respond as one would to pornography; as if in defiance of Cousin, he expresses a 'love of the beautiful' that is strong enough to be described as erotic.

At the same time it should be stressed that this is not a 'formalist' response. In his article on the beautiful, Gautier poured scorn on the formalist position that would divorce abstract form from the idea it embodies. As we have seen, he made a related point about Delacroix's *Women of Algiers*: the visible or sensuous forms of the picture are both fully representational and imbued with their own kind of meaning. Thus Gautier, despite his emphasis on immediate sensuous experience, carefully distinguished his position from formalism: '*L'art pour l'art* means not form for form's sake, but rather form for the sake of the beautiful, apart from any extraneous idea, from any detour to the profit of some doctrine or other, from any direct utility'.[52]

Gautier does not, however, use the phrase *l'art pour l'art* when writing about Ingres in 1855 and for good reasons: the motto had been controversial from the moment it was introduced, not only because of the misinterpretation that it was tantamount to 'form for form's sake', but principally because of the correct interpretation, that it meant a complete divorce between art and morality. For its proponents in the 1830s, when the motto became current in criticism, the dissociation of

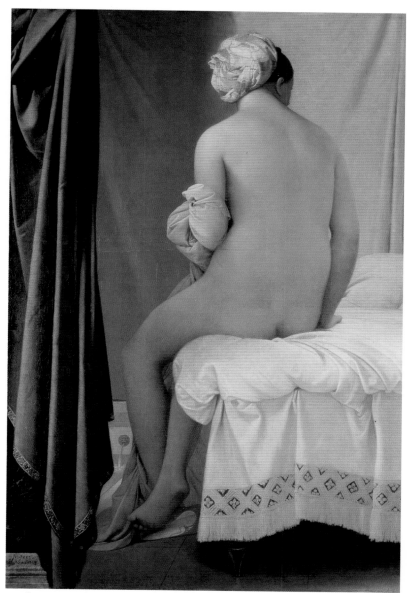

56 Jean-Auguste-Dominique Ingres
Bather of Valpinçon, 1808

art from morality meant art's independence both from academic doctrines that required art to demonstrate a lofty moral, and from the prudish and petty moralism of bourgeois critics (for whom, unsurprisingly, Gautier's poetry and novels were a particular target). Indeed *l'art pour l'art* was often seen as a repudiation of the increasing commercialism of the markets for literature and art from the 1830s onwards, a refusal of complicity with the profit-making ethos of bourgeois society.[53] But from the start it could also be seen as an irresponsible evasion of social or humanitarian aims for art. As the critic Gustave Planche (1808–57) put it as early as 1835, 'We are called upon to choose

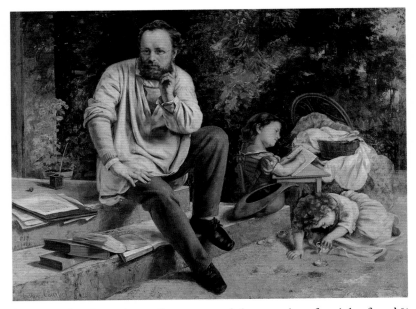

between the champions of pure art and the apostles of social reform'.[54]
In 1855 Courbet, angered by the rejection of some of his work from the
official Exposition Universelle, held his own private exhibition for
which he provided a manifesto statement promoting the notion of
'realism' and disdainfully repudiating the 'pointless objective' of *l'art
pour l'art*.[55] In the 1860s, the social theorist and friend of Courbet,
Pierre-Joseph Proudhon (1809–65, **57**), wrote perhaps the most swinge-
ing attack of the period on *l'art pour l'art*. Proudhon explicitly opposed
the claim, derived from Kant (and implicit in Cousin's title, 'On the
true, the beautiful and the good'), that there were three areas of human
endeavour: for Proudhon there were only two, the moral values of
conscience or justice on the one hand, and the logical values of science
or truth on the other. Thus there can be no role for art other than
servitude to one or the other (or both).[56] Proudhon's position was a
committed one, but it is also reductive. His binary conception of the
human mind leaves no room either for the delights of the senses or for
the innovatory potential of the imagination.

Thus the battle lines were drawn anew in the years around the
middle of the century—no longer between Classicism and Romanti-
cism, but between the proponents of a pure art, directed to no
end beyond itself, and the advocates of a humanitarian art directed
towards the goal of social improvement. Moreover, the concentration
of humanitarian critics on current social and political issues over-
whelmingly privileged the representation of modern life over subjects
from the past, and 'Realism' over either Romanticism or Classicism.
Once again we seem to have a clearcut polarity. On the one side are
proponents of a socially and politically progressive art, devoted to the

representation of modern life and strongly associated with realism, including if necessary the depiction of the ugly. On the other are the supporters of *l'art pour l'art*, deliberately divorced from the promotion of ideological ends of any kind, and devoted exclusively to the beautiful. If Ingres was, for Gautier, the ultimate example of *l'art pour l'art*, Courbet was the artist most frequently invoked by proponents of a social art. A painting such as Courbet's *A Burial at Ornans* [**58**], with its unglamorized figures from provincial life, sharply divided critics who praised it for its contemporaneity from those who expressed horror at its apparent indifference to beauty.

Most twentieth-century art historians followed the agenda of nineteenth-century humanitarian critics, to give overwhelming priority to works that directly engage with modern life, from Courbet and Édouard Manet (1832–83, **61**) to the Impressionists [**63**]. This is a moralizing position: we may reasonably ask why we should forgo the sensuous and erotic delights of Gautier's exceptionally catholic tastes. Moreover, we should not forget the radical potential of *l'art pour l'art*. In an essay of 1859 on Gautier's creative writing, the poet and critic Charles Baudelaire poured scorn on what he described as the 'heresies' of confusing art with morality or scientific truth. Beauty, for the poet of *Les Fleurs du mal* ('Flowers of Evil', published in 1857, dedicated to Gautier, and prosecuted for immorality), may be strange, grotesque, sinister, or macabre. But it cannot be reduced to subservience, whether to noble philanthropism or to petty bourgeois morality, to radical or repressive politics, without losing all its integrity and power. As we shall see in the next section, Baudelaire's thinking was too complex to be aligned neatly with any contemporary aesthetic faction. Nonetheless, he had no hesitation in applauding what he described as Gautier's *idée fixe*: 'the generative condition of works of art, that is to say the exclusive love of the Beautiful'.[57]

58 Gustave Courbet
A Burial at Ornans, 1850

Baudelaire and modern beauty

The most famous text to advocate subject-matter from contemporary life is Baudelaire's essay of 1863, 'The Painter of Modern Life'. But here the simple polarities break down abruptly. Baudelaire [**59**] hated realism, on much the same grounds we have already seen in Cousin, Quatremère, and Delacroix: a conviction that art should do something more imaginative than servile imitation of nature.[58] He ridiculed doctrines of progress as irrelevant to art.[59] Baudelaire's essay marks a crucial development because it offers a justification for modern-life subject-matter that is no longer tied to a moralizing agenda. Instead the key term is 'beauty'; the word occurs no fewer than 21 times in the first section of Baudelaire's essay, in which he declares his wish 'to establish a rational and historical theory of beauty, in contrast to the academic theory of an unique and absolute beauty'. To do so he presents a new version of the double aspect of beauty, which we have seen countless times since Staël:

Beauty is made up of an eternal, invariable element, whose quantity it is excessively difficult to determine, and of a relative, circumstantial element, which will be, if you like, whether severally or all at once, the age, its fashions, its morals, its emotions. . . . I defy anyone to point to a single scrap of beauty which does not contain these two elements.[60]

This declaration has sometimes been criticized, and more often ignored, by historians and critics principally interested in one side of the dichotomy, Baudelaire's championing of modern-life subject-matter, which seems specially relevant in the art world that would soon produce the Impressionists. But Baudelaire, like Delacroix, takes seriously the problem of how the artist is to create a work that is not only relative—of its time, or individual to the artist—but also 'beautiful' in some more universal sense. This can be seen to go back to the basic Kantian characterization of aesthetic experience as both subjective and universal. But Baudelaire brings into sharper focus a crucial aspect of that problem, its temporal dimension: the subjective aesthetic experience, based on a direct and singular encounter with an object, necessarily occurs in the present, the modernity of the beholder. But if that is so, how can that experience be anything more than a passing fancy? To put it from our own perspective, why should we take any interest in old French pictures that represent the life of their day, when they are no longer 'modern' for us, or relevant to our own social and humanitarian concerns?

At the end of the first section, Baudelaire declares that he is finished with 'abstract thought' and will now move on to 'the positive and concrete part of my subject'; for the rest of the essay he explores the drawings of an artist he names only as 'Monsieur C.G.' but who is readily identifiable as the illustrator Constantin Guys (1805–92).[61] But Baudelaire never loses sight of his initial theoretical proposition. Throughout the essay he maintains an almost magical balance between the 'relative, circumstantial element' and the 'eternal, invariable element' of beauty. The choice of Guys, rather than a major painter such as Courbet or Manet (whose paintings of modern life were just beginning to appear, **61**), seems to bias the agenda in favour of the 'relative, circumstantial element'. Guys's drawings were made to reflect the passing interests of the moment; many of them, drawn for the *Illustrated London News* as a form of pictorial reportage, were literally ephemeral. But if Baudelaire can show that these throw-away drawings of fleeting episodes demonstrate both aspects of beauty—the eternal as well as the transient—he can not only provide a justification for the portrayal of modern life in art, he can potentially elucidate the significance of the modern in aesthetic experience generally.

In a drawing such as *Standing Soldiers* [**60**] we see a scene that was modern for Baudelaire but is old-fashioned for us: groups of soldiers sketched in just enough detail to indicate their nineteenth-century costumes and the distinctive comportment encouraged in the military training of the time. The stiff, upright postures, the confident stances, the haughty carriage of the heads indicate men who are aware of the dignity of their profession; we can even surmise that the group of soldiers in the right foreground, elegantly slender and proud in bearing, are higher in rank than the stockier guard on the left.[62] But even though

we may find the subject-matter (from our point of view) antiquated, the drawing technique gives a strong sense of the immediacy of the artist's observation. Thus the subject is 'modern' in a different sense: the rapid strokes of the pen seem to capture a moment in the present day of the artist. The sketchy legs of the background horse, for instance, suggest that it is moving, and in another second will not look the same. The informality of the composition assists this; we seem to catch a sidelong glimpse of something happening before our very eyes, not composed in advance. Thus we connect our visual experience of the drawing, which we see in our own present day, with the visual experience of the artist who saw the scene in *his* present day. Moreover, the summary character of the execution makes it possible for us to grasp all of this virtually in an instant; this again feels modern in that it happens immediately.

All of this is obvious, but it is nonetheless quite a complex way of conveying a sense of modernity. As Baudelaire shows, it depends on two distinct stages of visual experience: Guys's, when he saw the scene; and ours, when we see the drawing. We understand both of these to be 'modern', although in slightly different ways: the one was modern when the drawing was made, the other is in our own modernity. But if we connect those two modernities fairly effortlessly, Baudelaire points out the contradiction: we can have this powerful experience of 'modernity' only because the first 'modern' moment, that of Guys, has passed into the duration of art—probably not literally an 'eternal' one (given the fragility of drawings on paper), but long enough, anyway, to allow us to recapture it. That means that what we are experiencing as modern is also lasting, and cannot logically be otherwise, or we could not see it. But Baudelaire goes a step further to point out that the same must also be true even of Guys's original impression. He describes Guys working

in a frenzy of inspiration to reduce the time lag to a minimum: 'skirmishing with his pencil, his pen, his brush, splashing his glass of water up to the ceiling, wiping his pen on his shirt, in a ferment of violent activity, as though afraid that the image might escape him'. But already it is an 'image' in his mind, a step removed from the raw experience of the scene. When it is 'reborn upon his paper' it is removed another step: 'The phantasmagoria has been distilled from nature. All the raw materials with which the memory has loaded itself are put in order, ranged and harmonized, and undergo that forced idealization which is the result of a childlike perceptiveness. . . .'[63] The words 'memory' and 'idealization' immediately remind us of Delacroix. Baudelaire has succeeded, then, in showing how Guys's ephemeral sketches partake after all of the eternal element of beauty. More than that, he has also proved his first point: that the transient element—the powerful modernity of the drawing—is inconceivable without the eternal one. And that goes not only for the drawing itself; it is true, too, of Guys's original aesthetic experience of the scene, and of our experience of the drawing.

Indeed, Baudelaire gives this special emphasis, for he insists (despite some evidence to the contrary) that Guys did not make his drawings while he was actually looking at the scene, but instead used a two-stage process: first, drinking in visual experience as intensively as possible, to imprint it on his memory; then, drawing on the memory later to transform it into the drawing. We have seen Delacroix employing some such method in the production of a complex oil painting [**48**]. The example of Guys's drawings gives Baudelaire a kind of limit case, in which our experience of the represented scene is both as direct as we can feasibly imagine, and yet already mediated *twice* through the 'eternal' aspect of beauty. The example of Guys also tests the limits of the problem Kant had raised about the intentionality of the artist. Guys's working method, as Baudelaire describes it, comes as close as possible to unpremeditated production: it is 'as unconscious and spontaneous as is digestion for a healthy man after dinner'. Yet every time Baudelaire suggests the pure immediacy—or modernity—of the process, he qualifies the notion.[64] So spontaneous is the process that no step in the making of the drawing can be seen as a mere stage on the way towards some more final resolution of the drawing—that would imply that there was a plan or goal towards which the artist was aiming. Therefore, each set of marks, the initial pencil notation, the washes added next, the firm contours drawn later, is an end in itself: 'at no matter what stage in its execution, each drawing has a sufficiently "finished" look; call it a "study" if you will, but you will have to admit that it is a perfect study'.[65] Thus not only the final drawing, but the drawing in progress, with every addition of a mark, is both utterly transient (modern) and utterly finished (eternal).

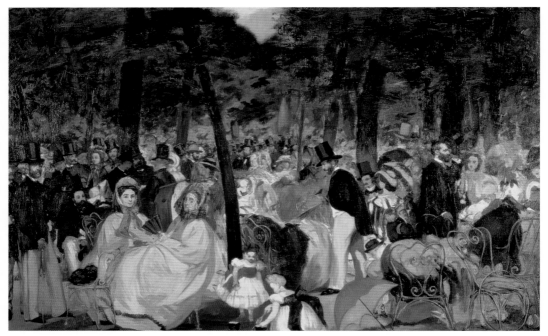

61 Édouard Manet

Music in the Tuileries, 1862

Baudelaire has done much more, then, than merely demonstrating the aesthetic validity of modern-life subject-matter; he has also shown that modernity is the essential condition of any aesthetic experience (or any act of artmaking; the two are as closely linked in his account of Guys as in Kant's discussion of genius). At the same time, he has shown that the eternal element—a form of antiquity—is inseparable from the modern or transient one. Modernity and beauty, beauty and antiquity, antiquity and modernity are locked together in this analysis.

But does this mean that Baudelaire is giving special status to procedures like that of Guys, which reduce to a minimum the gaps in time between aesthetic experience and its imaging, successively, in the mind of the artist, then on the paper, and finally in the mind of the spectator? That could explain what has puzzled many historians, Baudelaire's choice of Guys rather than a major artist of his day such as Manet. Manet's painting *Music in the Tuileries* [**61**] shares many characteristics with Guys's drawing: it presents a modern-life scene that seems glimpsed in a moment, rather than carefully composed, so that we cannot even make much sense of what is going on, and the execution is so rapid that some areas seem unfinished, such as the indeterminate grey scumble in the very centre, seemingly placed provocatively in just the position we would expect to be a focus for the work's meaning. But Manet's use of oil paint would inevitably require more planning and premeditation, and the experience of his more complex paint surfaces requires more time on the observer's part, too.

However, the difference would only be a relative one, for as we have

seen the Guys also involves temporal gaps at each stage; the timescales may expand or contract, but the processes of aesthetic experience and artmaking alike require the pure moment of modernity to be constantly shifting into the long duration of antiquity. Thus we might extend the argument, to observe that there is only a relative difference, too, between images with modern-life subject-matter, such as Guys's and Manet's, and subjects from the past, from history, literature, or mythology. Such a painting as *Scene from Tannhäuser* [62], by Henri Fantin-Latour (1836–1904), has a subject from the past of medieval legend; but it is also from the aesthetic present of the opera *Tannhäuser*, by the modern composer Richard Wagner (1813–83), produced in Paris just before the painting was made. Thus Fantin's painting is the remembered image of the aesthetic impression of the opera. It also has an element of the transient in the spontaneity of its execution, as sketchy as Manet's *Music in the Tuileries*, and seemingly captured in an instant, as the central figures whirl in their dance. The three works we have examined imply different lapses in time, from the notional time of the subject-matter, to the artist's experience of the subject, then to the making of the work, and finally to the spectator's experience; but all of them have both a transient and an eternal element, a modern and an antique component to their beauty.

In a sense this resolves the Kantian problem of how beauty can be both subjective (or modern) and universal (or eternal). But in another sense it leaves us with the old dilemma: if *all* aesthetic experiences, or acts of artmaking, can be given both dimensions, then how can we make any distinctions? Baudelaire took to task artists who neglected the 'modern' component of beauty by imitating the old masters too

62 Henri Fantin-Latour
Scene from Tannhäuser, 1864

slavishly. He also criticized painters who did not distil their raw material sufficiently, through imagination and memory: 'for any "modernity" to be worthy of one day taking its place as "antiquity", it is necessary for the mysterious beauty which human life accidentally puts into it to be distilled from it'.[66] Thus he found fault with Ingres, for the first reason, and with Realists such as Courbet for the second. But his theory of the beautiful is more powerful than his particular judgements. With hindsight a painting such as Ingres's *Vicomtesse d'Haussonville* [51] appears impressively to satisfy Baudelaire's description of the beauty of woman, inseparable from her modern costume;[67] while a painting such as Courbet's *A Burial at Ornans* [58] gives compelling visual expression to the 'heroism' of modern male clothing: 'Note . . . that the dress-coat and the frock-coat not only possess their political beauty, which is an expression of universal equality, but also their poetic

63 Claude Monet

Boulevard des Capucines, 1873–4

beauty, which is an expression of the public soul—an immense cortège of undertaker's mutes. . . .'[68] In his way Baudelaire produced the most powerful of the period's many reconciliations between Kantian subjectivism and traditional idealism. To make the black coat of bourgeois male attire seem both quintessentially 'modern' and also redolent with the deeper meaning traditionally associated with ideal beauty was a superb rhetorical feat. But there was no way to turn back the clock: Kant had demolished the authority of rules, hierarchies, or standards for aesthetic judgement, and it would be difficult indeed to argue that the diversity and experimentalism of French nineteenth-century painting would have been possible without this aesthetic revolution [63]. As Delacroix observed, 'the last word is never said' about beauty. Ingres and Courbet, Géricault and Flandrin, Guys and Fantin will remain 'modern' as long as we believe in the Kantian possibility that subjective estimates of beauty are for all of us (universally) to make and communicate.

Victorian England: Ruskin, Swinburne, Pater

3

In 1854 the art critic and theorist John Ruskin (1819–1900) wrote to the editor of *The Times* in defence of a painting, on view at the Royal Academy in London, which he thought had been misunderstood: *The Awakening Conscience* [**64**] by William Holman Hunt (1827–1910), one of the seven members of the Pre-Raphaelite Brotherhood. Ruskin acknowledged the overwhelming visual complexity of the picture, but showed his readers how a close observation of its multitudinous details could yield meaning. He reformulated the visual evidence into a sequential narrative: 'The poor girl has been sitting singing with her seducer; some chance words of the song, "Oft in the stilly night," have struck upon the numbed places of her heart; she has started up in agony; he, not seeing her face, goes on singing, striking the keys carelessly with his gloved hand.' For Ruskin this story, together with its moral implications, is unequivocally more important than the beauty of the work; indeed, he finds the woman's face more moving because it is 'rent from its beauty into sudden horror'. The interior setting is 'common, modern, vulgar', but its very ugliness reinforces the message of the narrative. It shows that this is not a family home, but a place decorated too gaudily, where a man keeps his mistress: 'That furniture so carefully painted, even to the last vein of the rosewood—is there nothing to be learnt from that terrible lustre of it, from its fatal newness; nothing there that has the old thoughts of home upon it, or that is ever to become a part of home?' Every object in the room is tainted by belonging to this illicit ménage, and its physical ugliness is an index of its moral badness: the expensive embossed books on the table are brand-new, unread, therefore 'vain and useless', and the neglected cat is dismembering a bird on the carpet. Ruskin even denies us visual pleasure in a lovely detail: 'nay, the very hem of the poor girl's dress, at which the painter has laboured so closely, thread by thread, has story in it, if we think how soon its pure whiteness may be soiled with dust and rain, her outcast feet failing in the street'. This extends the narrative into the future, predicting the woman's ruin, which for Ruskin is an inevitable consequence of her sinfulness. Moreover, the same logic of inexorable cause and effect applies to the painting itself: the scrupulous honesty with which the painter has represented his

Detail of 64

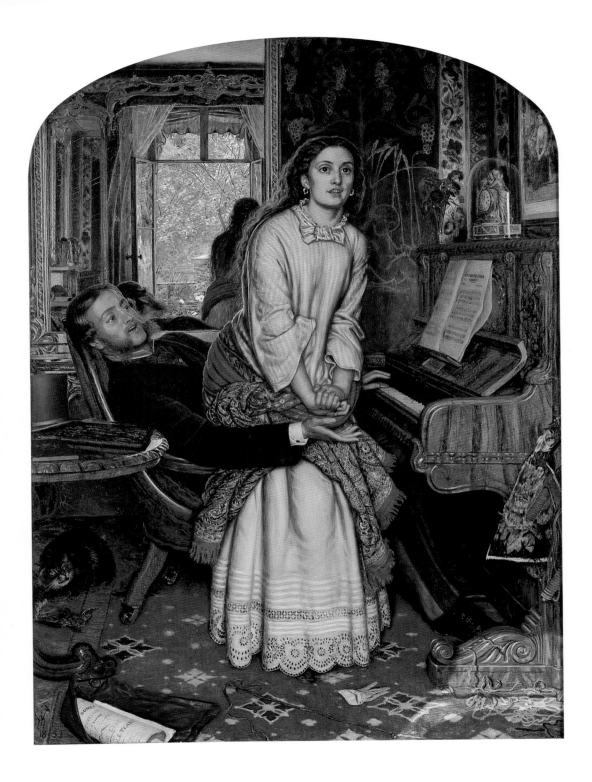

subject, down to the very threads of the hem, will guarantee its effectiveness in delivering its message. 'Examine the whole range of the walls of the Academy', Ruskin concludes: 'there will not be found one [picture] powerful as this to meet full in the front the moral evil of the age in which it is painted'.[1]

Ruskin presents *The Awakening Conscience* as just the kind of painting that French proponents of a social art were demanding at the same moment: a modern-life subject, relentlessly honest in its portrayal of ungainly furniture and ugly costumes, and aimed at social reform in the real world. Moreover, this is not, for Ruskin, simply to do with subject-matter. Ruskin shows clearly how the minutiae of the picture's execution are integral not only to the 'realism' of its representation of the external world, but equally to its effectiveness in delivering its messages. A detail such as the hem not only records observed fact with scrupulous exactitude, but also elaborates the pictorial narrative and its social implications; at the same time it serves as a sign of the painter's integrity. Thus the critical account fulfils one of Ruskin's most cherished aims: to prove that visual art is no mere entertainment or pastime, but instead is thoroughly integrated with the most urgent social, moral, and political issues of the modern world. For Ruskin it is vital that everything about the picture should be interconnected, that the tiniest visual detail (such as the hem) should signify the greatest moral truth (the inevitability of retribution for sin). In the process, he taught his readers in Victorian England—and can still teach us—to see much more in pictures than we should have thought possible, to look as industriously as Hunt painted.

Yet Ruskin's analysis leaves little room for the free play of the spectator's imagination; it is locked into a moral system that exists prior to, and independently of, the picture itself, one in which sexual immorality entails doom as certainly as the sincerity of the painter's labour guarantees the picture's worth. For all the closeness of his observation, Ruskin is unable to see clues to different stories: the brilliant sunlight of the garden towards which the woman raises her eyes, and which we see reflected in the background mirror, could be taken to prophesy the woman's moral redemption or her emancipation from her seducer. Hunt had elaborated the visual signs in his picture as comprehensively as his medium would permit, and yet they still could not deliver a meaning that was as fully determined as Ruskin desired. If they did, there would have been no need for Ruskin to write to *The Times* in the first place. But if, on the other hand, all Hunt's diligence was *still* not enough to guarantee perfect intelligibility, was Ruskin perhaps mistaken in believing that art could, or should, be fully integrated with the world around it?

In the next decade a group of English painters, many of whom came from the Pre-Raphaelite circle itself, comprehensively unpicked the

knot that, in Ruskin's criticism, bound art to the external world, through
narrative, visual realism, and moral didacticism. *Azaleas*, exhibited in
1868 by Albert Moore (1841–93, **65**), contains no clues to a story in
which cause-and-effect morality might operate. Indeed, it is practically
devoid of human interest: the face of the figure expresses no emotion,
and the title gives no hint of her moral character or social rank. Instead,
it names a still-life object, the azalea, which is visually gorgeous but
apparently meaningless. The various accessories do not define a coher-
ent historical setting: the woman's draperies are classicizing, but the
carp bowl, the decorations of the azalea pot, and the asymmetrical
arrangement of blossoms are Japanese in sensibility. The colour scheme
is artificially limited to a narrow range of hues—white, yellow, and
beige, with a few carefully placed accents of deeper red-orange. More-
over, the mesmerizing rhythms of the compositional lines appear to
obey a mathematical logic rather than naturalistic spontaneity. The

poet Algernon Charles Swinburne (1837–1909), commenting on the picture in his review of the exhibition, made no attempt to provide it with a narrative or derive a moral from it. Instead he emphasized its purely artistic character by likening it to poetry and music:

His painting is to artists what the verse of Théophile Gautier is to poets; the faultless and secure expression of an exclusive worship of things formally beautiful. . . . The melody of colour, the symphony of form is complete: one more beautiful thing is achieved, one more delight is born into the world; and its meaning is beauty; and its reason for being is to be.[2]

Ruskin, Venetian painting, and Rossetti

In his magisterial work of art theory, *Modern Painters* (published in five volumes, 1843–60), Ruskin showed himself acutely sensitive to the beauty both of the natural world and of art. But he was also unequivocally hostile to German aesthetics. At the beginning of volume II, which deals with 'Ideas of Beauty', he repudiates the very word 'aesthetic', because of its etymological link with sensuous experience, and proposes a different term, 'theoretic', to refer to the human faculty for receiving ideas of beauty: 'Now the mere animal consciousness of the pleasantness [of visible objects] I call Æsthesis; but the exulting, reverent, and grateful perception of it I call Theoria'.[3] This sounds something like Kant's distinction between the agreeable, as pleasing merely to the senses, and the beautiful; but Ruskin cannot follow Kant's next step, which is to distinguish the beautiful also from the good. For Ruskin the perception of the beautiful is inherently moral, because it responds joyfully to God's creation and because it is itself a faculty given to humans by a loving God. His condemnation of Schiller's *Aesthetic Letters*, several chapters later, involves the same issue; it is 'gross and inconceivable falsity' to maintain, as Ruskin claims Schiller does, that 'the sense of beauty never farthered the performance of a single duty'.[4] This is a superficial reading of Schiller's notion of aesthetic determinability (see above, pp. 45–61), for Ruskin ignores the wider role Schiller gives to beauty in freeing the mind from enslavement to prejudice and tradition, and thus opening the way for innovation. But Ruskin craves a world where human capacities are wholly integrated with one another and with external, God-given 'reality', not one in which human beings may enact radical change.

The theory of beauty presented in the first two volumes of *Modern Painters*, published in 1843 and 1846, can be described as an ambitious attempt at reconciling a strong Protestant faith with a genuine love of both natural and artistic beauty. Ruskin redeemed visual art from traditional Protestant misgivings about its sensuality by applying a rigorous version of the work ethic to its study. Yet the very integrity of Ruskin's methods of visual observation eventually threatened the enabling

premise of his project, that ideas of beauty could be kept distinct from the merely sensuous. For Ruskin it was the study of Venetian Renaissance painting, traditionally valued for its sensuous appeal, that forced a revaluation of his theory. In 1858, contemplating *Solomon and the Queen of Sheba* by Paolo Veronese (*c.*1528–88, **66**), Ruskin suddenly experienced a powerful sense of the sheer physical beauty of the painting. So intimately bound up with his religious faith were his ideas on art and beauty that a change in the one could not but affect the other, and Ruskin's new conviction of the importance of sensuous experience led him, at least temporarily, to renounce the evangelical Protestantism of his upbringing. As he later put it, he came away 'a conclusively *un-*converted man'.[5] In the final volume of *Modern Painters*, published in 1860, he adopts a startlingly new position. Taking Titian as the 'central type' of the Venetian attitude, he writes: 'the painter saw that sensual passion in man was, not only a fact, but a Divine fact; the human creature, though the highest of the animals, was, nevertheless, a perfect animal, and his happiness, health, and nobleness, depended on the due power of every animal passion, as well as the cultivation of every spiritual tendency'.[6] Although this insight continued to cause Ruskin the gravest misgivings, it made a powerful impact on readers who looked to him as the foremost English authority on the visual arts.

The year after Ruskin's 'un-conversion', the Pre-Raphaelite painter Dante Gabriel Rossetti (1828–82) embarked on a practical experiment in re-creating the style of Venetian Renaissance painting. Perhaps Rossetti, at the time a close friend of Ruskin's, was responding to the critic's new interest in Venetian painting when he began a simple panel picture of a single female head and shoulders [**67**]. The composition is reminiscent of Venetian portraits, and in a contemporary letter Rossetti described the work as a technical exercise in learning to paint human flesh, something for which Venetian painters such as Titian

were justly famous. He continued: 'Even among the old good painters, their portraits & simpler pictures are almost always their masterpieces for colour & execution'. In another letter he describes his picture as having 'a rather Venetian aspect'.[7]

Rossetti used this experimental picture to develop a wholly new technical method, quite unlike the Pre-Raphaelite method seen in pictures such as Hunt's *The Awakening Conscience*. Instead of painting thinly in bright, unmixed colours, Rossetti now built up a complex sequence of layers of rich colour; the meticulous individual brush-strokes of Pre-Raphaelite practice are replaced with carefully blended areas of broad modelling. Thus the paint surface itself, apart from what is represented in the picture, has a lusciousness and tactility quite alien to the more ascetic practice of Pre-Raphaelite painting. But Rossetti also uses this new style to enhance the sensuality of the represented figure, full-lipped and fleshy, adorned with jewels and flowers, and dreamy-eyed. The figure is based on a contemporary model, Fanny Cornforth (1835–*c.*1906). But it is equally based on portraits by Titian

and other Venetian painters of sensual women (for example **68**); the close-up presentation of the figure, the luxurious accessories, and the abundant red hair are all reminiscent of Venetian painting.

It seems to have been only after the picture was painted that Rossetti gave it a title, and with it a hint of subject-matter: *Bocca Baciata*, 'the mouth that has been kissed'. The reference is to the final line of a tale in the *Decameron*, by Giovanni Boccaccio (1313–75), in which the principal character, Alatiel, is the most beautiful woman in the world, and the most sensual; she exchanges sexual delights with eight men before marrying a ninth. In an abrupt reversal of the narrative of inevitable ruin for the fallen woman, Alatiel lives happily ever after, and the final line can be read as a celebration of promiscuity: 'the mouth that has been kissed does not lose its fortune, rather it renews itself just as the moon does'. Thus the title is perfectly adapted to the heady sensuality of the picture itself, but, importantly, it was an afterthought: the mean-

ings of the picture were created in visual terms, and the literary content was chosen later to amplify the picture's 'aesthetic ideas'.

If Ruskin's new-found enthusiasm for Venetian painting was one motivation for Rossetti, the work ended in flagrant defiance of Ruskin's own earlier advocacy of the 'theoretic' over the 'aesthetic': it is a powerful visual argument in favour of the pleasures of the senses as an appropriate subject for painting, apart from any moral or didactic considerations. More than that, it presents sensuous and erotic pleasures as inseparable. Holman Hunt was horrified: 'I will not scruple to say that it impresses me as very remarkable in power of execution—but still more remarkable for gross sensuality of a revolting kind. . . . Rossetti is advocating as a principle the mere gratification of the eye and if any passion at all—the animal passion to be the aim of art.'[8] Nonetheless, Rossetti's experiment in the purely 'aesthetic' caught on; within the next few years a number of painters in the social circles linked to Rossetti made pictures of single figures that had no evident purpose but to delight the senses. Rossetti's brother, the art critic William Michael Rossetti (1829–1919), described works exhibited in 1863 by Frederic Leighton (1830–96), including *A Girl with a Basket of Fruit* [**70**], as 'the art of luxurious exquisiteness; beauty, for beauty's sake; colour, light, form, choice details, for their own sake, or for beauty's'.[9] Rossetti's friend Simeon Solomon (1840–1905) produced a variant that features the male figure [**69**]. The photographers David Wilkie Wynfield

69 Simeon Solomon

Carrying the Scrolls of the Law, 1867

70 (left) **Frederic Leighton**
A Girl with a Basket of Fruit,
1863

71 (above) **David Wilkie Wynfield**
Portrait Photograph of the Painter Frederic Leighton,
1860s

72 (above right) **Julia Margaret Cameron**
Call, I Follow, I Follow, Let Me Die, c.1867

73 (right) **Gustave Courbet**
Jo, the Beautiful Irishwoman, 1865–6

(1837–87) and Julia Margaret Cameron (1815–79) experimented with the close-up presentation of both male and female figures [**71**, **72**]. The new picture type even spread to France: Courbet's *Jo, the Beautiful Irishwoman* [**73**] represents Jo Hiffernan, the mistress of another member of Rossetti's circle, James McNeill Whistler (1834–1903), who

also painted her with a mirror [**74**]. The motif of the mirror was perhaps borrowed from Rossetti himself [**75**], although Rossetti had borrowed it, in turn, from Titian [**68**].

But are such pictures merely examples of the Kantian 'agreeable', offering the 'interested' pleasures of visual luxury and erotic appeal? Mirrors are a traditional symbol of vanity, sometimes of lust, and the whole series of images can be read as a celebration of worldly pleasures. This we might regard as a salutary corrective to the supposed prudishness and visual insensitivity of Victorian England. But as we look

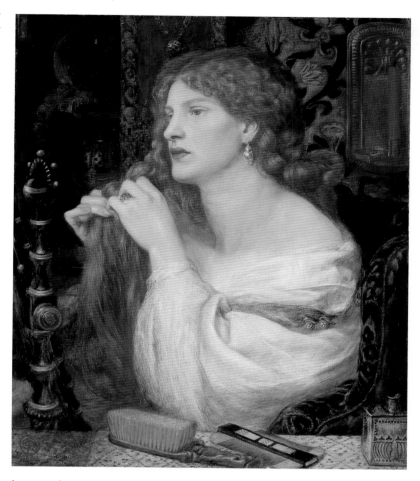

longer the mirrors begin to suggest further meanings. The figures' absorption in their own beauty is like that of the mythological Narcissus, falling in love with his own reflection; it may be introspective or introverted, not quite permitting the spectator to fathom its secrets; or it may be a figure for autonomous art, sufficient in its own beauty without reference to extraneous purposes or ends. Swinburne mused on some of these possibilities in a poem, written in response to Whistler's *The Little White Girl*. He lets the figure speak, but her self-contemplation remains enigmatic:

> I watch my face, and wonder
> At my bright hair;
> Nought else exalts or grieves
> The rose at heart, that heaves
> With love of her own leaves and lips that pair.[10]

In most of the pictures the mirror image remains tantalizingly hidden from view; in the Whistler, the haunting second face in the mirror

seems sadder, less serene, and the two figures fail to make eye contact with one another.

The mirrors, then, are capable of generating 'aesthetic ideas' in the free play of mind of the observer's response. Moreover, the critics and writers who supported these artistic experiments saw them as more than merely 'agreeable'. Drawing on ideas from the aesthetic traditions we have explored in Chapters 1 and 2, they presented them as 'beautiful' in the wider sense of offering something that logical and intellectual thought, moral and religious duty cannot offer, but which is nonetheless vital to human experience. We should take these claims seriously, if only because they generated a set of ideas that has been inordinately powerful ever since, under the controversial catchphrase, 'art for art's sake'.

Swinburne, Pater, and art for art's sake

In 1862 Rossetti's close friend, the poet Swinburne, published the first English review of Baudelaire's *Les Fleurs du mal*, in which he presented the beginnings of a theory of art's independence. Baudelaire's volume of 1857 had been prosecuted and six of its poems banned on moral grounds, but Swinburne protests that 'a poet's business is presumably to write good verses, and by no means to redeem the age and remould society'. Moreover, there are hints that he sees Baudelaire's poetic project as analogous to the experiments in painting of the Rossetti circle. He delights particularly in Baudelaire's poetic evocations of sensual female figures, and compares his 'beautiful drawing' to French paintings of the nude, citing Flandrin's *Study* [35] and a female nude by Ingres (compare **53**, **56**).[11]

Throughout the middle 1860s Swinburne was at work on a more extended discussion of aesthetic questions, published in 1868 as part of his book, *William Blake*. Here Swinburne continues the project of justifying art's attentiveness to beauty alone. He categorically repudiates the Ruskinian links between art and either morality or scientific accuracy, using language that matches Ruskin's own in polemical vigour: 'Handmaid of religion, exponent of duty, servant of fact, pioneer of morality, [art] cannot in any way become; she would be none of these things though you were to bray her in a mortar.' He goes on to warn the artist against aiming at moral or spiritual 'improvements':

Art for art's sake first of all, and afterwards we may suppose all the rest shall be added to her (or if not she need hardly be overmuch concerned); but from the man who falls to artistic work with a moral purpose, shall be taken away even that which he has—whatever of capacity for doing well in either way he may have at starting.

We have seen this idea before, in French writings: not only should art be independent of a moral purpose, but it will actually be vitiated by

any such purpose. There is evidence, here and elsewhere in Swinburne's writings, that he had read Cousin attentively. Moreover, Swinburne prominently introduces the phrase 'art for art's sake', obviously a translation of the phrase specially associated with Gautier, *l'art pour l'art*. He continues with an explicit reference to Baudelaire, whom he describes as a critic 'of incomparably delicate insight and subtly good sense, himself "impeccable" as an artist'; this includes a covert reference to Gautier, the poet whom Baudelaire had described as 'impeccable' when he dedicated to him *Les Fleurs du mal*.[12]

The sudden irruption of these allusions to French *l'art pour l'art* seems at first thought incongruous, in the context of a study of Blake (1757–1827), an English artist and poet who had died before the French phrase ever appeared in print. Yet Swinburne's project is not to import the French idea wholesale, but rather to embed it in an English context, one moreover closely associated with the artistic experimentation of the Rossetti circle. The Rossetti brothers had completed the first *Life of William Blake*, published in 1863 after the death of its original author; Swinburne's study continued the Rossettis' effort to redeem Blake from obscurity.[13] Countering critics who dismissed Blake's work as immoral, irrational, or even insane, Swinburne reinterpreted Blake as refusing to compromise between the demands of his art, on the one hand, and those of either morality or scientific accuracy on the other: 'To him, as to other such workmen, it seemed better to do this well and let all the rest drift than to do incomparably well in all other things and dispense with this one'.[14] The phrase 'as to other such workmen' is significant: Swinburne sees Blake as a rebel against his own society, but akin to other creative artists who devote themselves to art alone. Among the 'other such workmen', for Swinburne, are surely Baudelaire and Gautier, together with Rossetti and himself. In a footnote lamenting Baudelaire's recent death, Swinburne addresses him as a brother;[15] some years later he recalled that his own aesthetic thinking, at this period, derived from 'the morally identical influence of Gabriel Gautier and of Théophile Rossetti'.[16]

Thus in Swinburne's text the special integrity of the creative artist, dedicated to art alone, supplants the Ruskinian model of the artist who reverently imitates God's creation and endeavours to benefit humanity. In defiant language, Swinburne pours scorn on any possible compromise: 'Once let [art] turn apologetic, and promise or imply that she really will now be "loyal to fact" and useful to men in general (say, by furthering their moral work or improving their moral nature), she is no longer of any human use or value'.[17] This can be read as a rejoinder to Ruskin, who as we have seen castigated the view 'that the sense of beauty never farthered the performance of a single duty'. For Swinburne the artist's sole duty is to make good art.

Swinburne never flinches from the most extreme implications of his

declaration of art's independence; in this respect he perhaps goes further than his French mentors. Both Gautier and Baudelaire had preserved the possibility that art, if it remained true to itself, would eventually lead, not indeed to direct benefits in the social world, but nonetheless to some kind of spiritual transcendence. In an essay of 1857 on the American poet, essayist, and short-story writer Edgar Allan Poe (1809–49, another enthusiasm of Rossetti and his friends), Baudelaire had quoted Poe's succinct distinction among three areas of human endeavour: 'Pure Intellect has as its goal the Truth, Taste informs us of the Beautiful, while the Moral Sense teaches us Duty.'[18] In *William Blake* Swinburne echoed this tripartite formulation: 'To art, that is best which is most beautiful; to science, that is best which is most accurate; to morality, that is best which is most virtuous'.[19] The change in order, to place art first, is crucial: Baudelaire had been willing to give art a kind of mediating role between truth and morality, but Swinburne insists on a total divorce. Baudelaire goes on to suggest that beauty ultimately leads beyond sensuous or material experience:

It is this admirable and immortal instinct for Beauty that makes us consider the Earth and its shows as a glimpse, a *correspondence* of Heaven. The unquenchable thirst for all that lies beyond, and which life reveals, is the liveliest proof of our immortality. It is at once by means of and *through* poetry, by means of and *through* music, that the soul gets an inkling of the glories that lie beyond the grave. . . .[20]

Swinburne abruptly ceases to follow Baudelaire when he moves into this transcendental realm. Arguably Swinburne is more consistent: if art is genuinely to be 'for art's sake' *only*, then we cannot seek its value anywhere else, not even in a higher spiritual realm. Indeed, Swinburne makes this the basis for his distinction between art and morality. Art's 'principle', he writes, 'makes the manner of doing a thing the essence of the thing done, the purpose or result of it the accident'.[21] This is the reverse of 'the principle of moral or material duty'—that is, of the cause-and-effect morality that we have seen in Ruskin's criticism—in which 'purposes' and 'results' are tied together by inexorable logic. For Swinburne, art—and only art—contains its value entirely within itself; uniquely among the things human beings do, it does not depend on prior purposes or future consequences. This is consistent with the way Kant presents the beautiful at the beginning of the *Critique of Judgement*.

The references to heaven and immortality, in the passage from Baudelaire, suggest that the notion of transcendent value for art depends ultimately on a religious sanction. However, Swinburne's more uncompromising version of art for art's sake does not require any higher authority. William Michael Rossetti, writing in defence of Swinburne's volume of 1866, *Poems and Ballads*, when it was attacked as irreligious and immoral, described the poet as a 'pagan' and clearly

indicated his religious scepticism. Disbelieving in life after death, Swinburne can look for value only in things of this life:

His only outlet of comfort is his delight in material beauty, in the fragmentary conquests of intellect, and in the feeling that the fight, once over in this world for each individual, is over altogether; and in these sources of comfort his exquisite artistic organization enables him to revel while the fit is on him, and to ring out such peals of poetry as deserve . . . to endure while the language lasts.[22]

William Rossetti (also an unbeliever) offers the longevity of art as some consolation for the loss of faith in personal immortality. But if art can outlast its maker, there is no hint, here or in Swinburne's own writings, that it can transcend the limits of the material world. Perhaps this offers some kind of justification for an art of the senses, although it is a bleak one. In the words of another favourite text of the Rossetti circle, the *Rubáiyát of Omar Khayyám*:

Ah, make the most of what we yet may spend,
Before we too into the Dust descend;
 Dust into Dust, and under Dust, to lie,
Sans Wine, sans Song, sans Singer, and—sans End![23]

One of Swinburne's most attentive readers was the young Oxford don, Walter Pater (1839–94, **76**), just beginning his career as a critic, but already deeply learned in German philosophy. His first article,

76 Simeon Solomon
Walter Pater, 1872

published in 1866, was on Samuel Taylor Coleridge, among the earliest English writers to take an interest in recent German philosophy; in 1867 he published a study of Winckelmann, and he included German philosophy and criticism in his teaching at Oxford. Pater took up the phrase 'art for art's sake' immediately after it appeared in Swinburne's *William Blake*. Significantly, he too used it in a context related to the Rossetti circle, giving it special prominence in the final sentence of his essay on the poetry of Rossetti's friend William Morris (1834–96). To conclude his discussion, Pater muses on the role of beauty in human life:

> . . . we have an interval and then we cease to be. Some spend this interval in listlessness, some in high passions, the wisest in art and song. For our one chance is in expanding that interval, in getting as many pulsations as possible into the given time. High passions give one this quickened sense of life, ecstasy and sorrow of love, political or religious enthusiasm, or the 'enthusiasm of humanity.' Only, be sure it is passion, that it does yield you this fruit of a quickened, multiplied consciousness. Of this wisdom, the poetic passion, the desire of beauty, the love of art for art's sake, has most; for art comes to you professing frankly to give nothing but the highest quality to your moments as they pass, and simply for those moments' sake.[24]

The tone is elegiac rather than confrontational, but we should make no mistake: Pater is implicitly denying the Christian hope for resurrection. We have only 'one chance', he writes; without hope of a life after death we can only strive to make our lives on earth as rich in experience as possible. This was in flagrant violation of the doctrines of the Church of England, which as an Oxford don Pater was expected to uphold in his teaching. Moreover, the passage can be read to imply that, since we cannot hope to be rewarded in heaven for doing good on earth, it is better to abandon ourselves, if not to 'high passions', at least to art and beauty as offering more immediate fulfilment than religion, politics, or philanthropy. The passage became notorious when Pater reused it as the Conclusion to his volume of 1873, *Studies in the History of the Renaissance*. Its heterodox implications outraged some readers, and may have cost Pater advancement in his Oxford career; certainly he felt obliged to omit the Conclusion from the second edition of *The Renaissance*.

In later editions, Pater reinstated the passage with an explanatory footnote; in the meantime he had written a long novel, *Marius the Epicurean* (1885), which he felt had explained his position more fully. But the brief Conclusion remained famous; like Swinburne's *William Blake*, it presents the case for art's independence in its most rigorous form. Like Swinburne, Pater gives the highest value to the experience of art and beauty because it makes no pretence to deliver anything other than itself. Perhaps there is a concealed critique here of ideolo-

gies that offer false promises of future rewards; Christianity's promise of eternal life may be one such, since it is evident that neither Swinburne nor Pater believed in the resurrection at this period. This is a merely negative recommendation for art: by promising nothing that it does not deliver, art preserves its integrity, but by the same token it does not aim at any beneficial end. Clearly, though, both Swinburne and Pater believe that art also gives positive value, not in some transcendent realm, but in the immediacy of the present. Indeed, it is what makes life worth living; as Pater puts it, art gives 'the highest quality to your moments as they pass'.

In a way, Ruskin had been right: to locate art's value in itself proved, in the writings of Swinburne and Pater, tantamount to the rejection of religious authority. To make art the highest value in human life, as theories of art for art's sake may do, has sometimes been described as making art a substitute for religion. Perhaps so, but the religion of art in these texts is a pagan one, to borrow William Rossetti's term; unlike the religion of art of Cousin and other French writers, it does not hope for redemption or transcendence, but places its faith in the passing 'moment' or in 'the manner of doing a thing'. More accurately, it is a resurgent pagan religion, a rediscovery of the delights of 'free' beauty after a massive loss of faith in a formerly authoritative religious doctrine. Both Swinburne in *William Blake* and Pater in *The Renaissance* tell a fable about the earliest stirrings of the Renaissance in the late middle ages, when artists began to rebel 'against the moral and religious ideas of the time' and to seek instead 'the pleasures of the senses and the imagination'.[25] Swinburne writes of Chaucer (1345?–1400) and the French romances of the thirteenth century: 'One may remark also, the minute this pagan revival begins to get breathing-room, how there breaks at once into flower a most passionate and tender worship of nature, whether as shown in the bodily beauty of man and woman or in the outside loveliness of leaf and grass. . . .'[26] Pater, also writing of thirteenth-century France, refers repeatedly to 'the care for physical beauty, the worship of the body, the breaking down of those limits which the religious system of the middle age imposed on the heart and the imagination'.[27] In both texts this fable of the earliest Renaissance has clear contemporary relevance. Swinburne and Pater were partly responding to, partly predicting a new flowering in contemporary English art that would become associated, first with the term both of them introduced in 1868, 'art for art's sake', then with the label 'Aestheticism'.[28] Later still, Oscar Wilde (1854–1900) would confirm the analogy by describing recent developments as 'the English Renaissance of Art'.[29]

It should be stressed that, for both Swinburne and Pater, this early Renaissance art (whether of France in the thirteenth century, or of England in the 1860s) is unequivocally 'modern', in the terms of Baudelaire's 'The Painter of Modern Life', which both English critics read

attentively. For the English critics, it is true, modern-life subject-matter *per se* is relatively unimportant; that may be partly to do with the different circumstances in England, where modern-life subject-matter was readily accepted by traditionalist critics, and was even, by the 1860s, somewhat *passé*. But the fundamental premise of English art for art's sake, that art delivers its value in itself, in the present 'moment', is akin to Baudelaire's construction of 'modernity' in a more profound sense. Moreover, the writings of Swinburne and Pater take up an insight of Baudelaire's essay that was perhaps less influential in France: 'modernity' is an aspect of *all* art, not just the art of the most recent period. Baudelaire shows how Guys's drawings, the most 'modern' works we can imagine, already have an element of antiquity. The essays in Pater's *Renaissance* point out the corollary: such a work as Leonardo's *Mona Lisa* has lasting value only because it contains the element of 'modernity', which we rediscover in the 'moment' of our aesthetic experience of it (if we do not, Baudelaire would surely agree, it makes no difference whether the work was made ten minutes or ten centuries ago). The *Mona Lisa* [93], when Pater looks at it, is as 'modern' as Guys's drawings [60] or Rossetti's paintings [67, 75] are when we look at them.

The theory of 'art for art's sake' was, as the phrase indicates, in some sense a translation into English of the French *l'art pour l'art*; the Francophile Swinburne, although he was not the first critic to use the English phrase, was certainly the one to establish it as a key term for English criticism.[30] But English art for art's sake was different from French *l'art pour l'art*, and in some ways more radical. As we have seen, the French writers were not quite able to relinquish the Christian or Platonic hope that a 'pure' art would ultimately lead beyond itself, to spiritual transcendence. By giving up this aspiration, Swinburne and Pater were able to advance a more consistent and rigorous version of art for art's sake, one in which art had really to justify itself on its own terms, in the 'manner of doing a thing' or in the 'moment' as it passes, without recourse to any divine or spiritual sanction.

For Pater, indeed, it is precisely the 'passing' quality of the artistic moment that gives it positive value. Throughout his writings, Pater resolutely opposes any form of dogmatism; 'stereotype' and 'fixed principles' are anathema to him.[31] Art for him is the most powerful counter to dogma; it is a guarantee of the relative, the contingent, the fugitive and transitory. Pater uses the terminology of Baudelaire's 'The Painter of Modern Life', but the difference is clear. Pater rejects the 'absolute' or 'eternal' aspect of Baudelairean beauty, and puts his entire faith in the 'fugitive' or 'contingent' aspect. 'Every moment some form grows perfect in hand or face', he writes in the Conclusion to *The Renaissance*: 'some tone on the hills or the sea is choicer than the rest; some mood of passion or insight or intellectual excitement is irresistibly real and attractive to us,—for that moment only.'[32]

The worship of the body

A renaissance much like the one Swinburne and Pater described was really happening in the English art of the 1860s: a sudden proliferation of paintings of the nude human figure after a long period when the nude had been neglected, or even held in suspicion for its sensuality.[33] The reference, in Swinburne's Baudelaire review, to the nudes of Flandrin and Ingres suggests that this project was in view as early as 1862, and that like the idea of 'art for art's sake' it was oriented towards France, in abrupt contrast to the heavily-dressed subjects from modern life, English history, and literature that then dominated English exhibitions.

In 1863 Rossetti designed a nude version of what was by now his characteristic compositional type, a half-length female figure surrounded by luxuriant flowers, in this case roses and extravagant, pulpy honeysuckle [77]. Nothing could be simpler, and yet the composition is carefully orchestrated to produce an overwhelming effect of heady sensuality. The figure is as large as life, and faces the viewer at disconcertingly close range. The flesh is fully modelled in three-dimensional

77 Dante Gabriel Rossetti
*Venus Verticordia, c.*1863–8

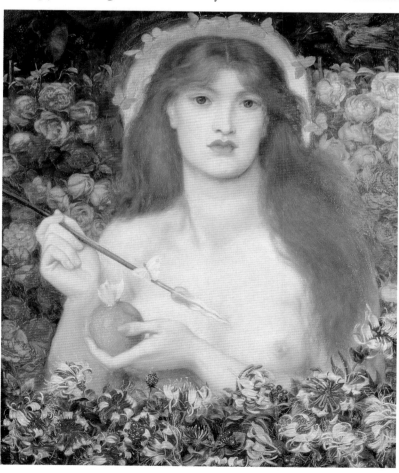

volume, yet there is no surrounding space; the flowers are so tightly packed that there is no chink between them, and the recession into pictorial depth is blocked, as the hot pinks and reds push forward around the figure. It is as if the picture had been turned inside out, projecting into the viewer's space rather than receding safely into illusionistic depth. Thus the picture can be called erotic not simply because it represents nude female flesh, but in the way it compels the viewer to experience a vivid relationship with the figure. Rossetti emphasized this sense of direct address in the sonnet he wrote to accompany the picture:

> She hath the apple in her hand for thee,
> Yet almost in her heart would hold it back;
> She muses, with her eyes upon the track
> Of that which in thy spirit they can see.[34]

This implicates the viewer: she holds the apple 'for thee' and can see into 'thy spirit'; the poem reinforces the sense of direct address projected by the painting. There is a hint here of Eve and the apple of original sin, but the primary reference is to the story of Paris, the Trojan prince, who awarded a golden apple to Venus in a contest among three goddesses [see **38**]. In classical mythology this led to the Trojan War, and the dart may refer to the arrow that killed Paris, as well as to Cupid's dart, inspiring love as it wounds. Butterflies, symbols of human souls enthralled by love, flit around the apple and dart, and encircle the golden halo—a surprising detail, equating Venus with a Christian saint. Rossetti called his picture *Venus Verticordia*, 'Venus, turner of hearts'; he had misinterpreted the word 'verticordia', used by Latin authors to refer to Venus's function in turning women's hearts towards chastity, and used it instead in the opposite sense, to hint that love can turn hearts towards new lovers. When his brother alerted him to the error, Rossetti temporarily corrected it, but later reinstated the title, *Venus Verticordia*. Perhaps he liked the rhythm and alliteration of the phrase, or perhaps he simply decided that it made no difference: as Swinburne would have agreed, beauty has no business to decide between good and evil moral consequences.

However it is interpreted, the subject of the pagan Venus is specially suited to an art of the senses: Venus is the goddess of both love and beauty, of both sensuous and sensual pleasures. Thus it is not surprising that in the next few years a number of other painters made representations of Venus; for western audiences there is no more effective signal that a painting is to do with beauty alone. Leighton was the first to exhibit a large-scale nude figure in public, at the Royal Academy in 1867: *Venus Disrobing for the Bath* [**78**]. Leighton's admiration for Ingres is evident in the smooth, supple contours of this figure, cooler and more remote than Rossetti's. In a different way, though, the painting exemplifies the new fascination with the human body. The flesh is without

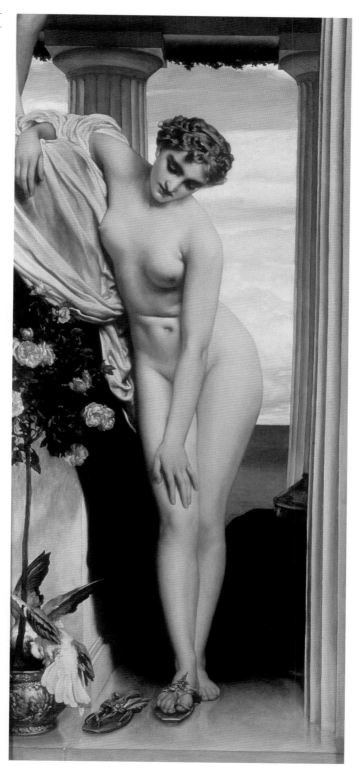

blemish, modelled with such magical seamlessness that it appears superhuman, and the pose twists the figure into a continuous curving shape, in stark contrast with the straight lines of the fluted columns. Critics emphasized the non-naturalism of the painting, sometimes with approval for its 'chastity', sometimes with a touch of distaste for its lack of human warmth. Was Leighton avoiding a too-evident sensuality that might prove offensive at a Victorian public exhibition, or was he exploring the forms of the human body 'for art's sake'?

The question might also be asked of Albert Moore's *A Venus* [**79**]. Here there is even less of a sense that the picture can be interpreted as a representation of a living human being; even the title indicates that this

is not Venus herself, but merely 'a' Venus, one work of art among many. Moreover, Moore painted thinly on a canvas with an unusually coarse weave: in contemplating the picture, the viewer cannot forget that this is an oil painting on canvas. A viewer conversant with ancient sculpture would immediately recognize, too, that the 'model' for the figure is not a human being at all, but rather a marble statue: the forms and even the markings of the torso faithfully copy those of the *Venus de Milo* [**80**], and Moore plausibly imagines a harmonious arrangement for the statue's missing arms. After its discovery on the Greek island of Melos in 1820, and its subsequent installation in the Louvre, the *Venus de Milo*, with its majestic, elongated forms, had come to supplant the daintier *Venus de'Medici* [**12**] as the most celebrated female statue from antiquity (both Émeric-David and Quatremère wrote treatises extolling the distinctive beauty of the newly discovered statue). The austerity of Moore's touch and colouring perhaps responds to the rather chilly grandeur of this new paradigm for classical female beauty. The body is reversed, which suggests that Moore consulted an engraving of the ancient statue. Moore's picture, then, is distanced three times from 'nature': it is a painted imitation of an engraved reproduction of a marble statue of a human figure, and the painting method draws attention to its artificiality.

At about the same time, Moore's close friend Whistler made yet another *Venus* [**81**], comparable to Moore's in the deliberate limitation of hue, but very different in its sketchy handling (attributable at least in

81 James McNeill Whistler
Venus (one of the 'Six Projects') *c.*1868, unfinished

part to the fact that it is unfinished) and in its evocation of movement: energetic brushstrokes suggest the rolling of the waves and whip the drapery into rippling curves. By the end of the 1860s, the artists were extending their explorations to the male figure. In 1869, when Moore's *A Venus* was on view, Leighton showed *Daedalus and Icarus* [**82**]. At the next year's exhibition of the Old Water-Colour Society, Edward Burne-Jones (1833–98) went further, presenting a fully nude male figure in *Phyllis and Demophoön* [**83**]; the picture caused such offence that Burne-Jones was obliged to remove it from exhibition. But Simeon Solomon was able to show his watercolour, *Dawn* [**84**], in 1872 at the Dudley Gallery (a smaller exhibiting society run by artists); here the full nudity of the figure is made more discreet by a pose that echoes that of Flandrin's *Study* [**35**].

83 Edward Burne-Jones

Phyllis and Demophoön,
1870

84 Simeon Solomon
Dawn, 1871

We can point to formal similarities among many of these nudes. The use of a rippling or billowing drapery as a foil to nude flesh recurs again and again, and the contrapposto stances of the standing figures have at least a family resemblance, no doubt ultimately derived from ancient sculptures [**11, 12, 80**]. Moreover, it is obvious that the artists introduced the nudes as a concerted project. The artists seem to have been in unanimous agreement that it was important to represent, in artistic form, what Swinburne called 'the bodily beauty of man and woman', and Pater 'the worship of the body'.

Nonetheless there are important differences among the pictures. Some of the nudes are painted with a passionate intensity that seems to draw the observer into intimacy with the painted figure. Others give a crystalline precision to the human form that seems to distance it from human concerns into a world of artistic perfectionism. Moreover, there are hints that the artists debated such questions. In his diary for February 1864, the watercolour painter George Price Boyce (1826–97) recorded a discussion at a breakfast party in Leighton's studio:

After breakfast long and pounding discussion occurred on the treatment of flesh in pictures. Whether it should be merely decorative and affording a note in the picture of no more value than any other piece of colour, or whether it should be also strictly, specially, and characteristically true and pre-eminent in perfection of rendering. (Of course I pleaded for the latter.)[35]

Boyce was a special friend of Rossetti, and the entry implies that the artists closest to Rossetti agreed with him, that flesh should be 'characteristically true and pre-eminent', while the artists who were closer to Leighton took the other position, that flesh-painting should be 'of no more value than any other piece of colour'. The ramifications of this discussion go beyond a mere question of technique. They point to two contrasted ways of thinking about what an art devoted to 'beauty', or 'for art's sake' alone, might be like. Should such an art offer visual and even sensual beauty, not merely as a protest against prudishness, but as a vital area of human experience that could not be fulfilled by the pursuits of business and commerce, politics and philanthropy? In that case the representation of flesh might have special importance as the visual expression of embodied human subjectivity. Or should art resolutely maintain its integrity, by seeking its own technical and formal perfection to the exclusion of all other considerations? In that case it would make no difference whether one were painting human flesh or, perhaps, an azalea; the artist's sole responsibility would be to paint as well as possible.

The first critical article to discuss the new tendencies in painting was published in 1867 by Sidney Colvin (1845–1927), a recent Cambridge graduate who had contacts in the Rossetti circle. Colvin did not use the term 'art for art's sake', which had not yet been introduced in Swinburne's *William Blake*, but he singled out, with enthusiastic approval, a tiny band of artists 'whose aim, to judge by their works, seems to be pre-eminently beauty'.[36] Moreover, he offers a cogent rationale for what we now call 'formalism' approximately forty years before Roger Fry (to be discussed in Chapter 4):

I would affirm that beauty should be the one paramount aim of the pictorial artist. Pictorial art addresses itself directly to the sense of sight; to the emotions and the intellect only indirectly, through the medium of the sense of sight. The only perfection of which we can have direct cognizance through the sense of sight is the perfection of forms and colours; therefore perfection of forms and colours—beauty, in a word—should be the prime object of pictorial art.[37]

Although in 1867 more than 700 artists exhibited at the Royal Academy alone, Colvin finds only nine artists who meet his criterion of making beauty their 'one paramount aim', including Leighton, Moore, Whistler, Rossetti, Burne-Jones, Solomon, and George Frederic Watts (1817–1904). Moreover, Colvin identifies two distinct tendencies: he groups Leighton, Moore, and Whistler together as artists who aim at 'beauty without realism', and links Burne-Jones and Solomon with Rossetti as combining beauty with 'passion and intellect'. Of Moore he notes, 'With him form goes for nearly everything, expression for next to nothing', and of Rossetti, 'on "the value and significance of flesh" this painter insists to the utmost'.[38]

However, the two approaches were never mutually exclusive. All of the artists showed an increased concern with technical perfection in the 1860s. Rossetti and Burne-Jones, for example, began to make refined drawings reminiscent of the techniques of Leighton or of the Renaissance masters [**85**]. On the other hand Leighton's paintings and sculptures appeared overtly sensual to many critics. A picture such as Watts's *The Wife of Pygmalion* explores ideas of both kinds [**86**]. Like Moore's *A Venus* it is a painted representation of an ancient sculpture, which Watts had discovered in the basement of the Ashmolean Museum in Oxford. Like Rossetti's *Venus Verticordia* it is a half-length figure with one exposed breast. The subject-matter is drawn from the ancient myth of Pygmalion, who made a sculpture of a female figure so beautiful that he fell in love with it. In answer to his prayers the goddess Venus brought the sculpture to life: it is this moment we see. The pallor of the flesh, the slight stiffness in the carriage of the head, and the blank look in the eyes show that the figure has not quite ceased to be a statue; but the faint colours of lips, eyes, hair, and exposed breast suggest the human blood beginning to infuse the flesh with life. The picture makes an exquisitely succinct summary of the set of ideas that had emerged, thus far, around the phrase 'art for art's sake'. It is exclusively to do with beauty, not merely in formal terms, but in its

subject-matter: the beauty of a work of art, Pygmalion's sculpture, has the power not only to enthral its creator (and viewer), but actually to bring stone to life. Moreover the picture does not narrate this story; it enacts it through its own technical processes, taking the inert stone of the ancient sculpture and bringing it to life in the form of a modern oil painting. The flower that starts to the surface just to the right of the figure's cheek sets up an analogy between the mythological story and the painter's activity. This is the sketchiest passage in the picture, yet the freshness and spontaneity of the handling give a powerful sense of the natural vitality of the flower; we see the painter's alchemy working before our very eyes, transforming paint into living presence.

Form and content

Of the artists Colvin mentioned, the one who has remained most closely identified with the motto 'art for art's sake' is the American

artist, James McNeill Whistler. Trained in France, Whistler came to England at the beginning of the 1860s and was at first associated with Rossetti's circle [74]. Later in the decade, though, Whistler became close to Albert Moore. Indeed, Colvin was perceptive, in 1867, in linking Whistler with both Moore and Leighton, and in identifying their project as concerned with 'beauty without realism'. By this date the three artists seem to have taken a more extreme view of the 'purity' of the work of art than the artists closer to Rossetti.

Three pictures exhibited at the Royal Academy in 1867, Leighton's *Spanish Dancing Girl* [87], Moore's *The Musicians* [88], and Whistler's *Symphony in White, No. 3* [89], experiment with a similar compositional type. All represent figures arranged on a bench in a shallow foreground space; in each a more upright figure on the left establishes an asymmetrical focus, while seated or reclining figures to the right look on, listen, or (in the case of the Whistler) seem lost in introspection. All three are ambiguous in period location. Leighton's 'Spanish' dancing girl wears draperies imitated from classical Greek sculpture, with crossing cords and a heavy overfold at the waist. Moore's classicizing setting includes palm fans and a Japanese-looking spray of flowers, and Whistler's combines a Japanese fan with another asymmetrical spray of foliage and curious dresses, reminiscent of early nineteenth-century Regency fashion, with high waists and puffed sleeves. In all three cases the blurring of period location prevents the spectator from interpreting the setting as a 'real' period or place. Even though the figures and objects are perfectly comprehensible in representational terms, the scenes are not realistic in the sense that they do not correspond to any particular historical 'reality'.

87 Frederic Leighton
Spanish Dancing Girl, 1867

88 Albert Moore

The Musicians, 1867

All three pictures make conspicuous reference to the art of music. In Moore's picture the male figure plays the lyre; in Leighton's the figures clap to accompany the dancer's movement. In Whistler's picture the musical reference is confined to the title, *Symphony in White, No. 3*. The picture does not represent music-making; instead, the title indicates that it is the picture itself that is the 'symphony'. It is a work of art,

89 James McNeill Whistler

Symphony in White, No. 3, 1865–7

analogous to a piece of music, and identified by its dominant colour (white), as a piece of music might be identified by its key ('Symphony in C'); moreover, it is the third of its kind in the artist's oeuvre, just as a musical composition might be designated by number (accordingly *The Little White Girl*, **74**, was retrospectively retitled *Symphony in White, No. 2*). Perhaps the implication of the particular musical term, 'symphony', is that the picture corresponds to absolute music rather than to programme music (music that dramatizes a story) or music set to words.

This equation between non-realist painting and absolute music is perhaps clearest in Whistler's *Symphony in White, No. 3*, although Whistler relies on a verbal title to convey his meaning rather than suggesting it entirely in visual terms; indeed, he inscribes the title conspicuously along the bottom of the canvas, an indication of how important it is to the picture's meaning, and probably also of how novel the idea still was in 1867. However, all three pictures order their compositions on principles of rhythm or proportion that can be seen as analogous to the proportional relationships of musical intervals and chords. Thus the idea of an analogy with music can suggest a compositional method based on spatial measurements, as music is based on quantifiable acoustic vibrations. Such a method would use geometrical proportions to generate a composition, rather than letting the requirements either of subject-matter or of realistic representation dictate the placement of figures and objects. Moore would take this idea furthest in his works of succeeding years [**65, 79**].

As we have seen, Colvin's article of 1867 comes close to advancing a theory that we might call 'formalist': art should concern itself with forms and colours, the qualities proper to its visual medium. But for the nineteenth-century artists this did not mean moving towards total abstraction. Instead the artists wished to bring form and content closer together. They sought ways to make the picture generate its meanings in the terms of its own visual medium, rather than merely referring to meanings generated elsewhere, say in a literary source, or even in the natural world. This is similar to what Gautier meant by an 'idea in painting', as opposed to an 'idea in literature' (see above, p. 88). In the pictures of 1867 (and many other works associated with art for art's sake), the artists proposed the analogy with music as one way of moving away from dependence on narrative or 'literary' subject-matter. Pater extended this idea in an essay of 1877, 'The School of Giorgione':

All art constantly aspires towards the condition of music. For while in all other kinds of art it is possible to distinguish the matter from the form, and the understanding can always make this distinction, yet it is the constant effort of art to obliterate it. . . . It is the art of music which most completely realises this artistic ideal, this perfect identification of matter and form. In its consummate moments, the end is not distinct from the means, the form from the matter,

the subject from the expression; they inhere in and completely saturate each other; and to it, therefore, to the condition of its perfect moments, all the arts may be supposed constantly to tend and aspire.[39]

For Pater music can stand as the ideal art form, not because it lacks content but because musical thought cannot be conceptualized separately from its sensuous embodiment as audible sound (this is less true, at any rate, of the literary or visual arts, whose subject-matter can be summarized in words). Moreover, it is not irrelevant that he introduces this discussion of music into an essay concerned with the painting of the Venetian Renaissance. Pater is perhaps thinking partly of Whistler, for the essay was first published in 1877 when Whistler's musical titles were intensively discussed in the press (see below, p. 152). But he is also thinking of Rossetti's explorations of Venetian style, which he specifically mentions.[40] Rossetti's paintings, often ingeniously, cast their 'literary' references into a form that is visual first of all. We have seen that in *Bocca Baciata* [**67**] Rossetti chose the subject-matter after the picture was painted, so that the visual form of the painting inspires and takes precedence over its 'literary' content. *Fazio's Mistress* [**75**] re-creates a poem by Fazio degli Uberti (*c.*1302–*c.*1367), in which the poet imagines looking at his beloved: the picture does not 'illustrate' the poem; rather, it realizes the poet's own visual experience. Later Leighton extended the project to the medium of sculpture. His *Athlete Wrestling with a Python* [**90**], exhibited at the Royal Academy in 1877, is a new meditation on the *Laocoön* [**3**], but Leighton eliminates the 'literary' context of the ancient sculpture (the Laocoön myth) to concentrate on the extension of the body in space. In this and a second sculpture with a contrasting subject, *The Sluggard* of *c.*1882–6 [**91**], Leighton also explored the special capabilities of the medium of polished bronze, exploiting the play of light on burnished metal and refining surface detail to emphasize the sensuous and tactile qualities of the medium.

Whistler never contemplated giving up the representation of figures and objects in his work. However, he was more strident than any of the other artists in declaring his antipathy to 'literary' subject-matter. His numerous letters to the press, pamphlets, and lectures present a witty and vivid account of his artistic project, oversimplified, perhaps, both to make it accessible to his readers and in spirited defiance of conventional opinions on art. An example is this excerpt from 'The Red Rag', first published in 1878:

Art should be independent of all clap-trap—should stand alone, and appeal to the artistic sense of eye or ear, without confounding this with emotions entirely foreign to it, as devotion, pity, love, patriotism, and the like. All these have no kind of concern with it; and that is why I insist on calling my works 'arrangements' and 'harmonies.'

92 James McNeill Whistler
Arrangement in Grey and Black: Portrait of the Painter's Mother, 1871–2

Take the picture of my mother [**92**], exhibited at the Royal Academy as an 'Arrangement in Grey and Black.' Now that is what it is. To me it is interesting as a picture of my mother; but what can or ought the public to care about the identity of the portrait?[41]

Whistler seems to offer us a crude choice between two antithetical ways of reading paintings. First there is an ideological reading, which refers to ideas such as 'devotion, pity, love, patriotism', and, we might add, motherhood; this reading is incompatible with 'art for art's sake', as Whistler indicates with the vivid observation 'art should be independent of all clap-trap'. Second there is a 'formalist' reading, which refers to form and colour alone. Whistler unequivocally opts for the second kind of reading, and he chooses an extreme example to make his point: the painting of his own mother, he insists, should be regarded as an *Arrangement in Grey and Black*—like a piece of pure instrumental music without subject-matter. Calling the picture *Arrangement in Grey and Black* leads us to experience it in a special way. We note the disposition of the black figure, marking a diagonal across a measured grid of

horizontal and vertical lines; the limitation of hue, virtually to a mono-chrome, emphasizes the simplification of forms. The delicate paint surface varies from an almost ethereal stain in the background greys, through the calligraphic waves and flecks at the left, to the transparent feathery whites towards the centre. We do not need to read these areas as a wall, a curtain, or a lace cap and cuffs to find them beautiful. In this reading Whistler's painting has a formal beauty similar to that of an abstract painting, such as one by Piet Mondrian (1872–1944).

But, despite Whistler's protestations, the public has always cared very much indeed about the 'identity of the portrait', so much so that—under the familiar title *Whistler's Mother*—it is still one of the most famous pictures in the world. We might even suspect Whistler, a consummate self-publicist, of raising the question to call attention to the painting's strangeness as a portrait. It is utterly memorable, partly because it is so unconventional as a representation of motherhood. The figure is anything but cuddly or nurturing; instead she is angular, stark in profile, immobile and unresponsive, dressed in the strict black and white of Protestant bourgeois rectitude. Suddenly 'devotion, pity, love, patriotism' come flooding back into the interpretation of the picture, together with piety, righteousness, and respect.

But is this reading, which takes account of the picture's content, inconsistent with art for art's sake? In fact Whistler was lying. At the Royal Academy he had exhibited the portrait with a double title: *Arrangement in Grey and Black: Portrait of the Painter's Mother*. Unlike the more strident statement in 'The Red Rag', the double title leaves us free to explore a richer set of possibilities, in which the formal elements of the picture (the 'arrangement' of lines and colours) and its content (the representation of the artist's elderly mother) are not mutually exclusive. This introduces the possibility of an aesthetic response that depends neither on a sentimental reaction to the depiction of mother-hood, nor on abstracting away the portrait character of the image. The picture is compelling as a set of abstract, monochrome shapes; it is fascinating as an unconventional representation of a mother. But Whistler's project is perhaps more daring still. He asks us to make the judgement of taste—'This is beautiful'—in relation to a painting of an old woman in plain black against a grey background. To see beauty in form and content *together* in this picture is a more complex and inter-esting experiment than the formalist approach that Whistler seems superficially to espouse in 'The Red Rag' and other writings.

In an essay first published in 1869, and subsequently incorporated into *The Renaissance*, Pater explored similar ideas in relation to one of the most famous portraits of past art, Leonardo's *Mona Lisa* [93]. First Pater suggests that the 'unfathomable smile' derives from artistic tradi-tion, from the designs of Leonardo's teacher Andrea del Verrocchio (*c*.1435–88), which the young artist copied in his student days. On the

other hand, Pater notes, the picture is a portrait of a historical woman of late-fifteenth-century Florence. And he immediately introduces a third possibility: 'From childhood we see this image defining itself on the fabric of his dreams; and but for express historical testimony, we might fancy that this was but his ideal lady, embodied and beheld at last' (this recalls Raphael's famous letter, about painting an ideal he had in his mind). Pater does not wish to make a final choice among these various possibilities; rather, he keeps all of them in play as 'aesthetic ideas' stimulated by the contemplation of the work: 'What was the relationship of a living Florentine to this creature of his thought? By what strange affinities had the dream and the person grown up thus apart, and yet so closely together?'[42] We might ask such questions about *Whistler's Mother*, or indeed about Rossetti's *Bocca Baciata*: what was the relationship between the living Victorians (Mrs Whistler or Fanny Cornforth) and the images that have come to seem quintessential expressions of the 'personal ideals' (to use Delacroix's term) of Whistler and Rossetti?

Pater leaves his questions unanswered. Instead he writes what became the most famous passage in all his writing:

The presence that rose thus so strangely beside the waters is expressive of what in the ways of a thousand years men had come to desire. Hers is the head upon which all 'the ends of the world are come,' and the eyelids are a little weary. It

is a beauty wrought out from within upon the flesh, the deposit, little cell by cell, of strange thoughts and fantastic reveries and exquisite passions. Set it for a moment beside one of those white Greek goddesses or beautiful women of antiquity [12, 80], and how would they be troubled by this beauty, into which the soul with all its maladies has passed! . . . She is older than the rocks among which she sits; like the vampire, she has been dead many times, and learned the secrets of the grave; and has been a diver in deep seas, and keeps their fallen day about her; and trafficked for strange webs with Eastern merchants: and, as Leda, was the mother of Helen of Troy, and, as Saint Anne, the mother of Mary; and all this has been to her but as the sound of lyres and flutes, and lives only in the delicacy with which it has moulded the changing lineaments, and tinged the eyelids and the hands. The fancy of a perpetual life, sweeping together ten thousand experiences, is an old one; and modern philosophy has conceived the idea of humanity as wrought upon by, and summing up in itself, all modes of thought and life. Certainly Lady Lisa might stand as the embodiment of the old fancy, the symbol of the modern idea.[43]

Pater has perhaps learned from Ruskin how the slightest visual sign can yield the widest meaning. But his method is altogether different. Ruskin analyses every last detail to pin down its meaning in an order of things understood to exist prior to the picture itself (necessarily so, since for Ruskin the origin of all meanings is God). Pater works in the opposite direction. He takes the visual cues of the picture as primary data—the water and rocks, the eyelids 'a little weary', the 'unfathomable smile'—and proceeds to elaborate the 'aesthetic ideas' to which they may give rise in the mind of the observer. Thus the beauty of the picture emerges from the consideration of form and content together. Moreover, Pater's account is 'for art's sake' in that it begins and ends in the aesthetic experience of the work of art. It does not, like Ruskin's, claim to reveal truths that go beyond that aesthetic experience; it does not even pretend to solve the questions raised by the picture itself. Yet Pater shows how this open-ended exploration of a work of art can, paradoxically, generate ideas even wider-ranging than a thought process that aims to link art to other areas of human endeavour. Furthermore, the aesthetic experience creates a new work of art. In the first edition of *The Oxford Book of Modern Verse*, which he compiled and published in 1936, the poet William Butler Yeats (1865–1939) printed part of Pater's passage on the *Mona Lisa* as the first poem of the collection. Thus Pater's meditation on Leonardo's painting became an initiating text for English literary modernism.

In the essay on Leonardo, Pater explored aesthetic issues that were central to current artistic experimentation; but he did so through the analysis of particular works of art, not in general theoretical terms. Indeed, both Swinburne and Pater, after introducing the phrase 'art for art's sake' in 1868, turned largely to practical criticism, and for good reasons. Having established basic terms for art's independence, theory

could go no further, since that would amount to providing a general concept or definition of beauty. Pater describes his critical approach at the beginning of the *Renaissance*, in terms strongly reminiscent of Kant: 'To define beauty, not in the most abstract but in the most concrete terms possible, to find, not its universal formula, but the formula which expresses most adequately this or that special manifestation of it, is the aim of the true student of aesthetics.'[44] 'To define beauty' would be tantamount to prescribing a rule for the artist, something that was anathema to both Swinburne and Pater.

This leaves complete freedom to artists; it also leaves them without guidance. It is simple enough to claim that art does *not* exist for the sake of preaching a moral lesson, of supporting a political cause, of making a fortune, or of a hundred other aims and objectives. But to say that it exists 'for art's sake' is merely to repeat oneself. 'To art, that is best which is most beautiful', Swinburne wrote; but that is no more helpful if we cannot define the beautiful. 'Art for art's sake' does not, then, authorize a particular kind of art, or provide criteria for critical judgement. Rather, it is the statement of an artistic question: what would art be like if it were not for the sake of anything else? In the absence of a general theory of art or beauty, the question can only be answered by seeing what art might be in a particular case; that is, in a particular work of art.

By the same token there is no reason why any particular case should resemble any other; this helps to account for the diversity of approaches among the English artists and writers involved in these aesthetic experiments. In 1877 the first exhibition was held at the Grosvenor Gallery, founded to offer a more sympathetic environment than the Academy; among those invited to exhibit were virtually all of the artists associated with what critics were beginning to call 'Aestheticism'. Thus the exhibition included works as different as Whistler's moody landscape, *Nocturne in Black and Gold* [94], and Burne-Jones's mythological fantasy, *Venus' Mirror* [95]. Ruskin, whose critical word was still powerful, loved Burne-Jones's work and hated Whistler's: 'I have seen, and heard, much of Cockney impudence before now; but never expected to hear a coxcomb ask two hundred guineas for flinging a pot of paint in the public's face', he wrote with obvious reference to the *Nocturne*.[45] Whistler sued Ruskin for libel.

The ensuing courtroom drama brought into public the aesthetic debates that had been going on in artistic circles for two decades; Albert Moore testified for Whistler, and Burne-Jones for Ruskin. Burne-Jones seems genuinely to have agreed with Ruskin, that Whistler was setting a bad example by putting too little labour into his pictures. This ought to have been straightforward to argue in court; members of the special jury of property-holding men were likely to be sympathetic with the work ethic. Moreover, the amount of labour expended in the

94 James McNeill Whistler
Nocturne in Black and Gold
(The Falling Rocket), 1875

95 Edward Burne-Jones
Venus' Mirror, 1877

making of a picture is quantifiable, at least in broad terms. Ruskin's counsel had no difficulty in proving that Whistler had spent less than two days making his *Nocturne*; by contrast Burne-Jones's *Venus' Mirror* must have required months of careful labour. Little wonder, then, that Burne-Jones agreed with Ruskin.

But something singular happened when Burne-Jones gave his testimony. He was resolute in response to all questions about the finish, completeness, composition, detail, and value-for-money of Whistler's pictures: in all of these respects he believed that Whistler had skimped his labour. But he found himself utterly unable to deny, under oath, that Whistler's work might be called 'beautiful'. Burne-Jones has been harshly criticized for his apparent weakness as a witness. But his testimony was not inconsistent, if we remember the aesthetic debates of the preceding years. The quantity of an artist's labour, the amount of finish or detail, are matters of fact; the importance of such things is an ethical issue. These matters belong to 'science' and 'morality', in Swinburne's tripartite scheme: they have nothing to do with beauty. As Burne-Jones found under cross-examination, any number of logical and moral objections cannot prevent us from finding something beautiful.

By the same token a court of law is not the place to decide aesthetic questions; the court can deal only with questions of truth and falsehood, or with right and wrong as defined by the law (Swinburne's 'science' and 'morality', again). Perhaps this helps to account for the jury's equivocal verdict: they found that Ruskin had libelled Whistler, but awarded only the derisory sum of a farthing in damages, as a signal that the case ought never to have been taken to court in the first place.

In effect the jury conceded the autonomy of art, by declaring it none of their business.[46]

Posterity has delivered its own judgement, tending to condemn Burne-Jones and Ruskin for conservatism, and to applaud Whistler's foresight and courage, in fighting to free art from its ties to representational accuracy and didacticism alike, and leading the way towards twentieth-century modernism. The wit and flair with which Whistler argued his case are indeed inspiring. But this judgement is no more justifiable than Ruskin's, aesthetically. As Burne-Jones discovered under cross-examination, to find *Venus' Mirror* beautiful does not mean that *Nocturne in Black and Gold* is not beautiful, or vice versa. Each may be judged beautiful in a judgement of taste, but to rank them would require a logical or moral argument. Each painting makes its own exploration of what it might mean to be 'for art's sake', rather than for the sake of something else: Whistler gives us the excitement of the artist's inspiration, in the very instant of his response to the bursting of a firework; Burne-Jones offers a compelling image of the contemplation or attentiveness that distinguishes aesthetic experience. Whistler catches the instant in its utmost contingency, over before we have time to take it in, and before the artist can make the shapes on the canvas cohere as recognizable form. Burne-Jones, instead, makes the world stand still, in an exquisite pause that leaves the passage of time out of the question, as the figures gaze on their own beauty in the unbroken surface of the crystalline pool. The two pictures have very little in common, but each of the two encapsulates a 'moment' in Pater's sense. Who would deny us either the one or the other? It is the special virtue of the aesthetic that we are not required to choose.

Modernism: Fry and Greenberg

4

Manet's *A Bar at the Folies-Bergère* [**96**] can be seen as a brilliant intervention into the aesthetic tradition we have been exploring. The reflection in the mirror permits a hallucinatory view of the figure's back that is strangely discrepant with the front view, a motif often seen in Ingres's portraiture [**51**]. Having noted this, we may observe that the simplification of form for which Manet is famous also has affinities with Ingres's treatment of the human figure. The simplified oval of the woman's face in the Manet, symmetrical and regular, with its deadpan expression, has the abstract beauty of one of Ingres's female faces. This leads to a startling insight: through Ingres, Manet's barmaid looks back to Raphael and to the ideal of beauty that Winckelmann had projected back farther still, to classical antiquity. There is a sidelong glance, too, at the pictures with mirrors of the Rossetti circle [**74, 75**]. *A Bar at the Folies-Bergère* explores the problem of a modern art that can no longer define itself as 'mimetic'—that is, as a mirror image of the external world. For Manet as for Rossetti and Whistler, the mirror has become a deeply problematic idea. Manet's painting presents the problem in a more obviously modern context, an urban place of public entertainment. But we should remember how Baudelaire made 'beauty' the key term for a painting of modern life. Manet's picture shows us what modern beauty might look like; it challenges us to make the judgement of taste about a scene that many contemporaries would have thought vulgar and ugly. We might say that Manet shows us the 'eternal' side of the barmaid's beauty inextricably with her 'modern' side. For Baudelaire both were necessary, and that might explain how Manet's art has come to have the status formerly enjoyed by Raphael or antique sculpture: in today's art history Manet's modernity has taken its place as 'antiquity' (to borrow Baudelaire's criterion for beauty).[1]

But Manet's art is not configured this way in standard histories of modern art. Manet is not presented as an artist who looks back to the western tradition of beauty. He is ordinarily seen in the reverse fashion: as the initiator of a 'modernism' in which beauty is no longer the prime concern. Some such role was already given to Manet in one of the key founding events of modernism: Roger Fry's exhibition of 1910, *Manet and the Post-Impressionists*, in which *A Bar at the Folies-Bergère* was a

Detail of 96

96 Édouard Manet
A Bar at the Folies-Bergère,
1881–2

star exhibit. Fry used Manet as the historical anchor for an exhibition that introduced London art audiences to more recent and contemporary French art that seemed, at least at first, to contravene all accepted notions of beauty. So new was this art that it did not even have a name. According to Desmond MacCarthy (1877–1952), Fry's co-organizer for the exhibition, numerous alternative titles were proposed and rejected until Fry, in exasperation, exclaimed: 'Oh, let's just call them post-impressionists; at any rate, they came after the impressionists'.[2]

'In so far as taste can be changed by one man, it was changed by Roger Fry', wrote Kenneth Clark (himself a notable arbiter of Anglo-American taste, as Director of the National Gallery in London and presenter of the famous television series, *Civilisation*).[3] This is no exaggeration: a century after Fry's exhibition, we still take for granted both Manet's founding role in the history of modernism and the crucial importance of the artists Fry named 'Post-Impressionists'. Moreover, the notorious shock effect of Fry's exhibition helped to establish the idea, powerful throughout the twentieth century, that new art should challenge existing conventions; that to shock or even repel audiences was a mark of the modernity, originality, and vitality of any new art movement. But where does this leave beauty?

Discarding beauty

Roger Fry (1866–1934, **97**) studied natural sciences at the University of Cambridge, but while he was there he became increasingly interested in art; Sidney Colvin, Slade Professor and founder of the Fine Arts Society at Cambridge, left for a post at the British Museum just as Fry arrived, but it is likely that Colvin's early version of formalism (see above, p. 139) left its mark on the study of art at the University and had some influence on Fry. After taking his degree Fry gave up his promising scientific career to train as a painter. In the process, he became a uniquely attentive student of the art of past and present, a notable connoisseur, critic, and lecturer. He was an aesthetic theorist only as a consequence of these other activities: 'My aesthetic has been a purely practical one, a tentative expedient, an attempt to reduce to some kind of order my aesthetic impressions up to date.'[4] He was never

97 Roger Fry
Self-Portrait, 1918

particularly learned in philosophical aesthetics, and his ingrained dislike of all things German (common enough among the English in the years leading up to World War I) perhaps prevented him from engaging in serious study of the German aesthetic tradition. Thus his theoretical writings can seem disappointing if they are probed for logical consistency. They are more interesting, though, if they are considered as attempts to grapple with the problems raised by the contemplation of objects that previous generations had not called beautiful: not only modern French art, but such things as African and Pre-Columbian sculpture, Islamic and Chinese art, cave paintings and children's drawings.

Fry's repudiation of 'beauty' as a key term for his emerging aesthetic has, indeed, the character of an expedient. He used the word extensively in a lecture of 1908, his first attempt to collect his thoughts on aesthetics, but largely purged it from the text he developed from the lecture for publication the next year, as 'An Essay in Aesthetics'.[5] Later he explained the problem: 'It became clear that we had confused two distinct uses of the word beautiful, that when we used beauty to describe a favourable aesthetic judgment on a work of art we meant something quite different from our praise of a woman, a sunset or a horse as beautiful.'[6] It was, then, partly to avoid confusion with everyday usage that, after 1909, Fry generally chose terms other than 'beauty' to indicate a 'favourable aesthetic judgment' on works of art: terms such as 'intrinsic aesthetic value', 'expressive plastic form', and above all 'design'. In 1914, Fry's close associate Clive Bell (1881–1964) published a blunter attack on the confusion of terms in his book *Art*: 'With the man-in-the-street "beautiful" is more often than not synonymous with "desirable"; the word does not necessarily connote any aesthetic reaction whatever, and I am tempted to believe that in the minds of many the sexual flavour of the word is stronger than the aesthetic.'[7] Bell's substitute term for 'beauty' was 'significant form' [**98**].

It will be evident that Fry and Bell were objecting, in part, to the use of the word 'beauty' in senses that Kant would have associated, instead, with the word 'agreeable'. The confusion they noted in everyday usage was nothing new, then; but the problem perhaps acquired a new urgency in relation to twentieth-century artistic projects. More than ever, 'beauty' seemed too bland or anodyne a term to describe the gritty, deliberately ugly, or confrontational art of certain modern artists, or the abrupt strangeness, to European eyes, of the arts of Africa, the Far East, or South America. Thus a number of twentieth-century artists and critics explicitly denounced 'beauty' as an artistic aim. In an article of 1948 entitled 'The Sublime Is Now', the American artist Barnett Newman (1905–70) declared that 'The impulse of modern art was [the] desire to destroy beauty', which he associated with the outmoded past of the European tradition.

98 Max Beerbohm

Significant Form, 1921.
Inscribed: 'Mr Clive Bell: I
always think that when one
feels one's been carrying a
theory too far, *then's* the time
to carry it a little further.'
Mr Roger Fry: 'A *little*? Good
heavens man! Are you
growing old?'

Perhaps it could be argued that by dropping the word 'beauty', twentieth-century writers were simply widening the range of objects that might be described as having aesthetic value. Indeed, Kant himself had used the term 'sublime' to describe powerful aesthetic experiences that involved feelings of displeasure or resistance. For all the aggressiveness of his repudiation of 'beauty', Newman uses the substitute term 'sublime' in ways that strikingly affirm the importance of aesthetic experience. 'We are reasserting man's natural desire for the exalted', he writes of his American contemporaries,[8] in terms that recall the aspirations to transcendence in such writers as Cousin or Baudelaire. Can it be argued, then, that substitute terms such as Fry's 'design', Bell's 'significant form', and Newman's 'sublime' represent attempts to recapture the wider implications of 'beauty' in the Kantian tradition, precisely by discarding the watered-down associations of the word in everyday usage? Desmond MacCarthy made just such a claim, in an article of 1912 entitled 'Kant and Post-Impressionism': 'What Mr. Bell means by "significant form" is what Kant meant by "free" beauty.'[9]

But MacCarthy was wrong, or at least he failed to emphasize a basic difference between Bell's aesthetic and that of Kant. Bell's 'significant form' is not, like Kant's 'beauty', a term conferred on objects simply to indicate that their contemplation arouses delight in the observer; it is, as Bell explicitly states, a *property* of art objects, and *only* of art objects. Likewise Fry's 'design', Newman's 'sublime', and other terms used by twentieth-century writers are designations specifically for art, and not for other objects in the contemplation of which we might take delight (such as 'a woman, a sunset or a horse', in Fry's phrase). Thus the disappearance of the word 'beauty' in twentieth-century writing is not merely a matter of avoiding the confusions of everyday usage. It is symptomatic, instead, of a thoroughgoing change in the agenda for aesthetics. In the twentieth century the basic question was no longer 'is *x* beautiful?' but, rather, 'is it art?'[10]

For Fry and Bell, this reorientation may have come about as a consequence, perhaps even an inadvertent one, of their zeal to promote modern art. To this end they diverted attention from the subjective and 'free' experience of beauty, and redirected it towards the properties of the art *objects* they championed. This entailed a number of further departures from the Kantian tradition: Fry and Bell divorced the experience of art from other kinds of aesthetic experience, they reinstated hierarchical distinctions among aesthetic objects, and, above all, they limited the aesthetic response to the purely formal characteristics of the object (as opposed to Kant's more open-ended notion of 'aesthetic ideas'). Moreover, this redirection in aesthetics proved as successful as the revolution in taste, to which it was, indeed, intimately linked: together, 'modernist' art and 'formalist' aesthetics achieved a

formidable dominance in art education, criticism, and academic art history for much of the twentieth century. As we shall see, this in turn produced a backlash which has threatened to discredit not only formalist aesthetics, but aesthetics of any kind. But in order to understand these recent developments, and the position of the aesthetic in our own time, we need to ask why the formalist aesthetic of Fry and Bell proved so powerful in the first place.

Fry's formalism

As a practising painter, Fry was specially alert to the technical and material aspects of works of art from the moment he began to write art criticism in 1900. However, it took some time for him to develop the 'formalist' approach for which he is now famous. At the beginning of his critical career, he wrote a series of articles on the early Italian Renaissance painter Giotto (*c.*1267–1337), in which he stressed the dramatic aspects of Giotto's approach to religious subject-matter. By 1920, when he republished part of his work on Giotto in a collection of his own criticism entitled *Vision and Design*, he had changed his critical approach so thoroughly that he felt obliged to explain the change in a footnote:

The following . . . is, perhaps more than any other article here reprinted, at variance with the more recent expressions of my aesthetic ideas. It will be seen that great emphasis is laid on Giotto's expression of the dramatic idea in his pictures. I still think this is perfectly true so far as it goes, nor do I doubt that an artist like Giotto did envisage such an expression. I should be inclined to disagree wherever in this article there appears the assumption not only that the dramatic idea may have inspired the artist to the creation of his form, but that the value of the form for us is bound up with recognition of the dramatic idea. It now seems to me possible by a more searching analysis of our experience in front of a work of art to disentangle our reaction to pure form from our reaction to its implied associated ideas.[11]

In this footnote Fry makes a distinction which had become crucial to his thinking: between 'pure form' on the one hand and 'associated ideas' on the other. Moreover, he claims that it is at least possible to respond to form alone, without considering either the 'dramatic idea' or any 'associated ideas'. But why should Fry insist on this possibility, in discussing works which, as he freely admits, were made in order to convey a 'dramatic idea'?

One of the works Fry had discussed in the original article was a fresco from the Arena Chapel in Padua that depicts the followers of Christ mourning over his body after it had been removed from the cross [99]; the traditional title, *Pietà*, refers to the emotion of pity felt by the mourners in the Christian story, and potentially also by viewers

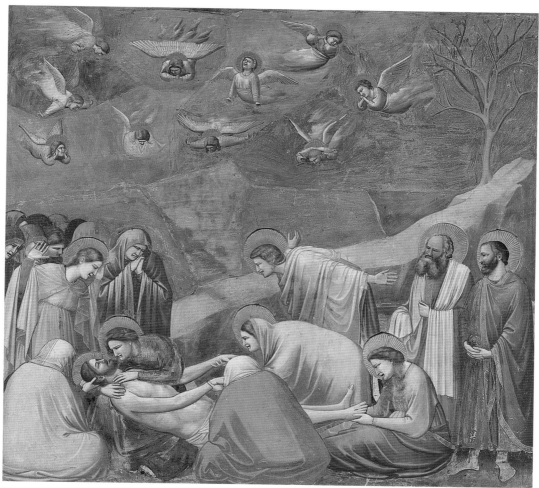

99 Giotto
Pietà, 1303–5

of the moving scene in Giotto's representation. Thus the viewer may respond both to the drama of the depicted event and to its emotional force. In 1901 Fry wrote memorably about the picture, considered in this fashion; he described it as an 'epic conception . . . for the impression conveyed is of a universal and cosmic disaster: the air is rent with the shrieks of desperate angels whose bodies are contorted in a raging frenzy of compassion.' For Fry at this date, the formal qualities of the picture are intimately bound up with its dramatic and emotional expressiveness: 'the effect is due in part to the increased command, which the Paduan frescoes show, of simplicity and logical directness of design'. The simplicity of the formal design, in this interpretation, elevates the religious message above the merely histrionic portrayal of grief to acquire a dignity that Fry associates with the art of classical antiquity. But he does not at this stage attempt to divorce this dignity of style from the emotional and religious expressiveness of the scene; as he concludes, the achievement of 'the urbanity of a great style' is all the

more impressive because in this work Giotto deals with profound human emotion.[12]

However, the footnote indicates that by 1920 Fry would have wished to interpret the painting differently. He would no longer stress the 'dramatic idea', the 'universal and cosmic disaster' of Christ's crucifixion. Nor would he take into account any 'associated ideas' such as, perhaps, the way the scene may remind us of our own experiences of grief or mourning. Now he believes that the viewer can respond to the forms alone, and moreover that these have 'value' independently of the dramatic idea or of any associated ideas. Although he does not attempt to provide a purely formal account of this work, we might construct one. The long diagonal establishes a rising slope from lower left to upper right within the square format. Massive forms beneath the diagonal follow and vary its sweep; their volume and solidity anchors the composition at lower left, giving a sense of physical gravity. By contrast the forms above the diagonal appear free and weightless, and even convey circling movement. As we shall see later in this chapter, some later versions of formalism stressed the flatness of the picture surface over the indication of three-dimensional form, but Fry was always happy to admit the 'plastic' or volumetric qualities of painted forms. Thus we may find the counterpoint between the massiveness of the forms at lower left and the lightness of the upper regions specially satisfying, and complementary to the large-scale linear organization of the picture along its diagonal slope.

There are a number of advantages to this 'formalist' approach. It would make it possible for a non-western viewer who had no knowledge of Christianity to find value in the picture. By extension it could permit viewers who object to the religious messages of Christian subject-matter to contemplate the painting. The formal account might also encourage a special freshness of response to the work, since the viewer would not bring her preconceptions about the Christian story, or even about emotions of grief and mourning, to bear on the experience. (This is a point of special importance to Fry and Bell, to which we shall return.) But Fry goes further: by 1920 he is convinced not only that an attention to 'pure form' is good on its own terms, but also that it is *superior* to a response that takes into account dramatic narrative, engagement of the emotions we feel in life (such as pity or grief), and, above all, 'associated ideas'. Why, we may ask, should we seek to cut off those other kinds of response? Indeed, we can observe a certain parallelism between the 'dramatic' and the 'formalist' accounts of Giotto's *Pietà*. Both lead us to attend to the dense group of figures at the lower left. We may account for this in formal terms, by noting how the convergence of linear elements and plastic volumes in this area produces a particularly arresting visual effect, or in dramatic terms, by observing that this is where the mourners cluster around the body of Christ. Is it

not the case that the two accounts reinforce one another, and that acknowledging *both* produces a richer interpretation than either one on its own?

Why, then, was Fry so concerned to promote attention to 'pure form'? In 'Retrospect', the last essay in *Vision and Design*, Fry explains how his encounters with recent French art had changed his thinking. When he first published the essays on Giotto, Fry had been pessimistic about the art of his own day; he believed that Impressionism, the most recent artistic movement with which he was then familiar, lacked the excellence in design that he found in artists of the early Italian Renaissance. Then, in 1906, Fry happened on two paintings by Paul Cézanne (1839–1906), which seemed to offer a new alternative: 'To my intense surprise I found myself deeply moved'.[13] The paintings were a still life and a landscape [**100**, **101**].[14] Thus they lacked important subject-matter of the kind found in Giotto's works, and initially Fry was at something of a loss to account for the intensity of his own reaction; he described the pictures' appeal as 'limited' when he first wrote about them in 1906. Nonetheless this initial review shows that the formal organization of the two works had impressed him strongly, even though he could not yet reconcile this with his beliefs about art (as he recalled in 1920, 'I was still obsessed by ideas about the content of a work of art').[15] The experience proved as decisive for Fry as Ruskin's 'unconversion' before Veronese's *Solomon and the Queen of Sheba* [**66**] had been. In the next few years Fry sought out the paintings of Cézanne and other artists, such as Paul Gauguin (1848–1903) and Vincent van Gogh (1853–90), who also seemed to have moved away from Impressionism. This led eventually to the Post-Impressionist exhibition of 1910 (and a follow-up exhibition two years later). But it also led Fry to reconsider his aesthetic views. Within a few years he no longer thought Cézanne's art 'limited' simply because it lacked important subject-matter; instead he elevated the importance of 'pure form', the quality he *did* find in the Cézannes, to prime position in his emerging aesthetic.

By 'form', Fry did not mean merely visual attractiveness. The paintings of the Impressionists were attractive enough. Moreover, the Impressionists were adept, as Fry always acknowledged, at capturing lovely visual aspects of the natural world, particularly effects of light and atmosphere [**63**]. The qualities of 'pure form' that Fry found in Cézanne and the Post-Impressionists were different. Fry believed that they no longer depended on imitating the loveliness of appearances in the world outside the picture; rather, they were created in the picture itself. This is already evident in his brief evaluation of the two Cézannes in 1906. In Fry's account of the still life [**100**], the local colours of the objects (white napkin, grey pewter, green earthenware) are given full intensity and juxtaposed for the 'decorative values' of their

relations on the canvas; the 'laws of appearance' are sacrificed to the pictorial 'pattern', for instance in the shadows of the white napkin, painted stark black even though the Impressionists had shown that such shadows appear coloured. It should be emphasized that Fry has no quarrel with the fact that the paintings are representational. Indeed, he finds the landscape [**101**] particularly powerful in presenting spatial relations: 'The sky recedes miraculously behind the hill-side, answered by the inverted concavity of lighted air in the pool'.[16] But this is achieved by 'a perfect instinct for the expressive quality of tone values' *within* the picture, not by cleverly reproducing the appearance of natural effects.

It may now be easier to see why it was so important to Fry to distinguish between the two usages of the word 'beauty', the one to denote the loveliness of a natural scene or appearance, the other to denote the special qualities of the work of art. It is indeed less confusing to use words such as 'form' or 'design' to replace 'beauty' in the second sense. For Fry the 'form' of a painting has nothing to do with the 'beauty' of the objects it represents. The scene in *The Pool at the Jas de Bouffan* is forbiddingly austere, the branches are bare and jagged, the houses are plain and uninviting, and the central tree bisects the picture in an ungainly fashion; all of this is not beautiful in any conventional sense. But, for Fry at least, the visual relationships among the lines and colours of this canvas demonstrate the greatest qualities of 'design'. They are 'expressive' and move the viewer with profound 'emotion'. These words denote something that is exclusively to do with the work of art and not with the world outside it. The forms do not 'express'

associated ideas, for example about the changing of the seasons, the loneliness of an uninhabited landscape, or the poverty of a rural hamlet; rather, they are 'expressive' in themselves. The viewer's 'emotion' is not one of those we experience in everyday life, such as sadness, nostalgia, or compassion; it is special to the contemplation of the work of art. By rigorously isolating 'pure form' from the kinds of visual attractiveness, expressiveness, and emotion that we experience in real life, Fry was able to claim that Cézanne's art was of superlative value, even though it might represent nothing more than a few bare trees in a bleak landscape, and offered little or no human interest. And the claim has proved utterly persuasive. Despite objections to Fry's formalism that gathered in force in the late twentieth century, his high valuation of Cézanne remains unchallenged to this day.

It can be argued, then, that Fry developed his formalist aesthetic in response to a particular kind of art, the kind he named 'Post-Impressionist', and that it was therefore specially adapted to that kind of art. Both Giotto's *Pietà* and Cézanne's *The Pool at the Jas de Bouffan* are visually compelling, but Fry's emphasis on 'pure form' seems to miss something important about the Giotto, while it makes the Cézanne more exciting than we might have anticipated. In Bell's *Art* the special pleading for Post-Impressionism is obvious. Indeed, Bell's blatant partisanship gives a polemical edge that makes for exciting reading; he claimed portentously, for example, that 'since the Byzantine primitives set their mosaics at Ravenna [in the sixth century] no artist in Europe has created forms of greater significance unless it be Cézanne'.[17] Fry

102 Anonymous (Song Dynasty)

Bowl, Jun ware

was subtler in his advocacy of Post-Impressionism; moreover, his interests were wider. He was not only concerned to promote the contemporary art he favoured, he genuinely believed that his formalist method should be extended to the art of all times and places.

Thus *Vision and Design* includes articles on aboriginal art, African sculpture, Pre-Columbian and Islamic art, as well as a wide variety of European artists. At the time of his death in 1934 Fry was in the midst of his first series of lectures as Slade Professor of Fine Art at Cambridge. In his initial lectures he had already discussed the ancient art of Egypt, Mesopotamia, the Aegean, Africa, the Americas, China, India, and Greece; moreover, he had dealt with media as diverse as pottery, masks, textiles, jewellery, as well as the traditional 'high' arts. Seventy years later, only a tiny number of university art history departments can cover a global range as extensive as Fry's, despite massive recent efforts to widen art history beyond its traditional focus on western Europe and on the 'high' arts of painting, sculpture, and architecture.

It was Fry's formalist method that allowed him to achieve this extraordinary coverage. Formalism gave him a way of looking at *any* work of art, even if he knew little or nothing about the historical circumstances in which it was created or the culture that produced it. In *Vision and Design* he offers a demonstration of how this might work in analysing a bowl from China in the Song period (for an example see **102**). He shows how we might attend to the bowl, not merely by glancing at it, but by exploring its forms in a logical sequence:

we apprehend gradually the shape of the outside contour, the perfect sequence of the curves, and the subtle modifications of a certain type of curve which it shows; we also feel the relation of the concave curves of the inside to the outside contour; we realise that the precise thickness of the walls is consistent with the particular kind of matter of which it is made, its appearance of density and resistance; and finally we recognise, perhaps, how satisfactorily for the display of all these plastic qualities are the colour and the dull lustre of the glaze.

Through looking at the forms alone, we become aware of 'a feeling of
purpose', a sense that we can grasp the artist's idea in making it. But
Fry is adamant that this has nothing to do with 'curiosity' (for instance
about the artist's personality or circumstances) and does not involve the
interests of 'actual life' (such as the functions the bowl served, or the
patrons who bought it). Fry acknowledges that we may choose to ask
different questions about the bowl:

We may, of course, at any moment switch off from the aesthetic vision, and
become interested in all sorts of quasi-biological feelings; we may inquire
whether it is genuine or not, whether it is worth the sum given for it, and so
forth; but in proportion as we do this we change the focus of our vision; we are
more likely to examine the bottom of the bowl for traces of marks than to look
at the bowl itself.[18]

For many art historians of the late twentieth century Fry's disregard of
historical circumstances not only neglected important data, it could
seem morally irresponsible, as Fry is prepared to ignore questions about
the Chinese political and social circumstances in which the bowl was
made, or the western ones in which it was appropriated for modern
delectation or, perhaps, for commercial gain. But for Fry all works of
art are contemporary, if they are powerful enough to move the observer
in the present day. Of the Song bowl he writes: 'our apprehension is
unconditioned by considerations of space or time; it is irrelevant to
us to know whether the bowl was made seven hundred years ago in
China, or in New York yesterday'; and indeed, Fry's looking method
would serve equally well in the contemplation of a modern bowl (such
as **103**).

Fry's accounts of non-western objects often betray the prejudices of
his age and social milieu. Thus he calls African sculptors 'savages' and
takes it for granted that their cultures are not 'civilized'. Since formal-
ism deliberately excluded the values of 'actual life', it gave no way to
overcome the knee-jerk prejudices of an upper-class Englishman. On
the other hand, Fry looked with utmost seriousness at an astonishing

variety of objects that most upper-class Englishmen would have dismissed as valueless; what is more, he made others of his and later generations look at them too. Fry's opinions of 'negroes' are rebarbative; but his opinion of what he calls 'negro sculpture' is nonetheless revelatory (for example **104**). Indeed, he believes African sculptures display a 'complete plastic freedom' that is superior to European sculpture. Even the best European sculpture, Fry argues, interprets sculptural form as four sides of a block carved in relief. African sculptures, however, are fully three-dimensional:

The neck and the torso are conceived as cylinders, not as masses with a square section. The head is conceived as a pear-shaped mass. It is conceived as a single whole, not arrived at by approach from the mask. . . . The mask itself is conceived as a concave plane cut out of this otherwise perfectly unified mass.

Most of Fry's contemporaries saw, in African sculpture, a lack of skill in representing the human body. But when Fry looks at African sculpture he sees, instead, an approach to form that is aesthetically *superior* to the naturalistic body in western sculpture. In Fry's view, human limbs as represented in the western classical tradition lack fine plastic form; they are too long, thin, and isolated from the other masses [**11**]. The African sculptor, however, rightly prefers plastic expressiveness to naturalism: 'his plastic sense leads him to give its utmost amplitude and relief to all the protuberant parts of the body, and to get thereby an extraordinarily emphatic and impressive sequence of planes'.[19]

Fry rigorously applies his formalist technique: he stops at formal analysis of the African sculptures. Arguably a wider interpretation of Kant's 'aesthetic ideas' would permit a further leap, so that perceiving the excellence of the sculptures could lead the viewer to muse on the distinctive values of the cultures that produced them. Thus formalism closes off possibilities for further interpretation; on the other hand, within its own, strictly limited province it permits a close attentiveness that may pinpoint unique qualities of the particular work under observation. Both the strength and the defect of formalism, then, consist in its strict limitation to the object's specificity. A thoroughgoing formalist analysis of Cézanne's *Apples* [**105**] would not use the word 'apples' at all, and certainly would not call upon any further ideas about apples (such as their association with the autumnal season, with the Garden of Eden and original sin, or with women's breasts); it would limit itself to describing their shapes and colours. Fry shows how this might be done in his account of the Song bowl; he uses almost no technical vocabulary, but confines himself to ordinary words for visual description: 'contour', 'curves', 'thickness', 'colour', 'lustre'. He manages to make a compelling narrative of this, at the same time teaching his readers a method for examining an object. In his descriptions of two-dimensional objects, such as the nine-page account of *Still Life with*

105 Paul Cézanne
Apples, c.1877–8

106 Paul Cézanne
Still Life with Compotier
[*Fruit Dish*], 1879–80

Compotier [*Fruit Dish*] [**106**] in his book of 1927 on Cézanne, he traces a visual path through the picture, beginning with a careful description of the shape of the individual brushstrokes, then showing how the strokes build into a unity over the picture surface, finally exploring the relations of the larger shapes, the evocation of three-dimensional volumes, and the sequence of pictorial planes. Only rarely does he resort to words that indicate the represented objects, such as the napkin or the knife. Yet he is able to make formal description into drama, for example in the passage on how Cézanne paints the contours of objects in the picture:

He actually draws the contour with his brush, generally in a bluish grey. Naturally the curvature of this line is sharply contrasted with his parallel hatchings, and arrests the eye too much. He then returns upon it incessantly by repeated hatchings which gradually heap up round the contour to a great thickness. The contour is continually being lost and then recovered again.[20]

This kind of criticism is by no means easy, and few critics have managed to write this way at any length. Fry's *Cézanne*, although a short book, is nonetheless a tour de force in making a compelling story out of purely formal analysis. To do this Fry is obliged to sacrifice much of what art historians, from Winckelmann to the present, have ordinarily discussed —the historical and social contexts of Cézanne's work, the artistic movements and intellectual debates of the time, even the artist's biography, which is sketched only through the briefest of hints. But his account is unparalleled in the way it brings out the uniqueness of Cézanne's art, the qualities that are special to it and shared with no other.

From disinterest to 'aesthetic emotion'

A strong argument in favour of formalism is that it can give us a way to start looking at an object about which we know nothing, or against which we might otherwise be prejudiced because of 'associated ideas' (such as the idea that African cultures are not 'civilized'). Thus formalism could be considered a particularly cogent interpretation of what Kant called 'disinterest': purging our minds of all 'associated ideas' ought to allow us complete freedom to contemplate objects without preconceptions or prejudices. At times both Fry and Bell come close to such notions, as for example in this passage from *Vision and Design*:

All art depends upon cutting off the practical responses to sensations of ordinary life, thereby setting free a pure and as it were disembodied functioning of the spirit; but in so far as the artist relies on the associated ideas of the objects which he represents, his work is not completely free and pure, since romantic associations imply at least an imagined practical activity. The disadvantage of such an art of associated ideas is that its effect really depends on what we bring with us: it adds no entirely new factor to our experience.[21]

Bell relies on a similar argument in *Art*. Most people, he says, are insensitive to 'significant form'; therefore they search works of art for 'associated ideas' that arouse more familiar responses:

they read into the forms of the work those facts and ideas for which they are capable of feeling emotion, and feel for them the emotions that they can feel—the ordinary emotions of life. . . . Instead of going out on the stream of art into a new world of aesthetic experience, they turn a sharp corner and come straight home to the world of human interests. For them the significance of a work of art depends on what they bring to it; no new thing is added to their lives, only the old material is stirred.[22]

This led Bell to posit an 'aesthetic emotion', different from 'the ordinary emotions of life', and characteristic of experiences of 'significant form'.

Apart from the inveterate snobbery that led both Bell and Fry to insist that most people were incapable of experiencing 'aesthetic emotion', this set of ideas has much to recommend it. 'Associated ideas' may indeed lead to stereotyped responses that merely confirm our prejudices. Divesting our minds of such ideas to concentrate on the formal characteristics of an object may therefore have a 'defamiliarizing' effect, jolting us out of our habitual responses and opening our minds to new and different possibilities. As we have already seen, giving up our European cultural prejudice in favour of the 'associated idea' that human beings ought to appear agile can allow us to experience a wholly different sense of vitality in the complex, fully plastic forms of African sculpture [**104**]. Cézanne's *Apples* [**105**] would appear fairly trivial if we responded as we respond to apples in everyday life; it might even appear crude, as Cézanne's work did to many observers at this date, in its use of chunky, painty strokes to denote the smooth polished spheres we expect when we see apples. But if we attend to the repeating rhythms of the parallel brushstrokes, the even weave of strokes across the surface, the way their slight diagonal orientation plays against the rectangular edges of the canvas, the juxtapositions of intense reds, greens, and yellows with dark contours, we see not just seven apples, but a whole pictorial world, consistent within itself and mesmerizing in its range from light to dark. For Fry the effect of Cézanne's pictorial forms was actually superior to that of real apples; Cézanne's painting could 'enforce, far more than real apples could, the sense of their density and mass'.[23]

Formalist looking may, then, provide a method of attaining disinterest in the contemplation of objects, and thus of moving beyond what we already know or believe (what apples look like, what characteristics human bodies should display) towards experiences that are unexpected, deeper, or wider-ranging. On the other hand, formalist looking is not *necessarily* disinterested, and indeed it may have lost some of its defamiliarizing effect in the century since Fry and Bell.

Most lovers of modern art no longer require pictures to resemble 'real' objects, but we bring all kinds of interests into the contemplation of form in art. We may take pride in our superior cultivation if we are able to comment on the 'purely formal' aspects of a painting by Cézanne (indeed the quotation from Bell indicates that the ability to appreciate 'significant form' in art was already a status symbol, at least among the progressive elite of London art-lovers, in 1914). Or we may interpret the abstract forms of a painting by Jackson Pollock [112] as evidence of American political freedom in the cold war period.

Despite his emphasis on the word 'free', Fry's characterization of aesthetic response is not open-ended; rather, it depends on 'cutting off' certain kinds of response, as Bell's 'aesthetic emotion' does by excluding the 'ordinary emotions of life'. Moreover, both writers at least imply that the properly aesthetic response is available only in relation to certain kinds of *objects*—for Bell, objects that display 'significant form'; for Fry, objects that do not depend too much on 'associated ideas'. For Fry and Bell a properly disinterested response is possible only in relation to art, because it is only in the contemplation of art that we can cut off the practical responses and emotions of 'actual life'. Fry's vivid example, in 'An Essay in Aesthetics', is the sight of a wild bull in a field. In actual life we do not see much of the bull, because we are too busy running away; it is only when we see the charging bull in a work of art, such as a film, that we are able to give it the kind of disinterested contemplation that characterizes aesthetic experience.[24]

At first thought this may seem reasonable enough, or even attractive: in an unjust world art may offer us the hope, at least, of a kind of experience that is not poisoned by self-interest, commercialism, hypocrisy, or the manipulation of others. But as soon as the aesthetic experience is made to depend, partly, on characteristics of the object under contemplation, the freedom of the Kantian aesthetic is lost. Once it has been conceded that the possibility of a disinterested judgement depends on something about the object (whether it is 'art' or not), it becomes reasonable to suppose that some art objects will be more suitable for disinterested contemplation than others. 'Formalism' then becomes not merely a way of attaining disinterested contemplation, but a characteristic of objects and, what is more, a criterion for judging them. Thus works that privilege 'pure form' over 'associated ideas' are to be preferred; a rule for artistic production is created, and with it a hierarchy of artworks past and present. Fry and Bell introduce all manner of manichaean divisions: between Graeco-Roman sculpture (bad) and African sculpture (good), between the highly developed illusionism of the European tradition, including Impressionism (bad), and the simplicity of primitive art forms (good), between the mass of observers who bring their own experiences to bear on art (bad) and the sophisticated connoisseur who is attentive to form alone (good).

Many of these judgements had the virtue, however, of overturning previous conventions for taste and introducing new possibilities not only for aesthetic contemplation, but for artmaking. We have been concentrating on the English critics, Fry and Bell, but similar ideas were alive in the international art world of the time. As early as 1890, the French artist and theorist Maurice Denis (1870–1943), an important influence on Fry's thinking, wrote: 'Remember that a painting —before being a warhorse, a nude woman, or any kind of anecdote—is essentially a flat surface covered with colours assembled in a certain order'.[25] Such ideas were played out with extraordinary inventiveness in the art of the early twentieth century, as artists used formal experimentation and non-western influences to break away from the conventions of previous European taste. Within a short space there appeared such art forms as Cubism, breaking up the solid masses of the Renaissance tradition into innumerable facets [**107**]; the total elimination of recognizable objects, as in the work of the Russian artist Kasimir Malevich (1878–1935, **108**) or the Dutch Theo van Doesburg (1883–1931, **109**); the use of colour to create form in the work of Wassily Kandinsky (1866–1944, **110**). The sight of Kandinsky's work in 1913 finally convinced Fry that abstract painting could be successful; he described the paintings as 'pure visual music'.[26]

108 Kasimir Malevich
Black Square, 1915

109 Theo van Doesburg
Composition 17, 1919

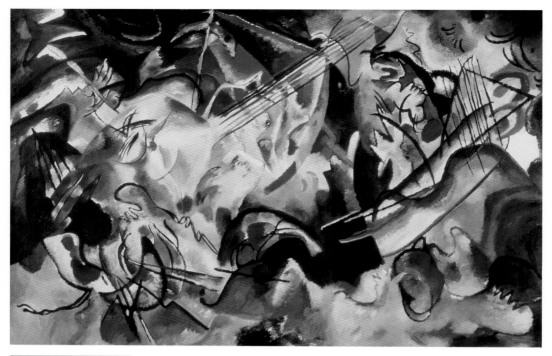

110 Wassily Kandinsky
Composition VI, 1913

Arguably the most radical experiment of all was that of the French artist Marcel Duchamp (1887–1968). From 1913–17 Duchamp devised a series of 'readymades', ordinary objects chosen, but not made, by the artist: a bicycle wheel, a bottle rack, a snow shovel, a dog-grooming comb, and—most notoriously—a porcelain urinal, entitled *Fountain* and signed with the fictitious name 'R. Mutt' [**111**]. Simultaneously with the efforts of critics such as Fry and Bell to establish an absolute difference between art objects and other kinds of object, Duchamp's readymades questioned the terms on which any such distinction could be made. Duchamp put this to the test by submitting *Fountain* to a New York exhibition of 1917. After it was rejected as unsuitable for an art exhibition, an editorial appeared in a little magazine run by Duchamp and his friends: 'Whether Mr. Mutt with his own hands made the fountain or not has no importance. He CHOSE it. He took an ordinary article of life, placed it so that its useful significance disappeared under the new title and point of view—created a new thought for that object.'[27] This passage, perhaps written by Duchamp himself, displays sophisticated knowledge of the western tradition of aesthetics. By the simplest of expedients—placing the urinal on its back—it loses its useful purpose; thus it becomes an object for aesthetic contemplation, in terms that go back to Madame de Staël (see pp. 69–70 above). Moreover, the fact that the artist had not 'made' it resolved, at a stroke, one of the problems that had surrounded artmaking since Kant's *Critique of Judgement*, the problem of how

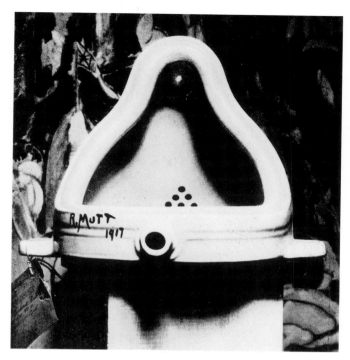

something intentionally executed could be counted a 'free' beauty (see pp. 56–81 above).

Duchamp's project has a special integrity: he tested the limits of art and taste in the most rigorous—and witty—way. *Fountain* has often been seen as a radical negation of the whole tradition of western aesthetics, and in a sense this is so; the object, signed like an artwork and submitted to an art exhibition, makes nonsense of the efforts of critics such as Fry and Bell to posit an absolute distinction between art and non-art. *Fountain* is perfectly amenable to a formalist description of the kind Fry practised; the looking method used for the Song bowl would work admirably for contemplating the urinal. Moreover, although the original *Fountain* soon disappeared, replicas of it now appear in museum collections; that is, it is now accepted as belonging to the category 'art'. By the most economical of means, Duchamp had demonstrated a fatal flaw in the attempt to make an objective distinction between art and non-art.

But does the work also negate the notion of beauty? Precisely by demonstrating that nothing about the *object* can distinguish it as art or non-art, beautiful or ugly, *Fountain* and the other readymades can be said to reinstate the Kantian principle of the subjectivity of taste. It is up to the artist to confer value upon it, by choosing it and thus 'creating a new thought' for it. The 'new thought' is like an 'aesthetic idea' in that it is not wholly determined by the object. Moreover, the observer remains free to call the readymade beautiful in a judgement of taste,

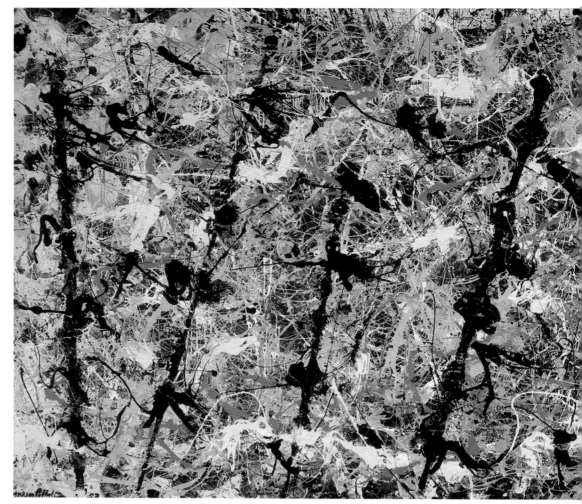

which was just what Duchamp's patron, Walter Arensberg, did when defending *Fountain*: 'A lovely form has been revealed, freed from its functional purpose'.[28] Perhaps the comment was made tongue in cheek, but the point holds: there is no logical rule that can prevent the object from being called beautiful in a judgement of taste.

Clement Greenberg and American abstraction

It is possible to accuse the painter Jackson Pollock, too, of bad taste; but it would be wrong, for what is thought to be Pollock's bad taste is in reality simply his willingness to be ugly in terms of contemporary taste. In the course of time this ugliness will become a new standard of beauty.[29]

Clement Greenberg (1909–94), the critic who wrote these lines in 1946, was correct in his prediction: the art of Jackson Pollock (1912–56) now

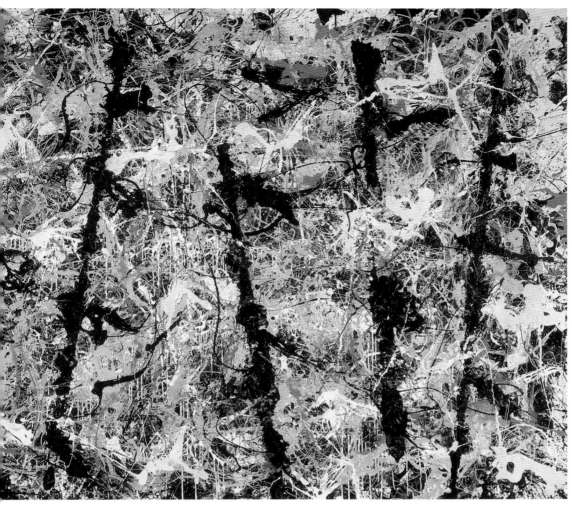

wins virtually universal aesthetic approval from art critics, historians, and audiences [**112**]. For Greenberg the emergence of such a consensus would have seemed a matter of course. As he wrote in his first major article, the famous 'Avant-Garde and Kitsch' of 1939:

All values are human values, relative values, in art as well as elsewhere. Yet there does seem to have been more or less of a general agreement among the cultivated of mankind over the ages as to what is good art and what bad. Taste has varied, but not beyond certain limits. . . . We may have come to prefer Giotto [**99**] to Raphael [**14**, **39**, **44**], but we still do not deny that Raphael was one of the best painters of his time.[30]

This can be read as an interpretation of what Kant meant by insisting that the judgement of taste was both 'subjective' (Greenberg's word is 'relative') and 'universal' (Greenberg's 'general agreement'). Later he would put the claim explicitly into the context of Kantian aesthetics:

Quality in art can be neither ascertained nor proved by logic or discourse. . . . This is what all serious philosophers of art since Immanuel Kant have concluded.

Yet, quality in art is not just a matter of private experience. There is a *consensus* of taste. The best taste is that of the people who, in each generation, spend the most time and trouble on art, and this best taste has always turned out to be unanimous, within certain limits, in its verdicts.[31]

It should be noted that Greenberg's argument for consensus, unlike Kant's, is empirical; he claims, somewhat tendentiously, that consensus has actually existed in history. Kant argues on safer ground that when we make the judgement of taste we are *asking* for the agreement of other people; thus the empirical question of whether people actually *do* agree makes no difference to Kant's argument. Nonetheless, Greenberg's allegiance to Kantian aesthetics is a distinguishing feature of his criticism, together with his forthright advocacy of abstract art and his powerful deployment of a formalist method to interpret that art. Indeed, it is largely through Greenberg's exceptional fame, as the foremost American art critic of the twentieth century, that formalist criticism, Kantian aesthetics, and abstract art have come to seem inseparable from one another.

But they are not inseparable, and Greenberg gives a very particular slant to the Kantian tradition. This is at once evident in his assumption, closer to Roger Fry than to the *Critique of Judgement*, that the consensus of taste is displayed exclusively in relation to art. Moreover, the assumption leads (again as in Fry) to the establishment of a standard or rule for taste, something that Kant was determined to avoid. In 'Avant-Garde and Kitsch', Greenberg continues the passage on taste, quoted above: 'There has been an agreement then, and this agreement rests, I believe, on a fairly constant distinction made between those values only to be found in art and the values which can be found elsewhere.'[32] The essay makes an impassioned and committed case for preserving the values of high art against what Greenberg saw as the tendency of both totalitarian regimes (the essay was published at the height of the power of Hitler, Mussolini, and Stalin) and the 'culture industry' of the 'free' world to reduce art to trivial entertainment. Thus it was crucial to Greenberg, in the historical circumstances of 1939, to make a sharp division between high art (which he calls 'avant-garde') and the art of mere entertainment, or 'kitsch'. For Greenberg it is obvious that 'a painting by Braque' (1882–1963, for example **113**) displays the 'values only to be found in art', whereas a *Saturday Evening Post* cover (such as **114**) is tainted by commercialism and by the promotion of other values, such, perhaps, as the virtues of life in middle America.[33] This is cogent enough, and we may sympathize with it, in the light of the apparently inexorable global spread of commercialized culture since Greenberg's time. Nonetheless, it imposes a value system

113 Georges Braque
Woman at an Easel, 1936

114 Norman Rockwell
Girl Running with Wet Canvas, cover for *The Saturday Evening Post*, 12 April 1930

on the judgement of taste. It may be important to preserve our freedom to find the *Saturday Evening Post* cover beautiful.

For Fry, as we have seen, the 'values only to be found in art' were not tantamount to total abstraction. But Greenberg, from the very beginning of his career, wished to develop a justification for the practice of abstract painting that was beginning to flourish in some New York studios, but which was often treated with hostility in the press. In 1940 he published a second theoretical article, 'Towards a Newer Laocoon', in which he presents a schematic history of modern art that culminates in abstraction. The title of the essay refers all the way back to Lessing's treatise of 1766, *Laocoön, or On the Limits of Painting and Poetry* (see p. 27 above).[34] Greenberg borrowed from Lessing a crucial principle,

the notion that an art form achieved its greatest excellence when it was truest to its own unique characteristics, the ones it shared with no other art form. For Greenberg the arts of Europe had taken a mistaken direction from the seventeenth century, when, as he argued, literature had become the dominant art form; painting and sculpture, in particular, had wrongly attempted to imitate literary values rather than remaining true to their own visual media. Thus the task of modern art, as Greenberg saw it, was above all to free itself from subservience to literature, to subject-matter and representational content. Paradoxically, the modern arts learned to reassert the 'purity' of their own forms by modelling themselves, no longer on literature, but instead on music. At this point Greenberg inserts a footnote to Walter Pater's 'The School of Giorgione' (see pp. 144–5 above). But this is tendentious in the extreme. For Pater, as we saw in Chapter 3, music could serve as the exemplary art form because its sensuous form was saturated with content or meaning. Greenberg presents music, instead, as an art of 'pure form' that does away with content altogether, one 'which is abstract because it is almost nothing but sensuous'.[35] This deprives music of the richness of content that Pater allowed to it. At the same time, though, it establishes a justification for total abstraction as the ultimate goal of art. Just as music reaches excellence by restricting itself to its sensuous medium, pure sound, so the visual arts, for Greenberg, should purge themselves of everything that is not integral to their sensuous media: coloured pigments on a flat surface for painting; wood, metal, or stone for sculpture.

In 'Towards a Newer Laocoon', then, Greenberg weaves Lessing's theory of the uniqueness of different art forms together with a schematic history of modern art to make total abstraction appear the logical culmination in both theoretical and historical terms. By concentrating on abstract art, he is able to take Fry's formalism a step further, with a gain in consistency: if we are to prize 'values only to be found in art', it makes sense to exclude not only the emotions of everyday life, but all representational reference to objects that exist in the world outside art—for Greenberg at his strictest, even Cézanne's *Apples* might smack too much of 'values which can be found elsewhere'. This permits him to strengthen the claim for disinterested contemplation that we have already seen in Fry and Bell:

the special, unique value of abstract art . . . lies in the high degree of detached contemplativeness that its appreciation requires. Contemplativeness is demanded in greater or lesser degree for the appreciation of every kind of art, but abstract art tends to present this requirement in quintessential form, at its purest, least diluted, most immediate.[36]

Greenberg's championship of abstraction in modern art displays exceptional lucidity. He sees modern art as progressively ridding itself of

'values which can be found elsewhere', and sketches a narrative of inexorable historical development reminiscent of Hegel or of Karl Marx (1818–83, an important point of reference for Greenberg, for political reasons). The visual arts first purge themselves of literary content. But that is not enough: each of the individual arts must then 'purify' itself more completely, by rejecting anything that might be shared with another art. With relentless logic Greenberg reasons that the *only* thing a particular art form can claim exclusively for itself is its medium, the physical materials out of which it is made. This emphasis on the physical medium is more restrictive, but also clearer and more concrete, than Fry's 'design' or Bell's 'significant form'. The idea is already in place in 'Towards a Newer Laocoon', but it attained its most forthright, and influential, form in Greenberg's famous essay of 1960, 'Modernist Painting'. The medium of painting, according to Greenberg, involves 'the flat surface, the shape of the support, the properties of the pigment'. Whereas old master painting had sought to deny or conceal these physical characteristics, for instance by creating a powerful illusion of three-dimensional space, modernist painting brought them to the fore. 'Manet's became the first Modernist pictures', Greenberg writes, 'by virtue of the frankness with which they declared the flat surfaces on which they were painted' [**61, 96**]; then the Impressionists emphasized the materiality of pigments [**63**]; then Cézanne designed his pictures to emphasize the rectangle of the canvas [**100–1, 105–6**]. Even this is not 'pure' enough, though, and Greenberg eventually narrows his criteria down to a single one:

It was the stressing of the ineluctable flatness of the surface that remained, however, more fundamental than anything else to the processes by which pictorial art criticized and defined itself under Modernism. For flatness alone was unique and exclusive to pictorial art. The enclosing shape of the picture was a limiting condition, or norm, that was shared with the art of the theater; color was a norm and a means shared not only with the theater, but also with sculpture. Because flatness was the only condition painting shared with no other art, Modernist painting oriented itself to flatness as it did to nothing else.[37]

It is easy enough to pick holes in the details of Greenberg's analysis: flatness is shared with drawing and printmaking, whereas colour in painting (if it is really a matter of the physical pigments, as Greenberg claims) is nothing like colour in the theatre or in sculpture. Moreover, Greenberg was obliged to admit that absolute flatness is unattainable: 'The first mark made on a canvas destroys its literal and utter flatness, and the result of the marks made on it by an artist like Mondrian is still a kind of illusion that suggests a kind of third dimension.'[38] The art of Greenberg's particular favourite, Pollock, depends on a three-dimensional weave of strands of pigment [see detail of **112**], about which Greenberg could write compellingly:

he began working with skeins of enamel paint and blotches that he opened up and laced, interlaced, and unlaced with a breadth and power remote from anything suggested by [his predecessors]. . . . At the same time, however, he wanted to control the oscillation between an emphatic physical surface and the suggestion of depth beneath it as lucidly and tensely and evenly as Picasso and Braque had controlled a somewhat similar movement with the open facets and pointillist flecks of color of their 1909–1913 Cubist pictures [107].[39]

Later, too, Greenberg could identify an altogether different way of stressing the medium in the 'colour field' painting initiated by Helen Frankenthaler (b. 1928) in *Mountains and Sea* [115]. Here a technique of staining the canvas, rather than applying paint to its surface, produces a special identity between pigment and support, which also allows the texture and grain of the canvas weave to remain apparent.

Greenberg's criticisms of particular artists and works—his judgements of taste—are often less dogmatic and more nuanced than his theoretical system. Perhaps he can be said to have proved Kant's point in spite of himself; his experience of particular works often produces insights that the 'logic' of his more theoretical writings misses. But the logic of his value system is nonetheless compelling, and perhaps more so because it is so severely restricted; Greenberg's 'formalism' is more limited than Fry's, but at the same time it is more rigorous. 'Modernist Painting' states Greenberg's debt to Kant in a very particular way. It is not Kant's views on beauty but, rather, the methodology of his Critiques that informs Greenberg's thinking: 'Because he was the first to criticize the means itself of criticism, I conceive of Kant as, the first real Modernist. . . . Kant used logic to establish the limits of logic, and while he withdrew much from its old jurisdiction, logic was left all the

more secure in what there remained to it.'[40] Greenberg's account of modernist painting is faithful to this interpretation of Kant's critical method: modernism works to establish the limits of painting, criticizing and rejecting anything inessential (such as illusionism or literary content), in order to strengthen it in its own unique competence (flatness). Moreover, Greenberg's own writing uses the same critical technique: he presents each artist and each movement in the same fashion as his overall schematic history of modernism, as moving relentlessly ahead towards greater purity and definitiveness. Thus, although much in Greenberg's historical narrative about modern art is questionable in detail, the overarching logic of the narrative remains compelling. His historical scheme for modernist art, like Winckelmann's historical scheme for ancient art, remains largely intact in art history textbooks, despite massive criticism of the selectivity of its data. Overwhelmingly, we still conceive of modern art along Greenberg's trajectory: from Manet through the Impressionists and Cézanne to Cubism and Abstract Expressionism.

But there is a tension here, similar to the problems we have already observed in Fry's and Bell's versions of formalism. Does Greenberg's value system apply only to modernist art, with its consummation in total abstraction? Is it then valid only within the particular historical circumstances of modern western society? That would be rigorous and logical, and Greenberg often claims that it is the case. As the passages quoted above demonstrate, he consistently writes of the development of modernism in the past tense, so that it appears as a particular and contingent historical event. At the end of 'Towards a Newer Laocoon' he writes:

I find that I have offered no other explanation for the present superiority of abstract art than its historical justification. . . . My own experience of art has forced me to accept most of the standards of taste from which abstract art has derived, but I do not maintain that they are the only valid standards through eternity.[41]

And in 1978, in a postscript to a reprinting of 'Modernist Painting', Greenberg defends himself against the charge that the essay prescribed an absolute norm for painting: 'The writer is trying to account in part for how most of the very best art of the last hundred-odd years came about, but he's not implying that that's how it *had* to come about, much less that that's how the best art still has to come about.'[42] The terms 'abstraction', 'avant-garde', and 'modernism' are Greenberg's most powerful substitute words for 'beauty'. It seems reasonable to suppose, then, that Greenberg is presenting an aesthetic for modern avant-garde art, not an account, like Kant's, of aesthetic experience in general.

But such a historicist position is inconsistent with Greenberg's views on the 'general agreement' of taste 'over the ages', and a number of comments show that he was well aware of this. As his career progressed he increasingly emphasized the continuity between modernism and the past tradition of western art. This produces some strange inconsistencies. In 'Modernist Painting' he first argues that modernism proceeds on a totally new basis, emphasizing the properties of the physical medium whereas the old masters had attempted to hide them; then he insists that modernism does not mean a break with the past: 'Modernist art continues the past without gap or break, and wherever it may end up it will never cease being intelligible in terms of the past. The making of pictures has been controlled, since it first began, by all the norms I have mentioned.'[43] Such statements are often taken as a sign of increasing conservatism on Greenberg's part, but some of his earliest writings on art hint at the same view, and for a good reason. If modernist art is thought to function, and to be judged, according to a completely different set of norms from the art of the old masters, the category 'art' would cease to have any precise meaning: we would have merely a variety of different artefacts, made by human beings at different times and places, which do not necessarily have anything in common and should therefore be judged by different criteria (illusionistic depth in some cases, flatness in others). More especially, the category 'high art' would lose any coherence. But Greenberg never swerves from his initial conviction that it is of the utmost importance to maintain the practice of sophisticated, complex art. In a note to 'Avant-Garde and Kitsch' of 1939, Greenberg acknowledges that folk art can be 'on a high level': 'but folk art is not Athene, and it's Athene whom we want: formal culture with its infinity of aspects, its luxuri-

ance, its large comprehension'.[44] Not for Greenberg the romantic association between modern art and the 'primitive' in which Fry and Bell indulged: he demands a modern art that is difficult and highly sophisticated, technically and intellectually. Such art should be challenging enough to seem 'ugly' at first, as he said of Pollock; only then will it be worthy of becoming 'beauty' and joining the western high art tradition (possibly there is a reminiscence in these ideas of Baudelaire, whose writings Greenberg read attentively).

If the category 'art' is to have any meaning, then, it cannot be the case that the quality or value of modernist art works on a different basis from that of the old masters. Greenberg was also concerned to argue that contemporary American abstraction could convincingly be placed in the same category, 'art' or 'high art', as the old masters; again this would scarcely be possible if its criteria for value were utterly different. Having established such a lucid and internally consistent value system for modernist art, Greenberg was virtually obliged to claim that it also applied to the greatest art of former ages. And so he did:

The old masters stand or fall, their pictures succeed or fail, on the same ultimate basis as do those of Mondrian or any other abstract artist [**109**]. The abstract formal unity of a picture by Titian [**68**] is more important to its quality than what that picture images. To return to what I said about Rembrandt's portraits, the whatness of what is imaged is not unimportant—far from it—and cannot be separated, really, from the formal qualities that result from the way it is imaged. But it is a fact, in my experience, that representational paintings are essentially and most fully appreciated when the identities of what they represent are only secondarily present to our consciousness.[45]

This is unpersuasive in the extreme; we are back to the problem of Fry's interpretation of Giotto's *Pietà* [**99**]. Why should we leave representation, dramatic action, the expression of human emotions, or any other idea out of our experience of an object? When he is acting as a critic Greenberg knows that this is true even of the experience of an abstract painting. In an article on Paul Klee (1879–1940, **116**), one of his favourite artists, he writes: 'We can never be sure as to what takes place when a picture is looked at, and there may be unconscious recognitions of "literary" meanings and associations which affect the observer's experience, no matter how much he concentrates upon the picture's abstract qualities.'[46]

The problem, as with Fry and Bell, derives from Greenberg's unswerving commitment to the importance of the category 'art', something that it is difficult not to admire on other grounds; his call in 1939 for a high art that could 'keep culture *moving* in the midst of ideological confusion and violence' remains relevant in the twenty-first century.[47] But as an aesthetic theory it is both intellectually incoherent and unacceptably authoritarian. As in the case of Fry and Bell, the

switch from 'beauty' to 'art' as the key word leads inexorably to manichaean divisions: between good and bad art, good and bad artists, good and bad connoisseurs of art.

In the last decades of the twentieth century 'Greenbergian formalism' came under powerful attack, both from practising artists and from academic art historians. At the same time many artists, historians, and critics rejected modernism and Kantian aesthetics. Greenberg's crime, it is often imputed, was to have overvalued the aesthetic. Yet from the perspective of the preceding discussions, it would appear that the problem is that his theoretical writing was *not aesthetic enough*. By imposing a formalist value system derived from modernist abstraction on the entire history of art, Greenberg denied the wider range of aesthetic response found in such writers as Winckelmann and Baudelaire, Gautier and Pater. Nonetheless there is something powerful about formalist looking, and Greenberg's writing persuasively shows us the 'beauty' of abstract art. In the article of 1959 in which Greenberg explores the disinterested contemplation of abstract art, there is a hint of a way out of the dilemma. Greenberg suggests that the kind of looking encouraged by abstract art—the kind we have called formalist

looking—is a valuable education, teaching us how to attend, seriously and with sophistication, to visual objects. Abstract art, Greenberg says, can 'train us', can 'refine our eyes for the appreciation of non-abstract art'.[48] Formalism might be valuable, then, as a way of teaching ourselves to see. But we should be philosophically unwise, as well as foolishly self-denying, if we were to stop there. 'Beauty' can give us more than 'art' and more than 'formalism'.

Afterword

By the end of the twentieth century, hostility to 'Greenbergian modernism' had become a commonplace. In understandable frustration with modernism's imperious promotion of its own narrow range of artistic values, many came to reject aesthetics wholesale, along with modernism. As the French critic and philosopher Thierry de Duve has remarked, 'some are ready to throw the baby out with the bath water—I mean, Kant's aesthetics with Greenberg's'.[1] Thus an influential collection published in 1983 linked the demise of modernism with opposition to the aesthetic in its title: *The Anti-Aesthetic: Essays on Postmodern Culture*. The substitution of the word 'culture' for the word 'art' is also telling; although most of the essays deal with works that can easily be categorized as 'high art' according to the conventions of today's institutions, the word 'art' seemed, at this moment in the 1980s, as suspect as 'beauty' or 'aesthetic'. The preface, by the collection's editor, Hal Foster (b. 1955), explains the terminology:

'Anti-aesthetic' . . . signals that the very notion of the aesthetic, its network of ideas, is in question here: the idea that aesthetic experience exists apart, without 'purpose,' all but beyond history, or that art can now effect a world at once (inter)subjective, concrete and universal—a symbolic totality. Like 'postmodernism,' then, 'anti-aesthetic' marks a cultural position on the present: are categories afforded by the aesthetic still valid?[2]

The cloudy language betrays Foster's weak grasp of the philosophical tradition he criticizes; as we have seen, the aesthetic (as it has been theorized since the late eighteenth century) does not afford 'categories', still less anything that could be described as a 'symbolic totality'. Yet Foster rightly identifies an important aspect of modernist art theories, the categorical separation between the values of art and those of life. This introduces a powerful new version of the most longstanding objection to the aesthetic. Where earlier critics such as Ruskin had attacked the separation of the aesthetic from morality, Foster and many other critics of the 1980s updated this to denounce what they saw as modernism's irresponsible separation of the aesthetic from the social and political.

Detail of 122

Thus the modernist repudiation of beauty was succeeded, in the late

twentieth century, by a more strident denial of the aesthetic on political grounds. Yet the 'anti-aesthetic' proposes divisions as manichaean as those of modernism: between 'reaction' and 'resistance' (Foster's terms),[3] between the 'aesthetic' and the 'political'. This proves as authoritarian, in its way, as Greenbergian modernism; it simply replaces formalist criteria for judging art with political ones. Perhaps, then, it is no surprise that beauty, so strongly associated in the philosophical tradition with freedom, has at last re-emerged in the critical discourse. After about 1990 calls for a return to beauty began at first tentatively to emerge in the criticism of contemporary art, then to multiply. By the turn of the millennium leading academics in the fields of literature, cultural studies, and philosophy were publishing books on beauty and the aesthetic (see Further Reading, pp. 211–12). While this development has been slow to reach the discipline of art history, several important exhibitions have explored the question of beauty in recent and contemporary art. In 1999, for example, the Hirshhorn Museum and Sculpture Garden in Washington, DC, mounted *Regarding Beauty: A View of the Late Twentieth Century*.

In the 1990s, then, beauty was once again discussed and debated. Indeed, the 'anti-aesthetic' position of the previous decade had lent a subversive tinge to the very word 'beauty'. The paradoxical effect was to rescue the word from the watered-down connotations that had caused the early modernists to take issue with it; suddenly beauty was oppositional, challenging, nonconformist. At the same time a number of writers and artists began to call attention to a different kind of politics: a politics of gender that permeated the rhetoric of both modernism and the 'anti-aesthetic'. Greenberg's modernism, Newman's 'sublime', and calls for a politically engaged art all tended to use overtly masculine language and terminology; Greenberg's favourite words of praise are 'strong' and 'major', while Foster's are 'critical' and 'resistant'. Beauty, on the other hand, tended to be denigrated by association with the feminine or the 'effeminate'. In this context, beauty could become a powerful term of opposition to patriarchy, misogyny, and homophobia, in the writings of such critics as Dave Hickey and Wendy Steiner. As Hickey comments in *The Invisible Dragon: Four Essays on Beauty* (1993), one of the first texts to raise the question of beauty afresh:

the cultural demotic that [formerly] invested works of art with attributes traditionally characterized as 'feminine'—*beauty, harmony, generosity*, etc.—now validates works with their 'masculine' counterparts—*strength, singularity, autonomy*, etc.—counterparts which, in my view, are no longer descriptive of conditions.

Hickey observes, too, that 'in the Balkanized gender politics of contemporary art, the self-consciously "lovely," i.e., the "effeminate" in art, is pretty much the domain of the male homosexual', a situation he calls

'blatantly sexist (and covertly homophobic)'.[4] Steiner's *The Trouble with Beauty* (2001) argues that beauty, in the western tradition, is so closely bound up with the representation of the female figure that to suppress beauty is effectively misogynistic.[5] She quotes the Dutch artist Marlene Dumas (b. 1953):

> (They say) Art no longer produces Beauty.
> She produces meaning
> but
> (I say) One cannot paint a picture of
> or make an image of a woman
> and not deal with the concept of beauty.[6]

Steiner applauds the work of such artists as Dumas and Cindy Sherman (b. 1954) for raising the question of the female model anew. In the series of *Untitled Film Stills* of 1977–80, Sherman photographs herself as the model in scenarios that recall the glamour of Hollywood film [**117**]. In the 1990s, an artist such as Jim Hodges (b. 1957) could again take up the image of the flower, the most familiar symbol for both the beautiful and the feminine, in a kind of protest, deliberately non-aggressive, against the devaluation of such ideas as sentiment, loveliness, or fragility [**118**].

By the end of the twentieth century, then, beauty could again be associated with a progressive politics, as it had been in the eighteenth century, and often in the nineteenth. Nonetheless, it has proved inordinately difficult to dispel the sense that beauty is somehow a thing of

the past. Even proponents of the new attention to beauty in contemporary art have tended to describe it as a 'return' or a 'revival' rather than as a new departure. As both a philosopher and a critic of contemporary art, Arthur C. Danto has taken a leading role in the reassessment of beauty. In a brief article of 1992 entitled 'Whatever Happened to Beauty?', Danto applauds two solo exhibitions, by Dorothea Rockburne (b. 1921) and Robert Mangold (b. 1937, **119**), for signs of a new interest in beauty. But he frames this development as a return to the values of the past: 'Rockburne and Mangold stand in a certain continuity with a past that unites them with classical antiquity, with marble forms and cadenced architectures, with clarity, certainty, exactitude and the kind of universality Kant believed integral to our concept of beauty.'[7] In the same article, Danto argues against a simple opposition between aesthetics and politics. Nonetheless, his vocabulary reinforces the sense that an interest in beauty is somehow conservative.

A return to the past would in some respects be welcome. After all, it has been an important argument of this book that the explorations of beauty in the periods before modernism deserve fresh attention. Moreover, artists have often used a return to the distant past as a way of casting aside more recent artistic conventions, as the many 'primitivist' movements of the nineteenth and twentieth centuries show. We have seen that Winckelmann proposed a radical return to classical antiquity to enliven the art of his own day, which he saw as having grown stale and conventional. Schiller, too, counsels the artist to break decisively with present-day convention by seeking fresh inspiration in Greek antiquity: 'Then ... let him return, a stranger, to his own century; not, however, to gladden it by his appearance, but rather, terrible like Agamemnon's son, to cleanse and to purify it'.[8] In the later decades of

Attic Series III, 1990

the twentieth century, a number of artists have in effect followed this advice, by renewing attention to the art of classical antiquity. Mangold refers to ancient Greek vase painting [**119**], Rockburne to the architecture of the Roman Pantheon; other artists have even gone back to the sculptures that Winckelmann and his contemporaries revered. In *Blue Venus* [**120**], the French artist Yves Klein (1928–1962) imbues the forms of ancient sculpture (compare **80**) with his own signature colour, I.K.B. or 'International Klein Blue'. The procedure is analogous to that of

120 Yves Klein

Blue Venus, undated (c.1961–2)

Watts's *The Wife of Pygmalion* [**86**]; in both cases the addition of colour
to sculptural form transforms ancient beauty into modern art. I.K.B. is
a luminous ultramarine that may call to mind the limitless blues of the
sky or sea; coloured thus, the Venus seems almost to float, released from
the gravity of ancient marble. The deep saturation of the blue colour,
with its associations of tranquillity, may be a new way of conveying the
'noble simplicity and quiet grandeur' that Winckelmann found in
ancient sculpture. The Italian artist Giulio Paolini (b. 1940) draws on
the *Venus de'Medici* [**12**] in a work entitled *Mimesis*, with reference to
the western tradition of artmaking as imitation [**121**]. The new work is

a double imitation, repeating the ancient sculpture twice in the form of pristine plaster casts. The answering curves of the two casts bring out a new aspect of the original sculpture, emphasizing the sinuous contrapposto of the female body. The two figures are elevated on rectilinear plinths, which allude to the museum presentation of ancient sculptures as objects of special reverence; they also suggest the raw block from which the sculptor creates forms so supple that they persuade us as imitations of the human body. In *Untitled* [**122**], the Greek artist Jannis Kounellis (b. 1936) juxtaposes fragmentary casts of ancient sculpture, including the head of the *Apollo Belvedere* [**11**], within a doorway,

precariously perched among slabs of uncut marble. The blocked door-
way could be read as a meditation on how the classical tradition can
seem to overwhelm the modern artist, something like Fuseli's *The
Artist in Despair over the Magnitude of Ancient Fragments* [**13**]; alterna-
tively this might be a doorway to the future, with light streaming
through the gaps among multifarious sculptural materials ready for cre-
ative reconfiguration. In the photographs by Robert Mapplethorpe
(1946–89), the models frequently appear in poses reminiscent of classi-
cal sculptures [**124**]; in *Ajitto* [**123**], Mapplethorpe redeploys the pose
of Flandrin's classicizing *Study* [**35**]. The British artist Mary Duffy uses
echoes of ancient sculptures such as the *Venus de Milo* [**80**], with evoca-
tions of classical drapery, to reveal the beauty of her own body, in a
powerful challenge to preconceptions about the visual appearance of
disability [**125**].

It makes some sense, then, to speak of a 'return' to beauty in
much recent art; allusion to the past, and particularly to the remote

123 Robert Mapplethorpe
Ajitto, 1981

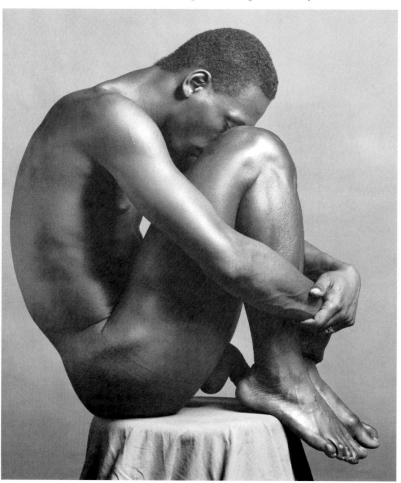

124 (above right) **Robert Mapplethorpe**
Thomas, 1987

125 (below and right) **Mary Duffy**
Cutting the Ties That Bind, 1987

past of classical antiquity, has proved crucial to much of the art we call 'postmodern' (in a distant echo of Fry's original coinage, 'Post-Impressionist'). But there is a danger, here, of reinforcing the perception that beauty is a thing of the past, and that an art that aspires to beauty must therefore be merely nostalgic, if not positively reactionary. Thus opposition either to Greenbergian modernism or to the 'anti-aesthetic' runs the risk of capitulating to the terms of those discourses. To resist an authoritarian progressivism (whether artistic or political), the only course would seem to be voluntary retrogression.

But the choice is a false one, as Baudelaire's 'The Painter of Modern Life' should remind us. A work of art belongs to the past as soon as it has been made, whether it is the ancient *Venus de Milo* or the latest work of a contemporary artist such as Hiroshi Sugimoto (b. 1948, **126**); but its beauty is in the present moment of the observer's judgement. The artist Agnes Martin (1912–2004) puts this well, in an essay of 1989 entitled 'Beauty Is the Mystery of Life': 'When a beautiful rose dies, beauty does not die because it is not really in the rose. Beauty is an awareness in the mind. It is a mental and emotional response that we make.' Martin's own work may easily be judged 'strong' in modernist terms, for its formal purity and for its acknowledgement of the flatness of the picture surface [**127**]. But as her essay suggests, that will have no bearing on whether we choose to call it 'beautiful': 'You must discover the artwork that you like, and realize the response that you make to it'. The essay, which despite its non-technical language is deeply informed by philosophical aesthetics, goes on to suggest how it might be possible for an artist to make beautiful work: 'You must especially know the response that you make to your own work. . . . If you do not discover your response to your own work, you miss the reward. You must look at the work and know how it makes you feel.' Artmaking can thus be seen as a continual invocation of the judgement of taste, a constant process

126 Hiroshi Sugimoto
Pine Tree Landscape, 2001

of contemplating the work you are making to see whether you can call it beautiful; Martin makes it clear that this does not mean facile self-congratulation, but instead a tough, even relentless, testing of the work's aesthetic integrity. Thus, with regard to beauty, the artist is simply the observer of her own work: 'The response is the same for the observer as it is for the artist'. Martin's essay is daring for its date in rejecting the political as an aim for art: 'It is not in the role of an artist to worry about life—to feel responsible for creating a better world'. But there is no hint of conservatism about this: 'An artist's life is adventurous: one new thing after another'.[9]

It is evident, even from the necessarily limited selection of texts and works mentioned in this Afterword, that 'beauty' has at last reappeared as a term of power in current discourses on the visual arts. Yet it is equally clear that there is no consensus about what this will mean for our debates on art in the twenty-first century—not even, as we have seen, about whether it is a progressive or retrogressive development. Academic art historians have only just begun to evaluate the shift to a new (or renewed) consideration of beauty. As Ivan Gaskell concludes in a recent essay: '["Beauty"] can no longer be counted a taboo word, even if its adequate art-historical use requires further definition and elaboration, for aesthetic evaluation is returning to art-historical practice as part of a new theoretical turn.'[10] Here the vocabulary of return or revival mingles with that of novelty and innovation. It is telling that Gaskell's essay on 'Beauty' was added in 2003 to the second edition of an influential collection, *Critical Terms for Art History*; the first edition, published as recently as 1996, included no consideration of beauty or aesthetics.

This book has aimed to make a contribution to the 'new theoretical turn' that Gaskell identifies. But what could it mean to say that 'aesthetic evaluation is returning' to art history? We cannot pretend that

questions of value have ever been absent, even from our most 'anti-aesthetic' discussions; it is a commonplace to observe that we make value judgements every time we select a work of art to discuss, whether the criteria we use for that discussion are aesthetic, moral, political, or of any other kind. In the recent past, debates on value have been polarized between a modernist position, with its allegiances to hierarchy, to formalism, and to the conceptual or institutional category 'art', and an 'anti-aesthetic' position that refers instead to value systems from other discourses, such as politics or history. Yet in either case the object under contemplation is referred to some pre-existing value system. As this book has argued, attention to beauty has at least this advantage: it may permit us to begin an enquiry the outcome of which is not known in advance. In that sense, there can be no such thing as a 'return' to beauty. We can only, like Winckelmann, go forward in the hope that we may, in the end, discover a fresh example of beauty.

Notes

Introduction

1. Wendy Steiner, *The Trouble with Beauty*, London: William Heinemann, 2001, p. xv.
2. See David E. Cooper, ed., *Aesthetics: The Classic Readings*, Oxford: Blackwell, 1997.
3. Charles Baudelaire, 'Further Notes on Edgar Poe' (1857), repr. in *The Painter of Modern Life and Other Essays*, trans. and ed. Jonathan Mayne, 2nd edn, London: Phaidon, 1995, p. 106.

Chapter 1. Eighteenth-century Germany: Winckelmann and Kant

1. Johann Joachim Winckelmann, *Geschichte der Kunst des Alterthums* (1764, rev. edn 1776); English version, *The History of Ancient Art*, trans. G. Henry Lodge, London: Sampson Low, Marston, Searle, & Rivington, 1881, vol. 1, p. 301 (IV.II.5). All subsequent references are to the Lodge translation, also citing Winckelmann's book, chapter, and paragraph numbers.
2. *Ibid.*, vol. 2, p. 312 (XI.III.9).
3. *Ibid.*, vol. 1, p. 329 (V.I.21).
4. *Ibid.*, vol. 1, pp. 343 (V.II.5), 391 (V.V.22).
5. *Ibid.*, vol. 1, p. 403 (V.VI. 2).
6. *Ibid.*, vol. 1, p. 404 (V.VI.3).
7. *Ibid.*, vol. 2, p. 306 (XI.II.36).
8. *Ibid.*, vol. 1, p. 309 (IV.II.20).
9. *Ibid.*, vol. 2, p. 154 (VIII.III.19).
10. *Ibid.*, vol. 1, p. 122 (Preface to the Notes, para. 10).
11. *Ibid.*, vol. 1, p. 408 (V.VI.13).
12. Johann Joachim Winckelmann, *Reflections on the Imitation of Greek Works in Painting and Sculpture* (1755), trans. Elfriede Heyer and Roger C. Norton, La Salle, Illinois: Open Court, 1987, pp. 33–5.
13. Winckelmann, *History*, vol. 2, p. 227 (X.I.9).
14. *Ibid.*, vol. 2, p. 228 (X.I.11).
15. *Ibid.*, vol. 2, p. 58 (VII.I.16).
16. *Ibid.*, vol. 2, p. 231 (X.I.16).
17. Johann Wolfgang von Goethe, 'Observations on the Laocoon' (1798), anonymous English translation (1799), repr. in John Gage, ed., *Goethe on Art*, London: Scolar Press, 1980, pp. 82, 81 (spelling modernized).
18. Kenneth Clark, *The Nude: A Study of Ideal Art* (1956), Harmondsworth: Penguin, 1987, p. 45.
19. Winckelmann, *History*, vol. 1, p. 314 (IV.II.32).
20. *Ibid.*, vol. 2, pp. 312–13 (XI.III.11).
21. Johann Wolfgang von Goethe, 'Winckelmann' (1805), repr. in H. B. Nisbet, ed., *German Aesthetic and Literary Criticism*, Cambridge University Press, 1985, pp. 236–58.
22. Winckelmann, *History*, vol. 1, p. 342 (V.II.3).
23. Winckelmann, *Reflections*, p. 5.
24. Winckelmann, *History*, vol. 1, p. 108 (Preface, para. 4).
25. Winckelmann, *Reflections*, p. 39.
26. *Ibid.*, p. 41.
27. Winckelmann, *History*, vol. 1, p. 407 (V.VI.12).
28. *Ibid.*, vol. 1, pp. 339–40 (V.I.44).
29. Johann Wolfgang von Goethe, *Italian Journey (1786–1788)*, trans. W. H. Auden and Elizabeth Mayer (1962), Harmondsworth: Penguin, 1970, p. 208.
30. Immanuel Kant, *The Critique of Judgement* (1790), trans. James Creed Meredith (1911), Oxford: Clarendon, 1952, pp. 41–2 (§ 1). All subsequent references are to the Meredith translation, also citing Kant's section numbers.
31. See for example Pierre Bourdieu, *Distinction: A Social Critique of the Judgement of Taste*, trans. Richard Nice, London: Routledge & Kegan Paul, 1984 (first published in French in 1979), Chapter 1.
32. Kant, *Critique of Judgement*, pp. 48–50 (§ 5).
33. *Ibid.*, pp. 57–60 (§ 9).
34. Friedrich Schiller, *On the Aesthetic Education of Man: In a Series of Letters* (1795), ed. and trans. Elizabeth M. Wilkinson and L. A. Willoughby, Oxford: Clarendon, 1967.

35. Kant, *Critique of Judgement*, pp. 50–60 (§§ 6–9).

36. *Ibid.*, p. 55 (§ 8).

37. *Ibid.*, pp. 72–4 (§ 16).

38. *Ibid.*, p. 72 (§ 16).

39. *Ibid.*, p. 73 (§ 16).

40. *Ibid.*, p. 78 (§ 17).

41. See the excellent discussion of this painting in Darcy Grimaldo Grigsby, *Extremities: Painting Empire in Post-Revolutionary France*, New Haven and London: Yale University Press, 2002, Chapter 1, especially p. 56 (on 'beauty').

42. Kant, *Critique of Judgement*, p. 79 (§ 17; Kant's example is the *Doryphoros* of Polyclitus).

43. *Ibid.*, p. 80 (§ 17).

44. See Joseph Leo Koerner, *Caspar David Friedrich and the Subject of Landscape*, London: Reaktion Books, 1990, especially Chapter 10; and *ibid.*, 'Borrowed Sight: The Halted Traveller in Caspar David Friedrich and William Wordsworth', *Word & Image*, vol. 1, no. 2, April–June 1985, pp. 149–63.

45. Kant, *Critique of Judgement*, p. 171 (§ 47).

46. See Ernst Kris and Otto Kurz, *Legend, Myth, and Magic in the Image of the Artist*, New Haven and London: Yale University Press, 1979.

47. Kant, *Critique of Judgement*, pp. 168–9 (§ 46).

48. *Ibid.*, pp. 175–82 (§ 49).

49. *Ibid.*, pp. 175–6 (§ 49).

50. *Ibid.*, p. 176 (§ 49).

51. *Ibid.*, p. 181 (§ 49).

52. *Ibid.*, p. 168 (§ 46).

Chapter 2. Nineteenth-century France: From Staël to Baudelaire

1. *The Journal of Eugène Delacroix*, trans. Walter Pach, London: Jonathan Cape, 1938, p. 705.

2. Théophile Gautier, *Les Beaux-Arts en Europe: 1855*, Paris: Michel Lévy Frères, 1855–6, vol. 1, pp. 286–7.

3. See John Claiborne Isbell, *The Birth of European Romanticism: Truth and Propaganda in Staël's 'De l'Allemagne', 1810–1813*, Cambridge University Press, 1994, pp. 1–5.

4. Madame de Staël, *De l'Allemagne*, new edn, Paris: Charpentier, 1844, p. 488 (Third Part, Chapter 9).

5. On 'idealism' in art theory see Erwin Panofsky, *Idea: A Concept in Art Theory*, trans. Joseph J. S. Peake, Columbia, South Carolina: University of South Carolina Press, 1968. On academic art theory more generally, see for example Moshe Barasch, *Theories of Art*, New York and London: Routledge, 2000, vols 1 and 2; Albert Boime, *The Academy and French Painting in the Nineteenth Century*, London: Phaidon, 1971; Nikolaus Pevsner, *Academies of Art: Past and Present*, Cambridge University Press, 1940.

6. Staël, *De l'Allemagne*, pp. 462–3 (Third Part, Chapter 6).

7. *Ibid.*, p. 462.

8. See Mark A. Cheetham, *The Rhetoric of Purity: Essentialist Theory and the Advent of Abstract Painting*, Cambridge University Press, 1991, Chapter 1; the Platonic bias that Cheetham finds in late-nineteenth century French art theory is present much earlier.

9. Victor Cousin, 'Du beau et de l'art', *Revue des Deux Mondes*, n.s. 11, 1 September 1845, p. 783.

10. *Ibid.*, pp. 778–9 (Cousin refers to the *Venus* of the Capitoline Museum, Rome).

11. *Ibid.*, pp. 788–9.

12. *Ibid.*, p. 798.

13. Quoted from the edition of 1836, published from notes on the lecture course of 1818 by Cousin's student Adolphe Garnier, *Cours de philosophie . . . sur le fondement des idées absolues du vrai, du beau et du bien*, 22nd lesson. Interestingly the passage was toned down somewhat in later versions revised by Cousin himself (including the more polished version published in 1845 in the *Revue des Deux Mondes*). There is perhaps an echo of Hegel, whom Cousin first met in 1817; compare for example G. W. F. Hegel, *Aesthetics: Lectures on Fine Art*, trans. T. M. Knox, Oxford: Clarendon, 1975, vol. 2, p. 992 (first published 1835, based on lectures of the 1820s).

14. See John Wilcox, 'The Beginnings of l'art pour l'art', *Journal of Aesthetics and Art Criticism*, vol. XI, June 1953, pp. 366–9.

15. Cousin, 'Du beau et de l'art', p. 800.

16. *Ibid.*, pp. 795–6.

17. Plato, *Timaeus* 28B; Cicero, *Orator* ii. 9.

18. Quoted in Martin Rosenberg, *Raphael and France: The Artist as Paradigm and Symbol*, University Park: Pennsylvania State University Press, 1995, p. 50.

19. See Neil McWilliam, *Dreams of Happiness: Social Art and the French Left, 1830–1850*, Princeton University Press, 1993, especially Chapter 7.

20. For a nuanced discussion of the political issues, see Darcy Grimaldo Grigsby, *Extremities: Painting Empire in Post-Revolutionary France*, New Haven and London: Yale University Press, 2002, Chapter 5.

21. *Stendhal and the Arts*, ed. David Wakefield, London: Phaidon, 1973, pp. 90, 120.

22. Henri Delaborde, *Ingres: sa vie, ses travaux, sa doctrine*, Paris: Henri Plon, 1870, p. 114.

23. *Stendhal and the Arts*, p. 114.

24. *Ibid.*, p. 107.

25. *The Journal of Eugène Delacroix*, ed. Hubert Wellington, trans. Lucy Norton, London: Phaidon, 3rd edn, 1995, p. 39. Subsequent references are to this edition.

26. *Ibid.*, p. 134.

27. *Ibid.*, p. 213.

28. *Ibid.*, pp. 383–4.

29. *Ibid.*, pp. 360–1.

30. *Ibid.*, p. 383.

31. 'Questions sur le beau' (1854), repr. in Eugène Delacroix, *Oeuvres littéraires*, Paris: G. Crès, 1923, vol. 1, p. 32.

32. Delacroix, *Journal*, p. 207.

33. *Ibid.*, pp. 208–9.

34. 'Des variations du beau' (1857), repr. in Delacroix, *Oeuvres littéraires*, vol. 1, p. 54.

35. Delacroix, *Journal*, p. 117.

36. Delacroix, 'Des variations du beau', p. 43.

37. Delacroix, *Journal*, p. 257.

38. *La Presse*, 22 November 1836, quoted in Stéphane Guégan, 'Gautier et l'art pour l'art 1830–1848', *Quarante-huit/Quatorze*, Conférences du Musée d'Orsay, no. 5, 1991–2, p. 67.

39. Delaborde, *Ingres*, p. 112; the formulation is repeated on p. 147.

40. Antoine-Chrysostome Quatremère de Quincy, *Essai sur la nature, le but et les moyens de l'imitation dans les beaux-arts* (1823), Part Two, Chapter II, repr. in Joshua C. Taylor, ed., *Nineteenth-Century Theories of Art*, Berkeley, Los Angeles, and London: University of California Press, 1987, p. 91.

41. Delaborde, *Ingres*, p. 113.

42. Gustave Courbet, letter of 25 December 1861, repr. in Charles Harrison and Paul Wood with Jason Gaiger, eds, *Art in Theory 1815–1900*, Oxford: Blackwell, 1998, p. 404.

43. Strabo, *Geography*, 8.3.30.

44. Delaborde, *Ingres*, p. 114.

45. Gautier, *Les Beaux-Arts en Europe*, vol. 1, p. 158.

46. *Ibid.*, p. 143.

47. The lecture was not published until 1836, by which time the term had already appeared in criticism; but the original lecture series of 1818 may have put the phrase into circulation. See Wilcox, 'The Beginnings of l'art pour l'art', pp. 366–77.

48. Gautier, *Les Beaux-Arts en Europe*, vol. 1, p. 143.

49. Théophile Gautier, 'Du beau dans l'art', *Revue des Deux Mondes*, vol. XIX, 1847, pp. 900, 899, 903.

50. A French translation of the *Critique of Judgement* was published in 1846; Gautier is likely to have read Cousin's 'Du beau et de l'art' published in the *Revue des Deux Mondes* in 1845.

51. Gautier, *Les Beaux-Arts en Europe*, vol. 1, pp. 160–1.

52. Gautier, 'Du beau dans l'art', p. 901.

53. See Albert Cassagne, *La Théorie de l'art pour l'art en France*, Paris: Lucien Dorbon, 1905 (repr. 1959), pp. 15–35.

54. Quoted in Wilcox, 'The Beginnings of l'art pour l'art', p. 375.

55. Gustave Courbet, 'Statement on Realism', repr. in Harrison and Wood with Gaiger, eds, *Art in Theory*, p. 372.

56. Pierre-Joseph Proudhon, *Du principe de l'art et sa destination sociale* (1865), Chapter XIV, repr. in *ibid.*, p. 407.

57. Charles Baudelaire, 'Théophile Gautier' (1859), repr. in *Curiosités esthétiques, l'art romantique et autres œuvres critiques*, ed. Henri Lemaitre, Paris: Garnier, 1986 (first published 1962), p. 669.

58. See for example Baudelaire's Salon of 1859, repr. in *Art in Paris 1845–1862*, trans. and ed. Jonathan Mayne, London: Phaidon, 1965, pp. 151–63.

59. See for example Baudelaire's review of the Exposition Universelle (1855), repr. in *ibid.*, pp. 125–8.

60. Charles Baudelaire, *The Painter of Modern Life and Other Essays*, trans. and ed. Jonathan Mayne, 2nd edn, London: Phaidon, 1995, p. 3.

61. *Ibid.*, pp. 4–5.

62. Baudelaire discusses 'the military man' in Section VIII, *ibid.*, pp. 24–6.

63. *Ibid.*, p. 11.

64. Here I am indebted to Paul de Man, 'Literary History and Literary Modernity', in *Blindness and Insight: Essays in the Rhetoric of Contemporary Criticism*, 2nd edn, Minneapolis: University of Minnesota Press, 1983, pp. 156–65.

65. Baudelaire, *The Painter of Modern Life*, p. 17.

66. *Ibid.*, p. 13.

67. *Ibid.*, pp. 30–1.

68. 'The Heroism of Modern Life', in Baudelaire's Salon of 1846, repr. in *Art in Paris 1845–1862*, p. 118.

Chapter 3. Victorian England: Ruskin, Swinburne, Pater

1. *The Works of John Ruskin*, Library Edition, ed. E. T. Cook and Alexander Wedderburn, London: George Allen, 1903–12, vol. XII, pp. 333–5.

2. W. M. Rossetti and A. C. Swinburne, *Notes on the Royal Academy Exhibition, 1868*, London: John Camden Hotten, 1868, p. 32.

3. Ruskin, *Works*, vol. IV, p. 47.

4. *Ibid.*, vol. IV, p. 215.

5. *Ibid.*, vol. XXIX, p. 89.

6. *Ibid.*, vol. VII, pp. 296–7.

7. William E. Fredeman, ed., *The Correspondence of Dante Gabriel Rossetti*, Cambridge: D. S. Brewer, 2002, vol. II, pp. 276, 269.

8. Quoted in Alastair Grieve, 'Rossetti and the Scandal of Art for Art's Sake in the Early 1860s', in Elizabeth Prettejohn, ed., *After the Pre-Raphaelites: Art and Aestheticism in Victorian England*, Manchester University Press, 1999, p. 22.

9. W. M. Rossetti, 'The Royal Academy Exhibition', *Fraser's Magazine*, vol. LXVII, June 1863, p. 790.

10. A. C. Swinburne, from 'Before the Mirror', *Poems and Ballads*, London: Edward Moxon, 1866.

11. *Spectator*, 6 September 1862, repr. in Clyde K. Hyder, ed., *Swinburne as Critic*, London and Boston: Routledge & Kegan Paul, 1972, pp. 28, 31.

12. Algernon Charles Swinburne, *William Blake: A Critical Essay*, London: John Camden Hotten, 1868, pp. 90–1.

13. The first *Life of William Blake*, left unfinished on the death of its author, Alexander Gilchrist, was completed for publication in 1863 by Gilchrist's widow, Anne, with extensive assistance from Dante Gabriel Rossetti and William Michael Rossetti. Swinburne began work on his essay, *William Blake*, in connection with the *Life*, but eventually published it as a separate study in 1868.

14. Swinburne, *William Blake*, p. 86.

15. *Ibid.*, p. 91.

16. Quoted in Grieve, 'Rossetti and the Scandal of Art for Art's Sake', p. 17.

17. Swinburne, *William Blake*, p. 92.

18. Charles Baudelaire, 'Further Notes on Edgar Poe' (1857), repr. in *The Painter of Modern Life and Other Essays*, trans. and ed. Jonathan Mayne, 2nd edn, London: Phaidon, 1995, p. 107.

19. Swinburne, *William Blake*, p. 98.

20. Baudelaire, 'Further Notes', p. 107.

21. Swinburne, *William Blake*, p. 88.

22. W. M. Rossetti, 'Swinburne's Poems and Ballads' (1866), repr. in Clyde K. Hyder, ed., *Swinburne: The Critical Heritage*, London: Routledge and Kegan Paul, 1970, pp. 67–8.

23. Edward FitzGerald, *The Rubáiyát of Omar Khayyám*, New York: Dover, 1990, stanza 23, p. 8 (repr. of first edn, 1859).

24. Walter Pater, 'Poems by William Morris', *Westminster Review*, n.s. vol. XXXIV, October 1868, p. 312.

25. Walter Pater, *The Renaissance: Studies in Art and Poetry*, ed. Donald L. Hill, Berkeley, Los Angeles, and London: University of California Press, 1980, pp. 18–19.

26. Swinburne, *William Blake*, p. 89.

27. Pater, *Renaissance*, pp. xxii–xxiii; similar phrases are repeated on pp. 1, 3, 4, 18–19.

28. The term 'art for art's sake' proved controversial (as happened with *l'art pour l'art* in France; see above, pp. 98–101) and was largely dropped by its original proponents after 1870; Swinburne modified his advocacy of 'art for art's sake' to accommodate politically engaged art, although he continued to insist on the need for art to occupy an independent position (Algernon Charles Swinburne, 'Victor Hugo: L'Année Terrible', *Fortnightly Review*, n.s. vol. XII, 1 September 1872, pp. 257–9). On the terminology see Prettejohn, ed., *After the Pre-Raphaelites*, pp. 2–8.

29. 'The English Renaissance of Art' (1882), repr. in *Aristotle at Afternoon Tea: The Rare Oscar Wilde*, ed. John Wyse Jackson, London: Fourth Estate, 1991, pp. 3–28.

30. See L. M. Findlay, 'The Introduction of the Phrase "Art for Art's Sake" into English', *Notes and Queries*, July 1973, pp. 246–8.

31. Walter Pater, 'Coleridge's Writings', *Westminster Review*, n.s. vol. XXIX, January 1866, p. 132.

32. Pater, *Renaissance*, p. 188.

33. See Alison Smith, *The Victorian Nude: Sexuality, Morality and Art*, Manchester University Press, 1996, pp. 99–161.

34. *The Works of Dante Gabriel Rossetti*, ed. William M. Rossetti, rev. edn, London: Ellis, 1911, p. 210.

35. *The Diaries of George Price Boyce*, ed. Virginia Surtees, Norwich: Real World, 1980, p. 39.

36. Sidney Colvin, 'English Painters and Painting in 1867', *Fortnightly Review*, n.s. vol. II, October 1867, p. 473.

37. *Ibid.*, p. 465.

38. *Ibid.*, pp. 473–4; the quotation is from Robert Browning's 'Fra Lippo Lippi'.

39. Pater, *Renaissance*, pp. 106, 109.

40. *Ibid.*, p. 114.

41. James McNeill Whistler, *The Gentle Art of Making Enemies*, New York: Dover, 1967, pp. 127–8 (repr. of 2nd edn, 1892).

42. Pater, *Renaissance*, pp. 97–8.

43. *Ibid.*, pp. 98–9.
44. *Ibid.*, p. xix.
45. Ruskin, *Works*, vol. XXIX, p. 160.
46. For a complete account of the trial see Linda Merrill, *A Pot of Paint: Aesthetics on Trial in Whistler v. Ruskin*, Washington and London: Smithsonian Institution Press, 1992.

Chapter 4. Modernism: Fry and Greenberg

1. See p. 108 above.
2. Desmond MacCarthy, 'The Art-Quake of 1910', *The Listener*, 1 February 1945, p. 124.
3. Kenneth Clark, 'Introduction' to Roger Fry, *Last Lectures*, Cambridge University Press, 1939, p. ix.
4. Roger Fry, *Vision and Design*, Oxford University Press, 1990 (first published 1920), p. 199.
5. Roger Fry, 'Expression and Representation in the Graphic Arts' (1908), in *A Roger Fry Reader*, ed. Christopher Reed, University of Chicago Press, 1996, pp. 61–71; 'An Essay in Aesthetics' (1909), in Fry, *Vision and Design*, pp. 12–27.
6. Fry, *Vision and Design*, p. 205.
7. Clive Bell, *Art*, London: Chatto and Windus, 1947 (first published 1914), p. 15.
8. Barnett Newman, 'The Sublime Is Now' (1948), repr. in Charles Harrison and Paul Wood, eds, *Art in Theory 1900–1990*, Oxford: Blackwell, 1992, pp. 573–4.
9. Desmond MacCarthy, 'Kant and Post-Impressionism' (1912), repr. in J. B. Bullen, ed., *Post-Impressionists in England*, London and New York: Routledge, 1988, p. 377.
10. See Thierry de Duve, *Kant after Duchamp*, Cambridge, Mass. and London: MIT Press, 1996.
11. Fry, *Vision and Design*, note p. 92.
12. *Ibid.*, p. 116.
13. *Ibid.*, p. 202.
14. The pictures have been identified by Alan Bowness; see Frances Spalding, *Roger Fry: Art and Life*, London, Toronto, Sydney, and New York: Granada Publishing (Paul Elek), 1980, p. 116.
15. Fry, *Vision and Design*, p. 202.
16. Roger Fry, 'The New Gallery', *Athenaeum*, no. 4081, 13 January 1906, p. 56.
17. Bell, *Art*, p. 130.
18. Fry, *Vision and Design*, pp. 34–5.
19. *Ibid.*, pp. 71–2.
20. Roger Fry, *Cézanne: A Study of His Development*, University of Chicago Press, 1989 (first published 1927), p. 48.
21. Fry, *Vision and Design*, p. 169.
22. Bell, *Art*, p. 29.

23. Fry, *Cézanne*, p. 45 (of the apples in **106**).
24. Fry, *Vision and Design*, p. 13.
25. Maurice Denis, 'Définition du néo-traditionnisme' (1890), repr. in *Le Ciel et l'Arcadie*, ed. Jean-Paul Bouillon, Paris: Hermann, 1993, p. 5.
26. Roger Fry, 'The Allied Artists', *Nation*, 2 August 1913, p. 677.
27. Quoted in Calvin Tomkins, *Duchamp: A Biography*, London: Chatto and Windus, 1997, p. 185.
28. Quoted in *ibid.*, p. 182.
29. Clement Greenberg, *The Collected Essays and Criticism*, ed. John O'Brian, University of Chicago Press, 1986–93 (4 vols.), vol. II, p. 74.
30. *Ibid.*, vol. I, p. 15.
31. *Ibid.*, vol. IV, p. 118.
32. *Ibid.*, vol. I, p. 15.
33. *Ibid.*, vol. I, p. 6.
34. Greenberg is also responding to a more recent text, Irving Babbitt's *The New Laokoön: An Essay in the Confusion of the Arts* (1910). See *ibid.*, vol. I, p. 30.
35. *Ibid.*, vol. I, pp. 31–2.
36. *Ibid.*, vol. IV, p. 82.
37. *Ibid.*, vol. IV, pp. 86–7.
38. *Ibid.*, vol. IV, p. 90.
39. *Ibid.*, vol. III, pp. 225–6.
40. *Ibid.*, vol. IV, p. 85.
41. *Ibid.*, vol. I, p. 37.
42. *Ibid.*, vol. IV, note p. 94.
43. *Ibid.*, vol. IV, p. 92.
44. *Ibid.*, vol. I, note p. 19.
45. *Ibid.*, vol. IV, pp. 82–3.
46. *Ibid.*, vol. I, p. 71.
47. *Ibid.*, vol. I, p. 8.
48. *Ibid.*, vol. IV, p. 83.

Afterword

1. Thierry de Duve, *Clement Greenberg between the Lines*, trans. Brian Holmes, Paris: Éditions Dis Voir, 1996, p. 108.
2. Hal Foster, ed., *The Anti-Aesthetic: Essays on Postmodern Culture*, Port Townsend, Washington: Bay Press, 1983, p. xv.
3. *Ibid.*, pp. xi–xii.
4. Dave Hickey, *The Invisible Dragon: Four Essays on Beauty*, Los Angeles: Art issues. Press, 1993, pp. 47, 41.
5. Wendy Steiner, *The Trouble with Beauty*, London: William Heinemann, 2001. See also Francette Pacteau, *The Symptom of Beauty*, London: Reaktion Books, 1994.
6. Marlene Dumas, 'on Beauty' (1995), quoted in Wendy Steiner, *The Trouble with Beauty*, London: William Heinemann, 2001, p. 216.
7. Arthur C. Danto, 'Whatever Happened to Beauty?' (1992), repr. in *Embodied Meanings:*

Critical Essays and Aesthetic Meditations, New York: Farrar Straus Giroux, 1994, p. 254.

8. Friedrich Schiller, *On the Aesthetic Education of Man: In a Series of Letters* (1795), ed. and trans. Elizabeth M. Wilkinson and L. A. Willoughby, Oxford: Clarendon, 1967, p. 57.

9. Agnes Martin, 'Beauty Is the Mystery of Life' (1989), repr. in Bill Beckley, ed. with David Shapiro, *Uncontrollable Beauty: Toward a New Aesthetics*, New York: Allworth Press, 1998, pp. 399–401.

10. Ivan Gaskell, 'Beauty', in Robert S. Nelson and Richard Shiff, eds, *Critical Terms for Art History: Second Edition*, Chicago and London: University of Chicago Press, 2003, p. 279.

Further Reading

Recent texts on beauty and the aesthetic

Isobel Armstrong, *The Radical Aesthetic*, Oxford: Blackwell, 2000.

John Armstrong, *The Intimate Philosophy of Art*, Harmondsworth: Allen Lane, The Penguin Press, 2000.

——, *The Secret Power of Beauty: Why Happiness Is in the Eye of the Beholder*, London: Allen Lane, 2004.

Bill Beckley, ed., with David Shapiro, *Uncontrollable Beauty: Toward a New Aesthetics*, New York: Allworth Press, 1998.

Neil Benezra and Olga M. Viso, with essay by Arthur C. Danto, *Regarding Beauty: A View of the Late Twentieth Century*, exh. cat., Washington, DC: Hirshhorn Museum and Sculpture Garden, 1999.

Peter de Bolla, *Art Matters*, Cambridge, Mass. and London: Harvard University Press, 2001.

Peg Zeglin Brand, ed., *Beauty Matters*, Bloomington: Indiana University Press, 2000.

Paul Crowther, *Art and Embodiment: From Aesthetics to Self-Consciousness*, Oxford: Clarendon, 1993.

—— *Critical Aesthetics and Postmodernism*, Oxford: Clarendon, 1993.

—— *The Kantian Sublime: From Morality to Art*, Oxford: Clarendon, 1989.

—— *The Language of Twentieth-Century Art: A Conceptual History*, New Haven and London: Yale University Press, 1997.

Daedalus: Journal of the American Academy of Arts & Sciences, vol. 131, no. 4, Fall 2002: issue on beauty, with contributions from Denis Donoghue, Susan Sontag, Plotinus, Arthur C. Danto, Alexander Nehamas, Dave Hickey, Rochelle Gurstein, Kathy Peiss.

Arthur C. Danto, *The Abuse of Beauty: Aesthetics and the Concept of Art*, Chicago and La Salle, Illinois: Open Court, 2003.

—— 'Whatever Happened to Beauty?' (1992), repr. in *Embodied Meanings: Critical Essays and Aesthetic Meditations*, New York: Farrar Straus Giroux, 1994, pp. 251–7.

Denis Donoghue, *Speaking of Beauty*, New Haven and London: Yale University Press, 2003.

Thierry de Duve, *Kant after Duchamp*, Cambridge, Mass. and London: MIT Press, 1996.

Terry Eagleton, *The Ideology of the Aesthetic*, Oxford: Blackwell, 1990.

Umberto Eco, *History of Beauty*, New York: Rizzoli International, 2004.

Hal Foster, ed., *The Anti-Aesthetic: Essays on Postmodern Culture*, Port Townsend, Washington: Bay Press, 1983.

Cynthia Freeland, *But Is It Art? An Introduction to Art Theory*, Oxford University Press, 2001.

Ivan Gaskell, 'Beauty', in Robert S. Nelson and Richard Shiff, eds, *Critical Terms for Art History: Second Edition*, Chicago and London: University of Chicago Press, 2003, pp. 267–80.

Berys Gaut and Dominic McIver Lopes, eds, *The Routledge Companion to Aesthetics*, London and New York: Routledge, 2001.

Jeremy Gilbert-Rolfe, *Beauty and the Contemporary Sublime*, New York: Allworth Press, 1999.

Dave Hickey, *The Invisible Dragon: Four Essays on Beauty*, Los Angeles: Art issues. Press, 1993.

John J. Joughin and Simon Malpas, eds, *The New Aestheticism*, Manchester University Press, 2003.

James Kirwan, *Beauty*, Manchester University Press, 1999.

Peter Kivy, *Philosophies of Arts: An Essay in Differences*, Cambridge University Press, 1997.

—— ed., *The Blackwell Guide to Aesthetics*, Malden, Mass., Oxford, and Carlton, Victoria: Blackwell, 2004.

Carolyn Korsmeyer, *Gender and Aesthetics: An Introduction*, New York and London: Routledge, 2004.

George Levine, ed., *Aesthetics and Ideology*, New Brunswick, New Jersey: Rutgers University Press, 1994.

Colin Lyas, *Aesthetics*, London: UCL Press, 1997.

Mary Mothersill, *Beauty Restored*, Oxford: Clarendon, 1984.

Peter Osborne, ed., *From an Aesthetic Point of View: Philosophy, Art and the Senses*, London: Serpent's Tail, 2000.

Francette Pacteau, *The Symptom of Beauty*, London: Reaktion Books, 1994.

Elaine Scarry, *On Beauty and Being Just*, Princeton University Press, 1999.

James Soderholm, ed., *Beauty and the Critic: Aesthetics in an Age of Cultural Studies*, Tuscaloosa: University of Alabama Press, 1997.

Wendy Steiner, *The Trouble with Beauty*, London: William Heinemann, 2001.

Anthologies of primary texts

J. M. Bernstein, ed., *Classic and Romantic German Aesthetics*, Cambridge University Press, 2003.

Clive Cazeaux, ed., *The Continental Aesthetics Reader*, London and New York: Routledge, 2000.

David E. Cooper, ed., *Aesthetics: The Classic Readings*, Oxford: Blackwell, 1997.

Susan Feagin and Patrick Maynard, eds, *Aesthetics*, Oxford University Press (Oxford Readers), 1997.

Charles Harrison and Paul Wood, eds, *Art in Theory 1900–1990: An Anthology of Changing Ideas*, Oxford: Blackwell, 1992.

Charles Harrison and Paul Wood with Jason Gaiger, eds, *Art in Theory 1815–1900: An Anthology of Changing Ideas*, Oxford: Blackwell, 1998.

H. B. Nisbet, ed., *German Aesthetic and Literary Criticism: Winckelmann, Lessing, Hamann, Herder, Schiller, Goethe*, Cambridge University Press, 1985.

David Simpson, ed., *German Aesthetic and Literary Criticism: Kant, Fichte, Schelling, Schopenhauer, Hegel*, Cambridge University Press, 1984.

Kathleen M. Wheeler, ed., *German Aesthetic and Literary Criticism: The Romantic Ironists and Goethe*, Cambridge University Press, 1984.

Joshua C. Taylor, ed., *Nineteenth-century Theories of Art*, Berkeley, Los Angeles, and London: University of California Press, 1987.

Primary texts

Charles Baudelaire, *Art in Paris 1845–1862: Salons and Other Exhibitions*, trans. and ed. Jonathan Mayne, London: Phaidon, 1965.

—— *The Painter of Modern Life and Other Essays*, trans. and ed. Jonathan Mayne, 2nd edn, London: Phaidon, 1995.

Clive Bell, *Art*, London: Chatto and Windus, 1947 (first published 1914).

Eugène Delacroix, *The Journal of Eugène Delacroix: A Selection*, ed. Hubert Wellington, trans. Lucy Norton, 3rd edn, London: Phaidon, 1995.

Roger Fry, *Cézanne: A Study of His Development*, repr. with intro. by Richard Shiff, University of Chicago Press, 1989 (first published Hogarth Press, 1927).

—— *A Roger Fry Reader*, ed. Christopher Reed, University of Chicago Press, 1996.

—— *Vision and Design*, ed. J. B. Bullen, Oxford University Press, 1990 (first published Chatto and Windus, 1920).

Johann Wolfgang von Goethe, *Italian Journey (1786–1788)*, trans. W. H. Auden and Elizabeth Mayer, Harmondsworth: Penguin, 1970 (translation first published Collins, 1962).

—— ed. and trans. John Gage, *Goethe on Art*, London: Scolar Press, 1980.

Clement Greenberg, *The Collected Essays and Criticism*, ed. John O'Brian, Chicago and London: University of Chicago Press, 1986–93 (4 vols).

Immanuel Kant, *The Critique of Judgement* (1790), trans. James Creed Meredith, Oxford: Clarendon, 1952 (translation first published 1911).

Linda Merrill, *A Pot of Paint: Aesthetics on Trial in Whistler v. Ruskin*, Washington and London: Smithsonian Institution Press, 1992 (includes reconstructed transcript of the court proceedings).

Walter Pater, *The Renaissance: Studies in Art and Poetry*, ed. Donald L. Hill, Berkeley, Los Angeles, and London: University of California Press, 1980.

John Ruskin, *The Works of John Ruskin*, Library Edition, ed. E. T. Cook and Alexander Wedderburn, London: George Allen, 1903–12 (39 vols).

—— *Modern Painters* (1843–60), ed. and abridged David Barrie, London: André Deutsch, 1987.

Friedrich Schiller, *On the Aesthetic Education of Man: In a Series of Letters* (1795), ed. and trans. Elizabeth M. Wilkinson and L. A. Willoughby, Oxford: Clarendon, 1967.

Stendhal and the Arts, selected and ed. David Wakefield, London: Phaidon, 1973.

Algernon Charles Swinburne, *Swinburne as Critic*, ed. Clyde K. Hyder, London and Boston: Routledge and Kegan Paul, 1972.

James McNeill Whistler, *The Gentle Art of Making Enemies*, New York: Dover, 1967 (repr. of 2nd edn, 1892).

Johann Joachim Winckelmann, *Reflections on the Imitation of Greek Works in Painting and Sculpture* (1755), trans. Elfriede Heyer and Roger C. Norton, La Salle, Illinois: Open Court, 1987.

Winckelmann: Writings on Art, selected and ed. David Irwin, London: Phaidon, 1972.

Secondary works

Lewis White Beck, *Early German Philosophy: Kant and His Predecessors*, Cambridge, Mass.: The Belknap Press of Harvard University Press, 1969.

Thierry de Duve, *Clement Greenberg between the Lines*, trans. Brian Holmes, Paris: Éditions Dis Voir, 1996.

John Golding, *Paths to the Absolute: Mondrian, Malevich, Kandinsky, Pollock, Newman, Rothko and Still*, London: Thames and Hudson, 2000.

Christopher Green, ed., *Art Made Modern: Roger Fry's Vision of Art*, exh. cat., London: The Courtauld Gallery, Courtauld Institute of Art (Merrell Holberton Publishers), 1999.

Darcy Grimaldo Grigsby, *Extremities: Painting Empire in Post-Revolutionary France*, New Haven and London: Yale University Press, 2002.

Michele Hannoosh, *Painting and the Journal of Eugène Delacroix*, Princeton University Press, 1995.

Francis Haskell and Nicholas Penny, *Taste and the Antique: The Lure of Classical Sculpture 1500–1900*, 2nd printing, New Haven and London: Yale University Press, 1982.

Ian Jenkins and Kim Sloan, *Vases and Volcanoes: Sir William Hamilton and His Collection*, exh. cat., London: British Museum Press, 1996.

Joseph Leo Koerner, *Caspar David Friedrich and the Subject of Landscape*, London: Reaktion Books, 1990.

Ernst Kris and Otto Kurz, *Legend, Myth, and Magic in the Image of the Artist*, New Haven and London: Yale University Press, 1979.

Jerome McGann, *Dante Gabriel Rossetti and the Game that Must Be Lost*, New Haven and London: Yale University Press, 2000.

Jeffrey Morrison, *Winckelmann and the Notion of Aesthetic Education*, Oxford: Clarendon, 1996.

Erwin Panofsky, *Idea: A Concept in Art Theory*, trans. Joseph J. S. Peake, Columbia, South Carolina: University of South Carolina Press, 1968 (trans. of 2nd corrected edn, Berlin, 1960).

Elizabeth Prettejohn, ed., *After the Pre-Raphaelites: Art and Aestheticism in Victorian England*, Manchester University Press, 1999.

—— *Rossetti and His Circle*, London: Tate Gallery Publishing, 1997.

Anna Gruetzner Robins, *Modern Art in Britain 1910–1914*, exh. cat., London: Barbican Art Gallery (Merrell Holberton Publishers), 1997.

Martin Rosenberg, *Raphael and France: The Artist as Paradigm and Symbol*, University Park, Penn.: The Pennsylvania State University Press, 1995.

Alison Smith, *The Victorian Nude: Sexuality, Morality and Art*, Manchester University Press, 1996.

Frances Spalding, *Roger Fry: Art and Life*, London, Toronto, Sydney, and New York: Granada Publishing (Paul Elek), 1980.

Calvin Tomkins, *Duchamp: A Biography*, London: Chatto & Windus, 1997.

William Vaughan, *German Romantic Painting*, 2nd edn, New Haven and London: Yale University Press, 1994.

Andrew Wilton and Robert Upstone, eds, *The Age of Rossetti, Burne-Jones and Watts: Symbolism in Britain 1860–1910*, exh. cat., London: Tate Gallery Publishing, 1997.

List of Illustrations

3), 1809, engraving, 34 × 28 cm. Bibliothèque Nationale, Paris (Département des Estampes).

21. Hans Veit Schnorr von Carolsfeld, *Immanuel Kant*, 1789, pencil drawing, 10.9 × 14 cm. Dresden, Kupferstich-Kabinett der Staatliche Kunstsammlungen Dresden/photo Deutsche Fotothek.

22. Édouard Manet, *White Peonies*, c.1864, oil on canvas, 31 × 46.5 cm, Musée d'Orsay (Galeries du Jeu de Paume), Paris/photo Giraudon/Bridgeman Art Library.

23. Vincent van Gogh, *Sunflowers*, 1887, oil on canvas, 43 × 61 cm. Metropolitan Museum of Art, New York, acquired 1949; purchase, Rogers Fund (inv. nr. 49.41)/photo Bridgeman Art Library.

24. Muhammad Zaman, *Blue Iris*, 1663–4. Opaque watercolour and ink on paper, 33.5 × 21.3 cm. © Brooklyn Museum of Art, New York (Hagop Kevorkian Fund and Middle East Special Fund)/photo Bridgeman Art Library.

25. Georgia O'Keeffe, *Abstraction, White Rose II*, 1927, oil on canvas, 92.1 × 76.2 cm. Georgia O'Keeffe Museum, Santa Fe, New Mexico (Gift of the Burnett Foundation and the Georgia O'Keeffe Foundation). © 2004 Foto Georgia O'Keeffe Museum/Art Resource/Scala, Florence.

26. Jacques-Louis David, *The Oath of the Horatii*, 1785, oil on canvas, 330 × 425 cm. Musée du Louvre, Paris/photo Giraudon/Bridgeman Art Library.

27. Jean-Baptiste-Siméon Chardin, *Glass of Water and Coffee Pot*, 1760, oil on canvas, 32 × 41.3 cm. Carnegie Museum of Art, Pittsburgh (Howard A. Noble Fund, 1966; 66.12/2)/photo Tom Barr.

28. Philipp Otto Runge, *Spray of Leaves with Orange-Lily*, c.1808, paper cut-out in white on black paper, 76.3 × 59 cm. Kunsthalle, Hamburg/photo Elke Walford/Bildarchiv Preussischer Kulturbesitz, Berlin.

29. Anne-Louis Girodet-Trioson, *Portrait of Jean-Baptiste Belley*, 1797, oil on canvas, 160 × 114.3 cm. Musée National du Château, Versailles/photo Peter Willi/Bridgeman Art Library.

30. Joseph Wright of Derby, *The Widow of an Indian Chief Watching the Arms of Her Deceased Husband*, 1785, oil on canvas, 101.6 × 127 cm, Derby Museum and Art Gallery/photo Bridgeman Art Library.

31. Caspar David Friedrich, *Wanderer above the Sea of Fog*, c.1818, oil on canvas, 94.8 × 74.8 cm. Kunsthalle, Hamburg/photo Bridgeman Art Library.

32. Caspar David Friedrich, *Woman at the Window*, 1822, oil on canvas, 44 × 37 cm.

Nationalgalerie, Berlin/photo Jörg P. Anders/Bildarchiv Preussischer Kulturbesitz.

33. Philipp Otto Runge, *The Times of Day*, 1805, etching with engraving on paper, *Morning* 71.7 × 48.2 cm, *Day* 71.6 × 48 cm, *Evening* 71.9 × 48.3 cm, *Night* 71.3 × 48.1 cm. Kunsthalle, Hamburg/photo Bridgeman Art Library.

34. Philipp Otto Runge, *Morning* (small version), 1808, oil on canvas, 106 × 81 cm. Kunsthalle, Hamburg/photo Bridgeman Art Library.

35. Hippolyte Flandrin, *Study (Young Male Nude Seated beside the Sea)*, 1835–6, oil on canvas, 98 × 124 cm. Musée du Louvre, Paris/photo Giraudon/Bridgeman Art Library.

36. Leonardo da Vinci, *Vitruvian Man*, c.1492, pen and ink on paper, 33 × 24 cm. Galleria dell' Accademia, Venice/photo Bridgeman Art Library.

37. François Gérard, *Corinne at Cape Miseno*, 1822, oil on canvas, 257 × 277 cm. Musée des Beaux-Arts, Lyon/photo Studio Basset.

38. Peter Paul Rubens, *The Judgement of Paris*, 1638–9, oil on canvas, 199 × 379 cm. Museo del Prado, Madrid/photo Giraudon/Bridgeman Art Library.

39. Raphael, *St Cecilia Altarpiece*, c.1513–16, oil on canvas (transferred from panel), 238 × 150 cm. Pinacoteca Nazionale, Bologna/photo Alinari/Bridgeman Art Library.

40. Jacques-Louis David, *The Death of Socrates*, 1787, oil on canvas, 129.5 × 196.2 cm. Metropolitan Museum of Art, New York, Catharine Lorillard Wolfe Collection, Wolfe Fund, 1931 (31.45). Photograph © 1995 The Metropolitan Museum of Art.

41. Théodore Géricault, *The Raft of the Medusa*, 1819, oil on canvas, 491 × 716 cm. Musée du Louvre, Paris/photo Giraudon/Bridgeman Art Library.

42. Jean-Auguste-Dominique Ingres, *The Vow of Louis XIII*, 1824, oil on canvas, 421 × 262 cm. Notre-Dame Cathedral, Montauban/photo Lauros-Giraudon/Bridgeman Art Library.

43. Eugène Delacroix, *Scenes from the Massacres of Chios*, 1824, oil on canvas, 417 × 354 cm. Musée du Louvre, Paris/photo Giraudon/Bridgeman Art Library.

44. Raphael, *Transfiguration*, c.1518–20, oil on panel, 405 × 278 cm. Pinacoteca Vaticana, Rome/© 1990, Photo Scala, Florence.

45. Théodore Géricault, *Study of Truncated Limbs*, c.1818–19, oil on canvas, 52 × 64 cm. Musée Fabre, Montpellier/photo Frédéric Jaulmes.

46. Eugène Delacroix, *Arrival at Meknès*, 1832,

watercolour on paper, each page 19.3 × 12.7 cm. Musée Condé, Chantilly/photo Bridgeman Art Library.

47. Eugène Delacroix, *Two Seated Women*, c.1832, watercolour and pencil on paper, 10.7 × 13.8 cm. Musée du Louvre, Département des Arts Graphiques, Paris/photo Réunion des Musées Nationaux/photo Gérard Blot.

48. Eugène Delacroix, *Women of Algiers*, 1834, oil on canvas, 180 × 229 cm. Musée du Louvre, Paris/photo Réunion des Musées Nationaux/Bulloz/Bridgeman Art Library.

49. Eugène Delacroix, *Women of Algiers*, 1847–9, oil on canvas, 84 × 111 cm. Musée Fabre, Montpellier/photo Bridgeman Art Library.

50. Jean-Auguste-Dominique Ingres, *Charles-Marie-Jean-Baptiste Marcotte*, 1810, oil on canvas, 93.7 × 69.4 cm. National Gallery of Art, Washington, DC, Samuel H. Kress Collection (1952.2.24 (PA))/photo Richard Carafelli.

51. Jean-Auguste-Dominique Ingres, *Vicomtesse Othenin d'Haussonville*, 1845, oil on canvas, 131.8 × 92 cm. The Frick Collection, New York (acc. no. 27.1.81).

52. Jean-Auguste-Dominique Ingres, *Jupiter and Thetis*, 1811, oil on canvas, 327 × 260 cm. Musée Granet, Aix-en-Provence/photo Bridgeman Art Library.

53. Jean-Auguste-Dominique Ingres, *Grande Odalisque*, 1814, oil on canvas, 91 × 162 cm. Musée du Louvre, Paris/photo Giraudon/Bridgeman Art Library.

54. Jean-Auguste-Dominique Ingres, *Studies for the Grande Odalisque*, pencil on three pieces of paper cropped and fastened together, 25.4 × 26.5 cm. Cabinet des Dessins, Musée du Louvre, Paris/photo Réunion des Musées Nationaux/J. G. Berizzi.

55. Auguste de Chatillon, *Portrait of Théophile Gautier*, 1839, oil on canvas, 130 × 84 cm. Musée Carnavalet, Paris/Photothèque des Musées de la Ville de Paris.

56. Jean-Auguste-Dominique Ingres, *Bather of Valpinçon*, 1808, oil on canvas, 146 × 97.5 cm, Musée du Louvre, Paris/photo Giraudon/Bridgeman Art Library.

57. Gustave Courbet, *Portrait of P.-J. Proudhon in 1853*, 1865, oil on canvas, 147 × 198 cm. Musée du Petit Palais, Paris/photo Giraudon/Bridgeman Art Library.

58. Gustave Courbet, *A Burial at Ornans*, 1850, oil on canvas, 315 × 668 cm. Musée d'Orsay, Paris/photo Giraudon/Bridgeman Art Library.

59. Édouard Manet, *Charles Baudelaire*, 1868, etching, third plate, second state,

17.5 × 10.6 cm. Nationalmuseum, Stockholm/photo Asa Lundén.

60. Constantin Guys, *Standing Soldiers*, undated, pen and wash on paper, 26.7 × 36.5 cm. British Museum, London.

61. Édouard Manet, *Music in the Tuileries*, 1862, oil on canvas, 76.2 × 118.1 cm. The Trustees of the National Gallery, London, Lane Bequest, 1917/photo Bridgeman Art Library.

62. Henri Fantin-Latour, *Scene from Tannhäuser*, 1864, oil on canvas, 97 × 130 cm. Los Angeles County Museum of Art, Gift of Mr and Mrs Charles Boyer © 1998 Museum Associates LACMA. All Rights Reserved.

63. Claude Monet, *Boulevard des Capucines*, 1873–4, oil on canvas, 80.4 × 60.3 cm. The Nelson-Atkins Museum of Art, Kansas City, Missouri (Purchase: The Kenneth A. and Helen F. Spencer Foundation Acquisition Fund) (F72-35)/photo Jamison Miller.

64. William Holman Hunt, *The Awakening Conscience*, 1853–4 (retouched later), oil on canvas, 76.2 × 55.9 cm. © Tate, London 2004.

65. Albert Moore, *Azaleas*, 1868, oil on canvas, 198.1 × 100.3 cm. Hugh Lane Municipal Gallery of Modern Art, Dublin.

66. Paolo Veronese, *Solomon and the Queen of Sheba*, c.1582, oil on canvas, 344 × 545 cm. Galleria Sabauda, Turin/photo Alinari, Florence.

67. Dante Gabriel Rossetti, *Bocca Baciata*, 1859, oil on panel, 32.2 × 27 cm. Museum of Fine Arts, Boston. Gift of James Lawrence (1980.261)/photo Bridgeman Art Library.

68. Titian, *Woman with a Mirror*, 1514–15, oil on canvas, 96 × 76 cm. Musée du Louvre, Paris/photo Bridgeman Art Library.

69. Simeon Solomon, *Carrying the Scrolls of the Law*, 1867, watercolour and gouache, 35.7 × 25.5 cm. Whitworth Art Gallery, University of Manchester/photo Bridgeman Art Library.

70. Frederic Leighton, *A Girl with a Basket of Fruit*, 1863, oil on canvas, 83.8 × 57.8 cm. Private Collection.

71. David Wilkie Wynfield, *Portrait Photograph of the Painter Frederic Leighton*, 1860s, albumen print, 21.3 × 16.2 cm. National Portrait Gallery.

72. Julia Margaret Cameron, *Call, I Follow, I Follow, Let Me Die*, c.1867, carbon print, 35 × 26.7 cm. The Board of Trustees of the Victoria and Albert Museum, London.

73. Gustave Courbet, *Jo, the Beautiful Irishwoman*, 1865–6, oil on canvas, 54 × 65 cm. Nationalmuseum, Stockholm/photo Bridgeman Art Library.

74. James McNeill Whistler, *The Little White*

Girl, 1864, oil on canvas, 76.5 × 51.1 cm. © Tate, London 2004.

75. Dante Gabriel Rossetti, *Fazio's Mistress*, 1863, oil on panel, 43.2 × 36.8 cm. © Tate, London 2004.

76. Simeon Solomon, *Walter Pater*, 1872, pencil on paper, 17.1 × 9.5 cm. Fondazione Horne, Florence.

77. Dante Gabriel Rossetti, *Venus Verticordia*, *c.*1863–8, oil on canvas, 83.8 × 71.2 cm. Russell-Cotes Art Gallery and Museum, Bournemouth (supported by the National Art Collections Fund)/photo Bridgeman Art Library.

78. Frederic Leighton, *Venus Disrobing for the Bath*, 1867, oil on canvas, 200.8 × 90.2 cm. Private Collection/photo Sotheby's Picture Library.

79. Albert Moore, *A Venus*, 1869, oil on canvas, 160 × 76.2 cm. York Museums Trust (York Art Gallery).

80. *Venus de Milo*, perhaps second century BCE, marble, height 202 cm. Musée du Louvre, Paris/photo Réunion des Musées Nationaux/Hervé Lewandowski.

81. James McNeill Whistler, *Venus* (one of the 'Six Projects', *c.*1868, unfinished), oil on mill-board, mounted on wood panel, 61.8 × 45.6 cm. Freer Gallery of Art, Washington, DC. Gift of Charles Lang Freer (F1903.175a-b).

82. Frederic Leighton, *Daedalus and Icarus*, 1869, oil on canvas, 138.2 × 106.5 cm. The Faringdon Collection Trust, Buscot Park, Oxfordshire.

83. Edward Burne-Jones, *Phyllis and Demophoön*, 1870, watercolour and gouache on paper, 91.5 × 45.8 cm. Birmingham Museums & Art Gallery/photo Bridgeman Art Library.

84. Simeon Solomon, *Dawn*, 1871, watercolour and bodycolour on paper, 35.3 × 50.7 cm. Birmingham Museums & Art Gallery/photo Bridgeman Art Library.

85. Edward Burne-Jones, *Head of a Woman*, 1867, pencil on paper, 22.7 × 15.3 cm. Birmingham Museums & Art Gallery.

86. George Frederic Watts, *The Wife of Pygmalion*, 1868, oil on canvas, 67.3 × 53.3 cm. The Faringdon Collection Trust, Buscot Park, Oxfordshire.

87. Frederic Leighton, *Spanish Dancing Girl*, 1867, oil on canvas, 86.3 × 137.2 cm. © Christie's Images, London.

88. Albert Moore, *The Musicians*, 1867, oil on canvas, 28.6 × 38.7 cm. Yale Center for British Art (Paul Mellon Fund), New Haven/photo Bridgeman Art Library.

89. James McNeill Whistler, *Symphony in White, No. 3*, 1865–7, oil on canvas, 51.4 × 76.9 cm. The Barber Institute of Fine Arts, The University of Birmingham/photo Bridgeman Art Library.

90. Frederic Leighton, *Athlete Wrestling with a Python*, 1877, bronze, height 174 cm. © Tate, London 2004.

91. Frederic Leighton, *The Sluggard*, c.1882–6, bronze, height 191.1 cm. © Tate, London 2004.

92. James McNeill Whistler, *Arrangement in Grey and Black: Portrait of the Painter's Mother*, 1871–2, oil on canvas, 144.3 × 162.5 cm. Musée d'Orsay, Paris/photo Giraudon/Bridgeman Art Library.

93. Leonardo da Vinci, *Mona Lisa*, 1510–15, oil on wood, 77 × 53 cm. Musée du Louvre, Paris/photo Giraudon/Bridgeman Art Library.

94. James McNeill Whistler, *Nocturne in Black and Gold (The Falling Rocket)*, 1875, oil on wood, 60.3 × 46.6 cm. The Detroit Institute of Arts, Gift of Dexter M. Ferry, Jr./photo Bridgeman Art Library.

95. Edward Burne-Jones, *Venus' Mirror*, 1877, oil on canvas, 120 × 200 cm. Museu Calouste Gulbenkian Foundation, Lisbon/photo Bridgeman Art Library.

96. Édouard Manet, *A Bar at the Folies-Bergère*, 1881–2, oil on canvas, 96 × 130 cm. Courtauld Gallery (The Samuel Courtauld Trust), Courtauld Institute of Art, London/photo Bridgeman Art Library.

97. Roger Fry, *Self-Portrait*, 1918, oil on canvas, 73.9 × 94 cm. By kind permission of the Provost and Fellows of King's College, Cambridge/photo Fitzwilliam Museum.

98. Max Beerbohm, *Significant Form*, 1921, pen, pencil, and wash, 13.1 × 18.9 cm. The Charleston Trust/© The Estate of Max Beerbohm, reprinted by permission of Berlin Associates.

99. Giotto, *Pietà*, 1303–5, fresco, 200 × 185 cm. Arena Chapel, Padua/photo © 1990 Scala, Florence.

100. Paul Cézanne, *Still Life with Green Pot and Pewter Jug*, *c.*1869–70, oil on canvas, 64 × 81 cm. Musée d'Orsay, Paris/photo Lauros/Giraudon/Bridgeman Art Library.

101. Paul Cézanne, *The Pool at the Jas de Bouffan*, 1878, oil on canvas, 47 × 56.2 cm. Private Collection/photo © Christie's Images, London.

102. *Bowl*, Jun ware, Song Dynasty, height 7.6 × diameter 17.5 cm. Ashmolean Museum (Gift of Sir Herbert Ingram), University of Oxford.

103. Lucie Rie, *Porcelain bowl with green glaze and gold rim*, *c.*1980, diameter 21 cm. Private Collection/Bonhams, London/Bridgeman Art Library.

104. Fang (Gabon), *Male Reliquary Figure*, wood, brass, and iron, height 60.9 cm. Trustees of the British Museum, London.

105. Paul Cézanne, *Apples*, *c*.1877–8, oil on canvas, 17.1 × 24.1 cm. By kind permission of the Provost and Fellows of King's College, Cambridge (Keynes Collection), on loan to the Fitzwilliam Museum.

106. Paul Cézanne, *Still Life with Compotier* [*Fruit Dish*], 1879–80, oil on canvas, 46 × 55 cm. Private Collection/photo Malcolm Varon, NYC © 2004.

107. Pablo Picasso, *'Ma Jolie'*, 1911–12, oil on canvas, 100 × 65.4 cm. The Museum of Modern Art, New York (Lillie P. Bliss Bequest)/photo Giraudon/Bridgeman Art Library. © Succession Picasso/DACS 2004.

108. Kasimir Malevich, *Black Square*, 1915, oil on canvas, 106.2 × 106.5 cm. State Tretyakov Gallery, Moscow.

109. Theo van Doesburg, *Composition 17*, 1919, oil on canvas, 50 × 50 cm, Haags Gemeentemuseum, The Hague/photo Bridgeman Art Library.

110. Wassily Kandinsky, *Composition VI*, 1913, oil on canvas, 194 × 294 cm. The State Hermitage Museum, St Petersburg/photo Scala, Florence. © ADAGP, Paris and DACS, London 2004.

111. Marcel Duchamp, *Fountain*, 1917, photograph by Alfred Stieglitz, from *The Blind Man*, no. 2 (May 1917), p. 4. Philadelphia Museum of Art, Louise and Walter Arensberg Collection. © Succession Marcel Duchamp/ADAGP, Paris and DACS, London 2004.

112. Jackson Pollock, *Blue Poles: Number 11, 1952*, 1952, enamel and aluminium paint with glass on canvas. 210 × 486.8 cm. National Gallery of Australia, Canberra. © ARS, NY and DACS, London, 2004.

113. Georges Braque, *Woman at an Easel*, 1936, oil on canvas, 130 × 162 cm. The Metropolitan Museum of Art, New York, Bequest of Florene M. Schoenborn, 1995 (1996.403.12). Photograph © 1987 The Metropolitan Museum of Art. © ADAGP, Paris and DACS, London 2004.

114. Norman Rockwell, *Girl Running with Wet Canvas* (cover for *The Saturday Evening Post*, 12 April 1930). Printed by permission of the Norman Rockwell Family Agency. Copyright © 1930 the Norman Rockwell Family Entities/photo Courtesy of the Norman Rockwell Museum at Stockbridge, MA.

115. Helen Frankenthaler, *Mountains and Sea*, 1952, oil on canvas, 220.1 × 297.8 cm. © 2004 Helen Frankenthaler. Collection of the artist

(on loan to the National Gallery of Art, Washington, DC).

116. Paul Klee, *Rose Garden*, 1920, oil and pen on paper on carton, 49 × 42.5 cm. Städtische Galerie im Lenbachhaus, Munich. © DACS 2004.

117. Cindy Sherman, *Untitled Film Still #14*, 1978, black-and-white photograph, 20.3 × 25.4 cm. Courtesy of the artist, and Metro Pictures, New York.

118. Jim Hodges, *Changing Things*, 1997, silk, plastic, and wire in 342 parts, 193.04 × 375.92 cm. Dallas Museum of Art, Mary Margaret Munson Wilcox Fund and Gift of Catherine and Will Rose, Howard Rachofsky, Christopher Drew and Alexandra May, and Martin Posner and Robyn Menter-Posner.

119. Robert Mangold, *Attic Series III*, 1990, acrylic and pencil on canvas, 228.5 × 310 cm. Courtesy the artist, and Lisson Gallery, London.

120. Yves Klein, *Blue Venus*, undated (*c*.1961–2), pigment and synthetic resin on plaster replica, height 69.5 cm. Musée d'Art Moderne et d'Art Contemporain, Nice. © ARS, NY and DACS, London 2004.

121. Giulio Paolini, *Mimesis*, 1975–6, two plaster casts, height 200 cm. Courtesy the artist and Christian Stein, Milan.

122. Jannis Kounellis, *Untitled*, 1980, door blocked with stones and fragments of plaster casts, 206 × 94 cm. Hirshhorn Museum and Sculpture Garden, Smithsonian Institution, Washington DC, Joseph H. Hirshhorn Purchase Fund, 1999/photo Lee Stalsworth. Courtesy the artist.

123. Robert Mapplethorpe, *Ajitto*, 1981, silver print, edition 15, 50 × 40 cm. © The Robert Mapplethorpe Foundation, courtesy Art & Commerce.

124. Robert Mapplethorpe, *Thomas*, 1987, silver print, edition 10, 60 × 50 cm. © The Robert Mapplethorpe Foundation, courtesy Art & Commerce.

125. Mary Duffy, *Cutting the Ties That Bind*, 1987, photographs, overall dimensions 56 × 80 cm . Collection of the Arts Council of Ireland/An Chomhairle Ealaíon. Courtesy the artist.

126. Hiroshi Sugimoto, *Pine Tree Landscape*, 2001, silver gelatin print, six parts, overall dimensions 182 × 750 cm. Courtesy the artist and Sonnabend Gallery, New York.

127. Agnes Martin, *Night Sea*, 1963, oil and gold leaf on canvas, 183 × 183 cm. Private Collection/photo Sotheby's, New York. © The artist, courtesy PaceWildenstein, New York.

Index